FIGURE
DRAWING
MASTER CLASS

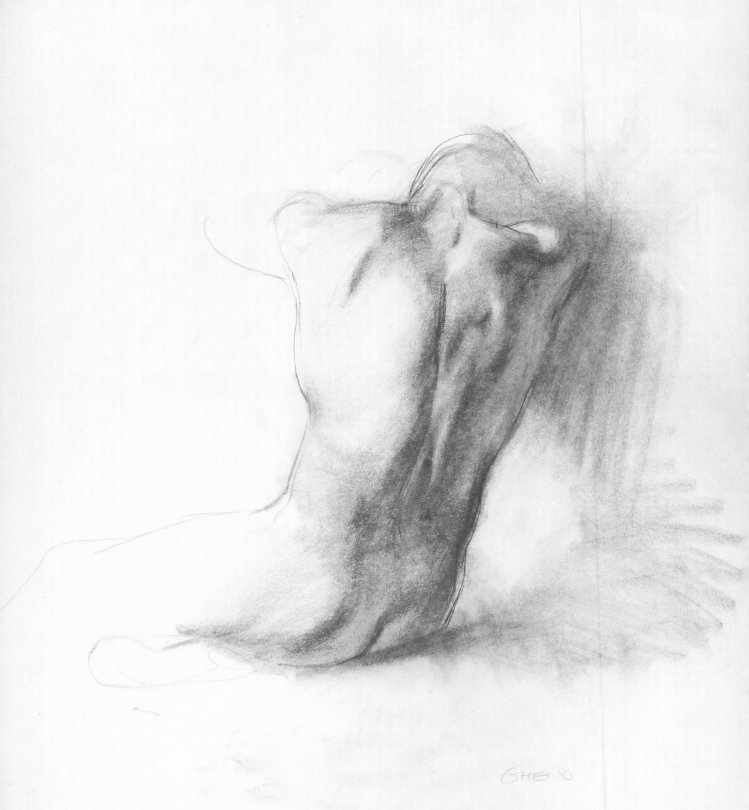

FIGURE DRAWING

MASTER CLASS

LESSONS IN LIFE DRAWING

DAN GHENO

NORTH LIGHT BOOKS
CINCINNATI, OHIO
ArtistsNetwork.com

Contents

WHAT YOU NEED

Assorted drawing boards: Masonite board, canvas board

Assorted charcoal pencils: 2H and HB, charcoal white

Assorted compressed charcoal sticks

Assorted graphite pencils: 2H, H, HB; and graphite 5.6mm stick: HB, B

Assorted mechanical pencils: 0.5 and 0.3 often with H leads

Assorted papers (no newsprint): bond, toned, tracing

Assorted sanguine pencils and sticks: Both oil and chalk base

Assorted thin lead colored pencils

Ballpoint pen

Bulldog clips

Compressed charcoal dust

Eraser

Hand-held mirror

Pencil holder

Vine charcoal (medium)

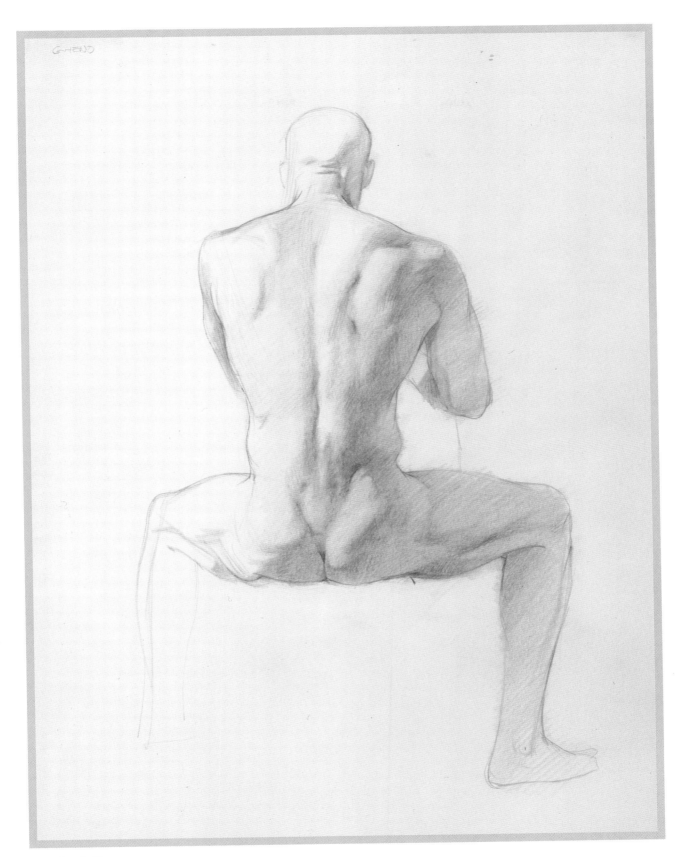

Seated Male Figure
Dan Gheno, 1996, colored pencil, 20" × 15"
(51cm × 38cm) collection of K Ko

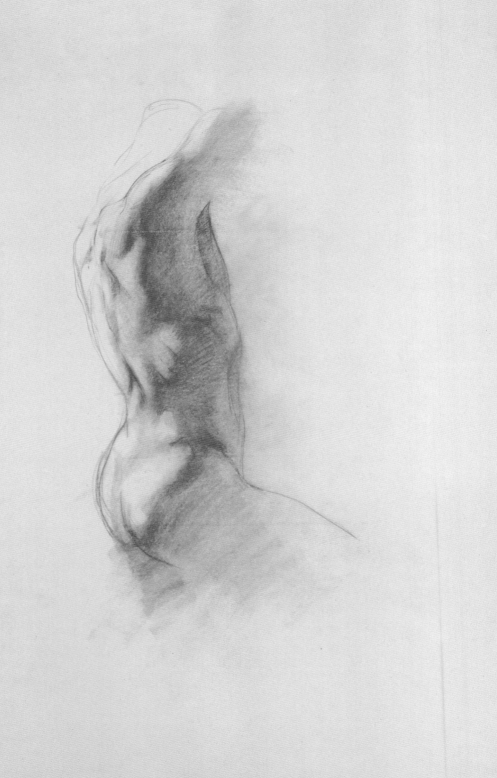

Introduction

For a while in the 1960s and 1970s, the study of the figure was declared dead by the art press. Indeed, many art critics and artists of the day proclaimed that all representational and even emotive, nonobjective arts such as Abstract Expressionism were passé, to be replaced in the future by a higher, more intellectual and minimalist form of nonmaterial, conceptual art.

Well, the future is here. Some things have indeed changed since then, or should I say changed back, such as the rebirth of the figurative movement. Actually, the figurative movement never died in the first place. The human form has always fascinated artists, and although artists of the figure went undetected by the media during that dry period, we never left the scene. It's the "official" fine-art world that's changed, becoming more inclusive of all aesthetic sensibilities, no longer treating the visual arts like some sort of horse race or a win/lose proposition.

When I began writing for *Drawing* magazine in 2003, I saw my articles as an organized series or chapters for a potential book that told a unified story on how to better draw the human figure. I wanted to prove how important it is to train your senses—your mind, eye and hand—to work in unison. I wanted to demonstrate that drawing the figure is not a mindless act but that it takes a fusion of all these skills and time and a conscious, deliberative effort and practice to pull it off.

When I finally reorganized these articles into book form, I designed this book so it could be used by readers of all levels in a sequential manner as if it were a class on the essentials of figure drawing. In fact, if you are a teacher, I hope you'll find my book useful, perhaps thinking of it as a suggestion for a week-by-week class outline and possibly treating it as a textbook.

For beginning artists who don't have access to a figure drawing class or for advanced artists who simply want to expand their understanding, try to use this book as a step-by-step study guide. Read through it at least once and try to absorb the broader meaning of the information presented. I suggest you then reread the book, setting aside one or two weeks per chapter, making drawings from the reproductions, trying to put the information in the text to use visually. It's only after you make this fusion of eye, hand and brain that the information truly becomes integrated and a part of your psyche.

I hope you'll also find that each time you reread this book you'll learn something new, something you missed before. This is true of most books on art technique. As your grasp of the material increases and your depth of understanding grows, you become more open to information you may have missed the first or second time. Perhaps it didn't seem important on the first read, or maybe it simply didn't register because you didn't have a proper frame of reference for it at the time. It's a psychological fact that we often don't see something right in front of our eyes until we're ready to accept it. For instance, it is said that many of the early American indigenous people could not initially see the Spanish galleons anchored off the coast, because they didn't have the concept of such large boats yet. But while it may seem drudgery, with each rereading, every time you learn or relearn an old concept, the excitement of discovery you experience will become its own reward.

It's a long journey for all of us. You're on your way when you make the decision to become an artist and then make the commitment to spend as much time as you can on your studies. Most important, you must get over your fear of the subject. Although the act of figure drawing is full of limitless complexities, it's far from an impossible task that requires the use of crutches, such as a camera lucida. The only real hurdle is your apprehension when you first pick up a pencil and stare at that blank page. Stalling only makes it worse, making the job look bigger and fiercer than it really is. Like a swimmer facing a cold ocean, you simply have to dive in and start drawing.

Dan Gheno

Male Torso
Dan Gheno, 1995, Sanguine, 24" × 18" (61cm × 46cm), collection of Sharon Hunter and Hank Putsch

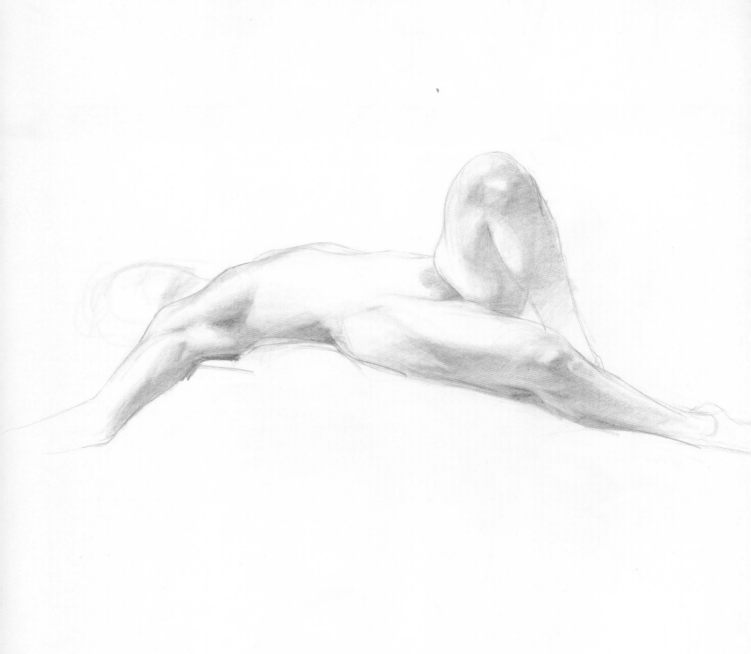

1 How to See Form

■ Artists are not born, they are made. Many of us can point to the defining moment when we felt compelled to become artists.

For me, that moment came when I was a child of ten watching the 1965 movie adaptation of *The Agony and the Ecstasy* with my older brother at a local drive-in theater. Charlton Heston brought to life the god of all drawing and sculpting artists, Michelangelo. Watching him, I was instantly inspired by the artist's heroic sense of volume and his powerful sense of anatomy. Even before the movie ended, I knew in my heart and felt impelled to become an artist of the figure.

I also knew as a child that it would take more than mere inspiration to become an artist. I had to study the figure in all its aspects and practice day in and day out. I spent a great deal of time studying anatomy and copying from Old Masters, especially Rubens, Pontormo, Raphael and modern masters such as Rico Lebrun, who seemed able to draw the human figure from the inside out with a firm conceptual understanding of its underlying structure. They all seemed to imbue their figurative work with a palpable, almost tactile sense of volume, extending outward beyond the page. Their examples pushed me to follow my instincts and look for a sculptural sense of form in my own drawings.

One cannot learn to draw the figure in all its volumetric splendor until one learns how to manage its proportions and gestures. I suggest first starting with some beginning block-in strategies described in my "How to Begin a Drawing" demonstration. Once you have set up a rough sketch for the drawing, this chapter will show you how to proceed.

Reclining Figure
Dan Gheno, 1995, Sanguine, 18" × 24" (46cm × 61cm), collection of the artist

Recognize the Light Source

As with any other endeavor, you need to spend a little time in preparation. Try to position yourself so that you have a clear view of the model and with your drawing paper at least a few feet away from your eyes. It will be difficult to judge proportion if you sit or stand too close to your paper or your model. Some artists recommend standing at an easel. I rigorously adhere to this policy while painting, but to give my back a break, I usually draw in a seated position.

It's also important to learn how to draw in any sort of situation. Some of the most dynamic images result from standing above or sitting below a model while drawing with the paper at a slanted angle to your line of sight. The Old Masters were bold when it came to drawing the figure at unusual angles. Their figures lunge into or out of space, and their work is full of foreshortening that heightens the *form effect*, or the illusion of solid, three-dimensional volume.

The Masters were equally daring when it came to their dramatic use of chiaroscuro, the use of strong light and dark. Give some thought to the light source in your work. It helps to shine at least one strong light on the model so there's a clear separation between light and shadow and so the muscle and bone structure will be more apparent. In my drawings, the light is usually positioned above or to the side of the model, and sometimes even behind the figure, so that some portions of the forms are in shadow.

Occasionally you will detect that there are several separate lights on the model. A reflective light can be troublesome, but nothing kills a sense of form more than too many light sources. I recommend sticking to a primary light source when working in your studio. In a classroom situation, in a sketch group or out in the real world, you can save yourself trouble by determining the direction of your dominant light source before you begin your battle with the drawing.

Although not primarily a sculptor, the Renaissance painter and draftsman Leonardo da Vinci was probably just as obsessed with the form effect as was Michelangelo. To the dismay of more than one impatient client waiting for a mural or painting to be completed, Leonardo spent many years filling countless pages in

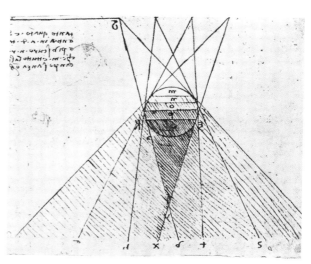

One of Leonardo's many diagrams of light and shadow.

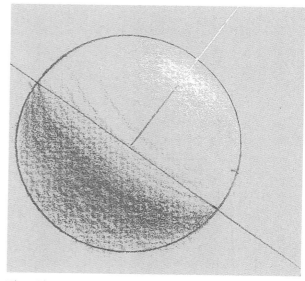

This Gheno diagram illustrates Leonardo's point.

his notebooks, analyzing various light sources and their effects on the human form. He found that on rounded or elliptical shapes, shadows tend to occur at right angles to the light source (see the Leonardo diagram). In contrast, shadows tend to follow the visual sides or contours of cylindrical or boxy forms (note the cylindrical arm and boxy fingers in *Arm Detail No. 1*).

The human figure is a complex combination of these modified volumes and their resulting shadows. Look

hard for the actual shapes of these shadows as they relate to the position of the light source. Few human shadows exactly parallel the outside contours.

Although arms and legs can be thought of as cylinders, with their overall shadows mostly echoing the edges, the rounded muscles and underlying bones often greatly modify their forms, and some of the inner shadows tend to follow oblique angles to the outside contours. In the case of *Arm Detail No. 2*, a strong light source from above and to the left illuminates the arm. You may notice that some of the shadows run nearly perpendicular to the direction of the light source on the rounded subforms of the spherical shoulder, and also on several other similar, small subforms that run down the arm.

There is a lot of variety within the world of shadow shapes. Some shadows turn very abruptly, while others develop in a very smooth, graduated manner. In the upper forward leg in *Dancer Seated*, notice how the sharply rendered bony mass of the knee moves gradually into the more broadly rendered shadow of the softer, fleshy muscle mass of the thigh. On the other hand, cast shadows almost always appear very sharp, and you can use these crisply edged shapes to reinforce the basic structure of a form, as in the upper legs of *Standing Female Figure*.

Trust your eye while charting the position of these shadow shapes or any other aspect of the form effect. It doesn't matter whether you're following a traditional or a modernist impulse. Each curve, value and line should have its own character. You don't want your work to degenerate into stylized and predictably bulbous forms or to borrow an old but true phrase, "form without substance."

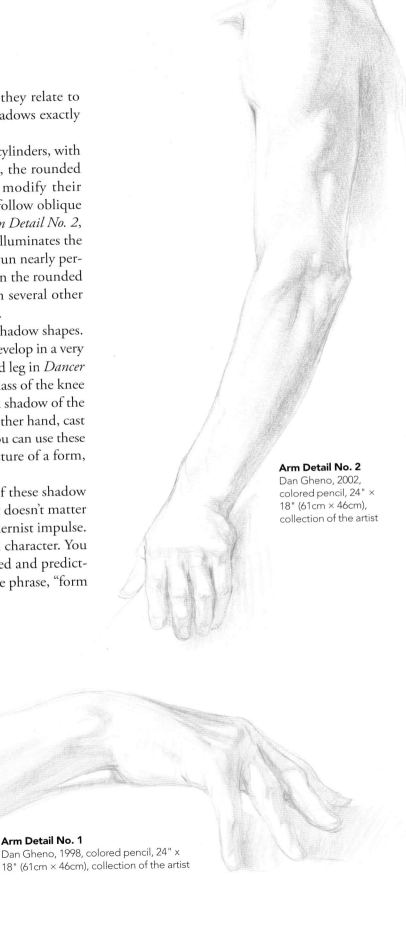

Arm Detail No. 2
Dan Gheno, 2002, colored pencil, 24" × 18" (61cm × 46cm), collection of the artist

Arm Detail No. 1
Dan Gheno, 1998, colored pencil, 24" x 18" (61cm × 46cm), collection of the artist

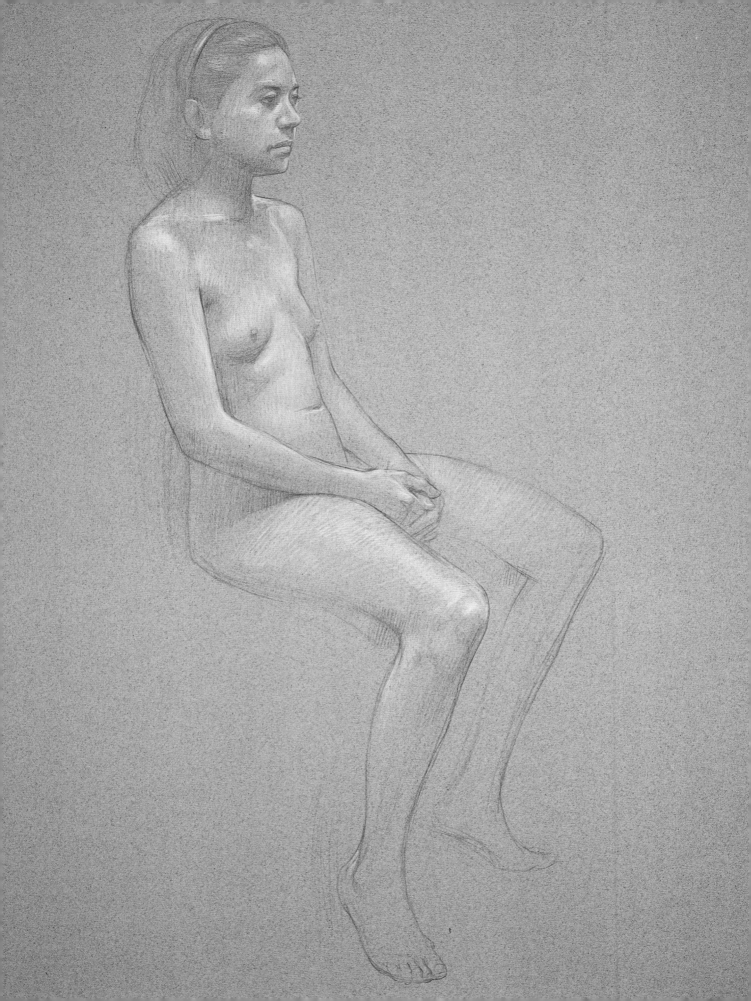

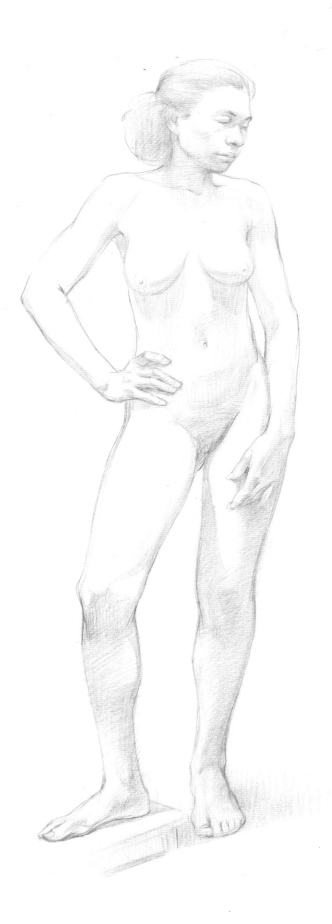

Create Quality Lines

Line is the first tool we learn to use as artists. In fact, line quality is one of the most important instruments in our toolbox for form creation. Be especially vigilant about the quality of line. Find contrast and variety in its use. Vary its thickness and thinness and its rough and smooth characteristics. You can use line to create the figure, working the outside contour as well as wandering within its perimeters.

Like the planes they describe, lines can be manipulated into a similar sort of balance of oppositions. Let your line interlock with or cross overlapping forms. I use a thick line to bring a form forward, toward the viewer. A coarse or heavily weighted line can have the same advancing effect. On the other hand, you can use a thin or lightly drawn line to tip a plane away from the viewer. Sometimes you can even dab at a line with a kneaded eraser to enhance the effect of recession.

I spend a lot of time whittling a large selection of pencils to long, sharp points to gain the maximum control over the quality of my line. As my pencils wear down, I switch to a new pencil rather than stop in the middle of the drawing process to sharpen a stubby point. I often hold my pencil in the direction of the stroke while drawing, which can give an almost needlelike effect. I can immediately find a contrast of line quality when I change to a more sideways approach, using the longer, broad side of the pencil point to create a rougher line and a fuller sense of form. All the while, I work downward, using gravity to give my hand and line a sense of determination.

So many artists confine their use of line to the outside of the form or the "outline" as many people call it. A deadweight line tends to flatten the form on the edge as if the volume ended abruptly at the outline. Line can infer so much more sculptural power if you let it wander more freely and loosely through the figure, following the interior, round or angled volumes of the human form.

Standing Female Figure
Dan Gheno, 2000, colored pencil, 24" × 18"
(61cm × 46cm), collection of the artist

Dancer Seated (opposite page)
2003, colored pencil and charcoal, 24" × 18"
(61cm × 46cm)

Identify the Big Planes

Examine the major masses or planes that underlay the human form. The figure is composed of an infinite array of planar forms. The most structural and obvious planes are the front, side and back surfaces, upon which all the other, more subtle form shifts occur.

At its core, the human figure is composed of simple shapes including boxlike, cylindrical and rounded shapes. Look for the orientation of these shapes toward each other. These shapes are usually interlocked or balanced in some sort of opposition, most dramatically in the chest and pelvic region (C).

In this case, as the chest tilts backward and to the right, the pelvic region tilts forward and to the left. Look for the anatomically parallel or bilateral landmarks such as the nipples, shoulder line, chest line and the pelvic crest to determine and emphasize the cant of these forms. To better appreciate the bulk of the figure, try to imagine a cross section slicing through its forms (D).

Notice that foreshortening pushes back the centerline (A). Pay close attention to this line so the far side of the chest doesn't become too big and contradict the form effect.

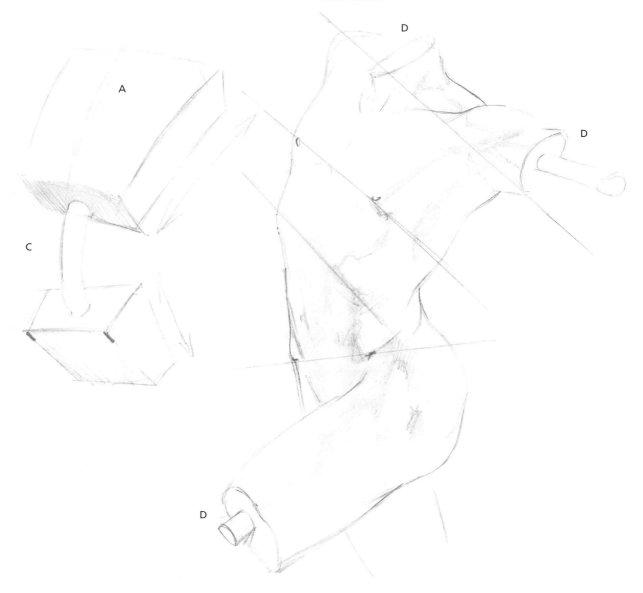

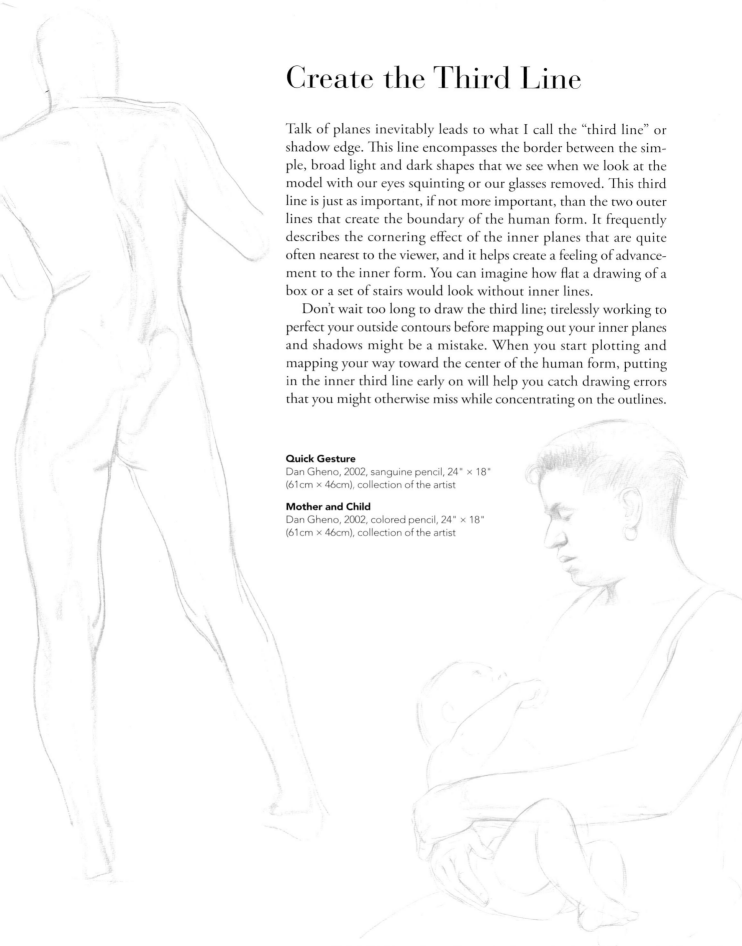

Create the Third Line

Talk of planes inevitably leads to what I call the "third line" or shadow edge. This line encompasses the border between the simple, broad light and dark shapes that we see when we look at the model with our eyes squinting or our glasses removed. This third line is just as important, if not more important, than the two outer lines that create the boundary of the human form. It frequently describes the cornering effect of the inner planes that are quite often nearest to the viewer, and it helps create a feeling of advancement to the inner form. You can imagine how flat a drawing of a box or a set of stairs would look without inner lines.

Don't wait too long to draw the third line; tirelessly working to perfect your outside contours before mapping out your inner planes and shadows might be a mistake. When you start plotting and mapping your way toward the center of the human form, putting in the inner third line early on will help you catch drawing errors that you might otherwise miss while concentrating on the outlines.

Quick Gesture
Dan Gheno, 2002, sanguine pencil, 24" × 18" (61cm × 46cm), collection of the artist

Mother and Child
Dan Gheno, 2002, colored pencil, 24" × 18" (61cm × 46cm), collection of the artist

Keep Some Original Lines

I often move my hand and pencil in a practice motion above the paper, trying with the sweeping arc of my hand movement to imagine the cylindrical or spherical shape underlying the form that I'm about to draw. This routine often leaves traces of a line where I accidentally touch the paper. Some artists call these "tracking lines." I erase some of them, but I occasionally leave many of them when they seem to hint at and reinforce the structure of the basic form.

For this same reason I often leave hints of beginning, gestural guidelines in my finished drawing. Sometimes I even leave the vector lines that describe the axes and the perspective of major planes, such as the line I often run along the base of the feet and the floor plane or the line across the tilt of the shoulders. These faint lines that remain help to buttress the essential rhythm of the figure as well as dramatize the excitement and expressiveness of the drawing process.

Leaning Figure
Dan Gheno, 2002, colored pencil, 24" × 18"
(61cm × 46cm), private collection

Depict the Form With Shadows

Shadow is just as important a tool as line for depicting form. I usually seek out lighting conditions that cause the shadow break to occur at a major plane change. Remember that value change relates to form change. As the form gradually turns away from the light, it gradually and subtly turns darker in the drawing until you hit a major plane change, such as the turn of the cheek and chin when, in the absence of much reflected light, the form turns radically darker.

To better understand the logic of this concept, try drawing on toned paper using a dark pencil for the shadows and a white pencil for the lights. Starting with your lightest value masses, block in the brighter values with the white pencil. Press harder where the figure or volume turns toward the light source, and watch how the drawing automatically turns brighter. To create your dark lights, gradually ease up a bit on the pressure. This gradual change of pressure will allow more of the toned paper to show through, and the drawing will automatically turn darker as you move your pencil onto the planes that turn away from the light source.

A little reflected or secondary light can help the form effect by keeping your shadows from becoming too dense. However, try not to get carried away with reflected light. Reflected light is just what the term indicates: a weak reflection of the primary light source bouncing off the surrounding surfaces such as the walls, ceiling, floor or sky. All reflected lights should remain subordinate and darker than the halftones on the light side of the third line.

Notice that as the shadow planes turn away from the sources of reflected light, they turn darker as they reach toward the third line. Many artists and several art historians call this darkening effect the "core shadow" because it literally sits at the core of the shadow. It is an extremely useful device, creating a magnificent cornering effect that is often found in the work of such Baroque masters as Rubens and Van Dyck, and exaggerated to an overwrought, almost comical extent by some of the rococo artists.

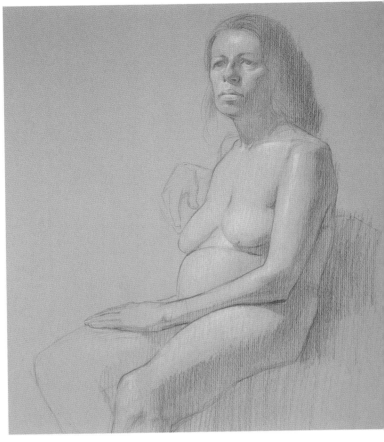

Seated Woman
Dan Gheno, 2003, colored pencil and charcoal, 24" × 18" (61cm × 46cm), collection of the artist

You can quickly kill the form effect by blasting into the reflected lights with a white pencil. Don't render the planes that turn away from the light source as brightly as the planes that turn toward the light source. This will put the opposed planes on the same gradient or position relative to the light source, and it will cancel out the sense of dimension that you've worked so hard to achieve.

HOW TO BEGIN A DRAWING

MATERIALS LIST
Graphite 5.6mm stick

Plunking down that first line can be the most difficult thing for many artists when beginning a drawing. You'll hold yourself back needlessly if you fear putting down the wrong line or making mistakes in general. The process of drawing is really a process of revision—especially in the beginning stages. Just start placing marks on your paper. You can then rearrange them once you have something more concrete to compare them against.

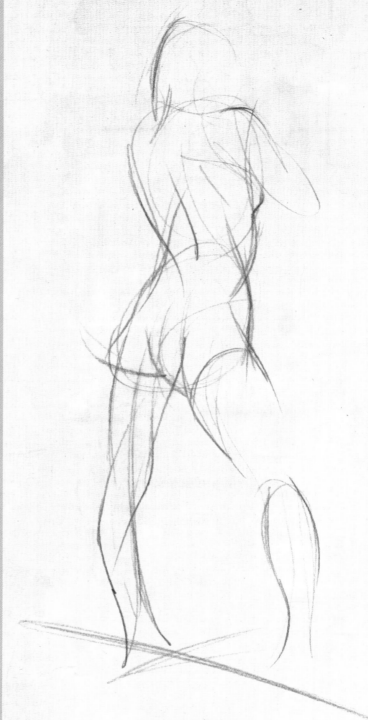

Create a Gesture Drawing
There is no one single best way to start a figure drawing from life. Personally, I like to start with a simple gestural drawing, looking for the major lines of actions. It doesn't matter if the drawing looks messy at first. You can clean it up later.

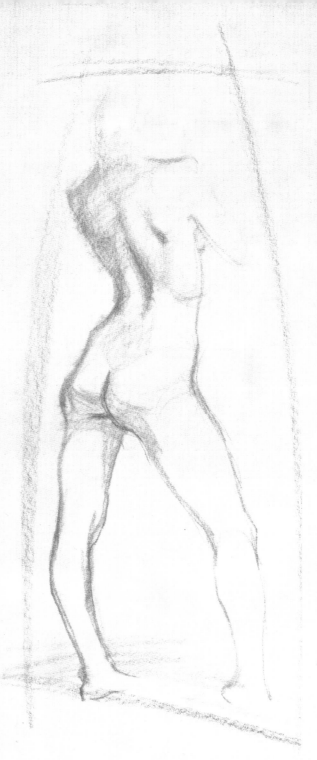

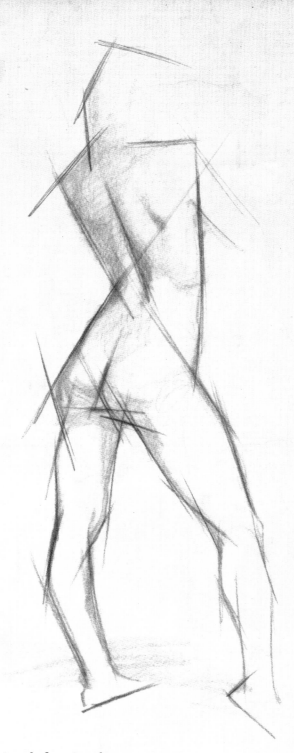

Draw an Imaginary Envelope

Some artists advocate drawing an imaginary envelope shape around the figure to help visualize the overall positive shape as well as the negative space enveloping the figure.

Look for Angles

Look for the variable angles that sweep across the figure's forms, making implied connections between arms, legs, ankles, shoulders or any other anatomical landmarks you wish to compare. Look for the big shapes these oblique lines make, comparing their relative lengths and angles. Use angles to find the exact crescendo or peak of each curve. These peaks are usually high or low and almost never in the middle of a curve. Once the correct angles are found, you can then start rounding them out to get a more organic, realistic look to your figure drawing.

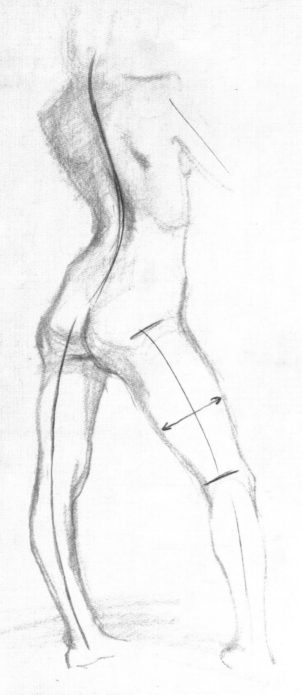

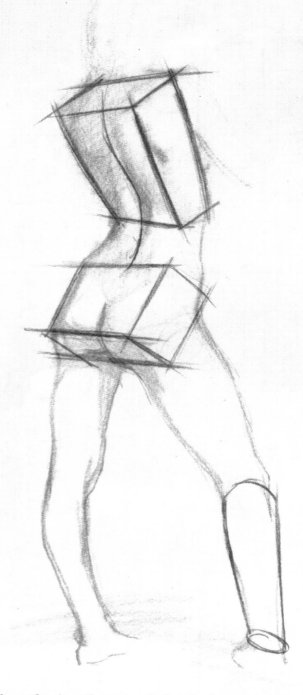

Find the Interior Lines

When concentrating on individual forms such as an arm or torso, make note of the interior lines of action in a gestural manner. Don't worry if a drawing looks like a stick figure initially. Just get something down. You can then use this simplified structure to compare the relative proportions of the figure. If revisions are necessary, it's much easier to make them now before you get into the details. As you move forward into the drawing process, note how the outside contours relate to the interior reference lines of action.

Identify the Shapes of the Body

Ensure that the underlying volumes of the figure reflect cylinders for the limbs, and opposing boxlike structures for the hips and rib cage.

When seen as an overall unit, the torso can be visualized as a kind of pliable tubular structure.

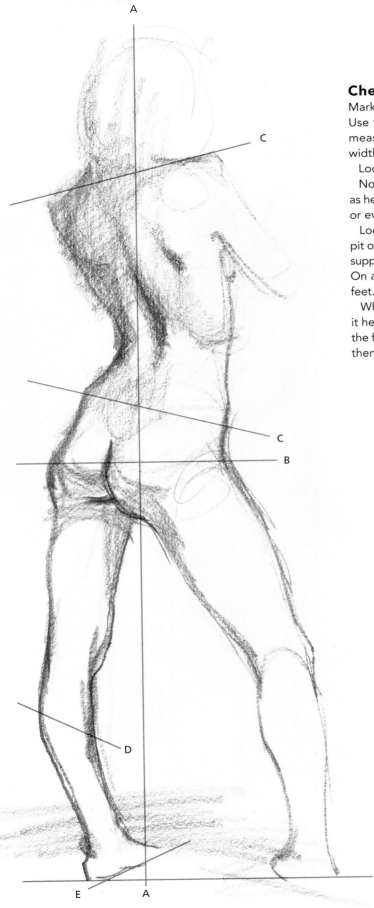

Check Your Measurements

Mark off the top, bottom (A) and middle (B) of the figure. Use the head or some other anatomical form as a unit of measurement, counting down the length and across the width of the figure.

Look for contrasting angles of the shoulders and hips (C).

Notice the high point and low point of opposing contours as here in the leg. They are almost never located horizontally or evenly across the form like a parenthesis (D).

Look for the center of gravity (A), normally starting in the pit of the neck and running through the figure to the point of support—in this case most of her weight is placed on one leg. On a balanced standing figure it would be in between both feet. Mark off the angle of the foot and floor placement (E).

When gauging the proportions of the details, say an arm, it helps to quickly indicate the beginning and end points of the form. Thomas Eakins said he "…would do the elbow and then the wrist, then I would finish in between."

WHAT'S YOUR MEASURE?

Don't just measure vertically up and down the page, but also measure "anatomically." For instance, how many head units fit along the long axis of the leg. compared to its width?

Standing Demo
Dan Gheno, 2014, graphite, 8" × 3"
(20cm × 8cm), collection of the artist

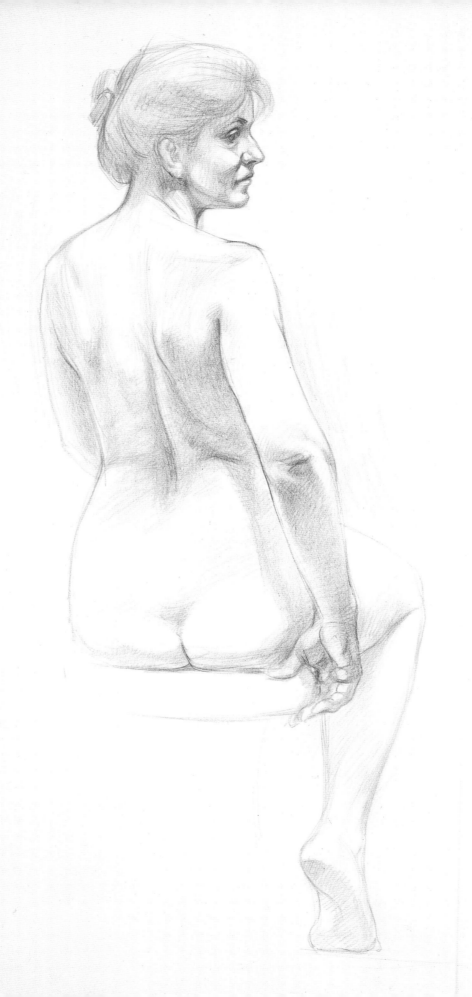

2 Training Your Hand

The secret is out: Drawing skill is a result of hard work, practice and acquirable eye-hand coordination. Don't believe the conspiracy theories.

How many times have you heard the lament, "I would love to draw and paint—if I had some talent for it." My response is usually, "You don't need any talent. You just need to work hard."

One might be better off not having any talent to start with. Too many people hopelessly fixate on the word *talent*. It is not an easily definable word. Talent is an elusive concept that means many things to many people. It can refer to all aspects of the artistic endeavor including broad, overarching issues of originality and imagination and the artist's ability to organize interesting color and value relationships. But to most people invoking this mysterious word, talent simply represents the ability to make the hand do what the eye sees and the brain wants or, to use a technical term, eye-hand coordination.

Many children are born with strong eye-hand coordination. As a kid, I knew young artists of my generation who could draw circles around me. I had so little eye-hand coordination that my more talented friends suggested I give up drawing and find another mode of creativity. Unfortunately, none of those individuals draw anymore. If you are born with great talent and you never had to fight to train your hand, it's easy to rest on your laurels. As a young artist, it's hard to know that if you don't use a talent, you're condemned to lose it.

As a child, I didn't personally know any adult artists; I looked to the Old Masters for inspiration. I scrutinized Michelangelo's life with exasperation, noting that he already had strong control of the medium by his teenage years. I used to lie in bed at night and fantasize about entering into a time warp for ten years, where I could spend a decade developing my eye-hand coordination, then return to my life as a child with some manual dexterity amassed. I knew the next-best solution was to practice, day in and day out, for at least an hour or two daily until I gained the control I lacked.

I practiced straight lines and circles, cubes and pyramids, drawing them repeatedly with abysmal results. I soon realized that I needed a new strategy. Taking a page from the many how-to manuals popular at the time, I started to copy body parts from Old Master drawings, anatomy books and expert comic-book artists of the 1950s and 1960s, trying to collect a vocabulary of visual shapes, just as a writer tries to build up a base of useful words and phrases.

Seated Woman, Twisting
Dan Gheno, 1998, colored pencil, 24" × 15" (61cm × 38cm), collection of the artist

23

Develop Your Visual Memory

In a further effort to train my hand, I tried very hard to develop my visual memory. In fact, I desperately wanted to learn how to draw the figure completely out of my head. Looking to the heroic figure work of the Old Masters, I began to study anatomy with a passion. I still have my first anatomy book, *Atlas of Anatomy for Artists* by Fritz Schider, which my mother bought for me when I was ten.

As a teenager, I also developed a system of visual mnemonics for myself, which I later learned was similar to an approach taught by one of Rodin's teachers, Lecoq de Boisbaudran. After each day of working from life or Old Master drawings, I would try to draw the forms as I remembered them, without referring to the originals. Then I would compare my memory drawings with the originals, make corrections and draw the subjects over and over from memory until the forms sat firmly in my mind.

The artist-in-training will also find that with time and experience, one's visual memory will replace the need to make systematic measurements from the model at every turn. Like a musician, the artist will find that the hand inevitably develops "muscle memory" and, with practice, automatically begins to draw a particular head or torso in correct proportion to the size of the paper or position in a given composition.

The more you know about the figure—the more you research anatomy and study the three-dimensional volumes of the human form by observing sculpture and people—the more your coordinated eye-and-hand memory will influence how you begin the drawing process. Although some artists seek to suppress this subliminal force, it is something that I yearn for. But it's important to keep your memory from taking over and dictating to your eye. If you're careful and true to interpreting what you see, your use of memory can give you a running start. It may invigorate your drawing, freeing up your conscious eye to chart the rhythms of the figure more rapidly, allowing your hand to respond to the ins and outs of the form with a reflective vocabulary of thick and thin, harsh and soft lines.

Torso of Belvedere
Peter Paul Rubens, ca. 1601, black chalk, 10¼" × 15½" (26cm × 39cm), collection of the House of Rubens, Antwerp, Belgium

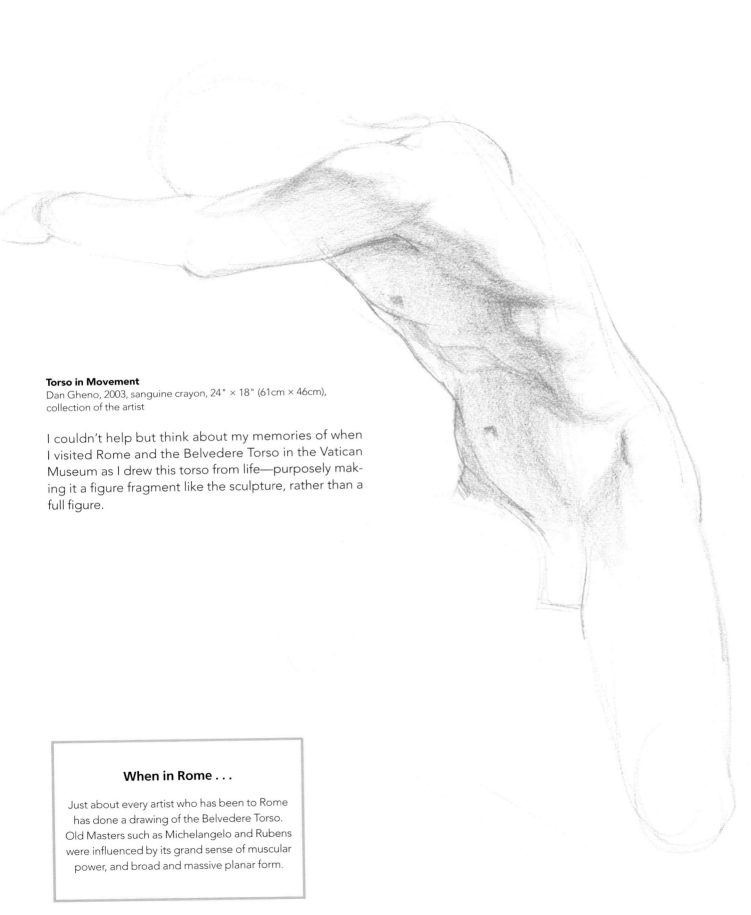

Torso in Movement
Dan Gheno, 2003, sanguine crayon, 24" × 18" (61cm × 46cm),
collection of the artist

I couldn't help but think about my memories of when I visited Rome and the Belvedere Torso in the Vatican Museum as I drew this torso from life—purposely making it a figure fragment like the sculpture, rather than a full figure.

When in Rome . . .

Just about every artist who has been to Rome has done a drawing of the Belvedere Torso. Old Masters such as Michelangelo and Rubens were influenced by its grand sense of muscular power, and broad and massive planar form.

How to Use Photography

Stabilize the hand before making a mark. Quite often, I pull back on my hand with the other hand so I'm drawing with a lighter touch. This can also solve the problem of bad lines due to hand tremors.

Photograph by Jim Falconer, Lyme Academy College of Fine Arts, Old Lyme, Connecticut

Photography also played an important part in my education as an artist and can play a role in yours as well. Although I had no interest in sports as a child, I was an avid collector of *Sports Illustrated*, spending hours every week drawing from the magazine's photos, studying muscles and limbs in a variety of positions and figures in a multitude of dynamic poses. I also took my own pictures in an attempt to discover how the fold patterns of cloth fall on the human figure. I photographed my family in every conceivable position, in every type and weight of cloth, trying to codify and commit the variations to memory.

There's even a time when you might want to momentarily break the no-tracing taboo. Most of us are hobbled by certain drawing mannerisms that we just can't seem to shake. Some of us make eyes too big, heads too small or put too many bulbous curves in the body. Whatever your problem, try copying a photo that depicts one of your problem areas; work hard at replicating the image without any distortion. Then put tracing paper over the photo and trace as dryly as you can. Compare the two drawings, taking note of your unintended distortions. Repeat this exercise with different photos, concentrating on the same mannerisms, and you will become more sensitive to your own idiosyncrasies. Over time, you will find less and less distortion creeping into your work.

The Red Bee
Lou Fine, 1940, ink, Copyright D.C. Comics, Courtesy of DC Comics. Original art for the cover of Hit Comics #5, November 1940, Quality Comics, New York, New York, Red Bee character © DC Comics.

Many of the classic comic book artists, such as Lou Fine, had traditional, figurative training and embodied the concepts promoted by Lecoq de Bois-baudran. Most of these artists worked from their memory, using their knowledge of anatomy to produce figurative works of great dynamic elegance.

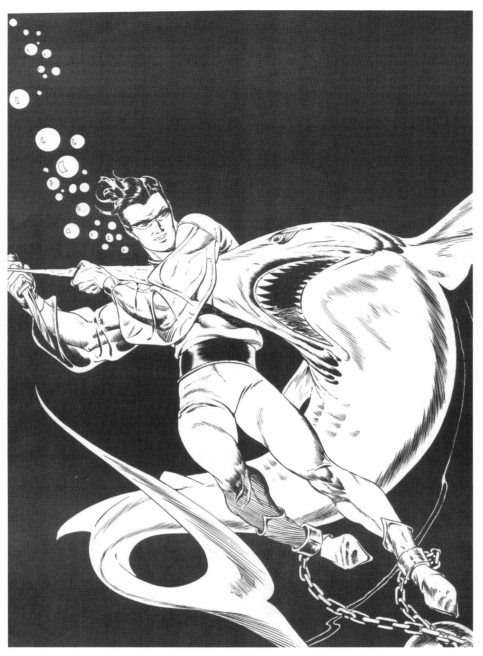

The camera lucida was a well-known toy to most North American kids who bought comic books during the 1950s through the early 1970s. National Periodicals, the same company that published Superman and Batman comic books, also produced and marketed inexpensive optical devices.

This ad appeared in the September 1963 issue of *Green Lantern*, issue no. 23, "Threat of the Tattooed Man."

3 Action and Gesture

■ Look for the model's gesture and let it be the guide for a more vigorous drawing.

A good, expressive gesture drawing is at the core of every effective figurative image, whether it's a loose three-minute drawing, a tight three-hour drawing, a highly resolved three-week drawing or an obsessively observed and reworked three-year painting.

Many people, especially nonartists, think a gesture drawing is nothing more than a scribbled quick sketch. Some drawings can be nothing more than this. But in the hands of observant artists, the initial gesture drawing means much more. It establishes the overall proportion of the figure, quickly fixing the mood, the sweeping action of the pose, and the underlying rhythms that give animation and life to a figure drawing. To artists, a good gesture drawing swings like a Duke Ellington song and serves as a foundation that keeps all of their later, detailed observations vital and alive.

As I mentioned in my How to Begin a Drawing demonstration in the first chapter, I feel that the line of action is the most important aspect of a figure drawing and certainly at the core of a well observed gesture. First, you want to establish the general action of the figure with a sweeping line, or line of action, that runs through the big shape of the figure, capturing the overall tilt of the pose. Then, you add further lines, looking for the individual slants of each limb. You can imagine these action lines in your head, or you can lightly draw them on the page. When drawn, the initial sketch can often look like a loose stick figure. It sounds simple enough, but it can get needlessly complicated if you don't develop strategies to systematically observe, record and retain the subtleties of gesture as you delve further into the detail of form and value. In this chapter I will examine the methods for achieving a successful gesture drawing.

Foreshortened Figure
Dan Gheno, 1995, sanguine crayon on bond paper, 24" × 18" (61cm × 46cm), collection of the artist

The Value of Speed Drawing

Move quickly when you first begin your drawing and don't worry about making mistakes. You need to get something on the paper before you can start making adjustments. Notice how the sculptor Don Gale moves his line randomly through the forms, crisscrossing all over the figure and wandering around the volumes of the torso and limbs like wire wrapping around a form.

Most people know Harvey Dinnerstein for his intensely observed, delicate imagery, but notice the brevity of his sketch, an initial study for his painting *Past and Present*. Look at the musician's limbs—you can still see an example of the long sweeping lines that Dinnerstein used to underpin the action of the pose and his initial observation of detail that would later appear in a more elaborate manner in the finished painting.

Rodin is a sculptor of great physical and psychological nuance, but notice how he blasts into a figure with a broad watercolor wash, establishing all of the essential action and movement of the figure with a very basic but vital silhouette that he reinforces with minimum line. *Centaur Embracing Two Women* (page 49) is a good example of this.

Speed forces you to observe reality with your gut, making observations that have vitality or maybe even some fleeting anxiety. You can later stop and look at the drawing in a more rational, calm manner, making revisions if you intend to push the drawing toward greater embellishment. Or you can leave it as is, to live as an example of a moment in time or as an expression of energy.

Many twentieth-century artist-educators, such as Robert Henri and Kimon Nicolaïdes, were great proponents of speedy gesture drawings, and they felt that one- or two-minute poses were an essential and ongoing part of an artist's training. I practice quick gesture drawing almost every day, using it to maintain my sense of proportion and to keep my skill level sharpened, much like a musician plays scales to keep his hand in shape.

Gesture Drawing
Don Gale, Conté, 11" × 8 ⅓" (28cm × 21cm), collection of the artist

Nine Figure Studies After Photographs of Nude Models
Thomas Eakins, ca. 1883, pen, ink and pencil on paper, 3 ⅛" × 9" (10cm × 25cm), Hirshhorn Museum and Sculpture Garden, Smithsonian Institution, Washington D.C.

It's important to draw or visualize these internal thrusts of action, and use them to orient the overall gesture of your figure and outside shapes of its forms.

Past and Present (Studies and Underpainting [below])
Harvey Dinnerstein, studio photograph of several studies and detail of underpainting, 96¼" × 172¼" (244cm × 438cm)

The full, complete painting is a very large, multi-figure composition depicting a psychologically, historically and socially evocative street scene.

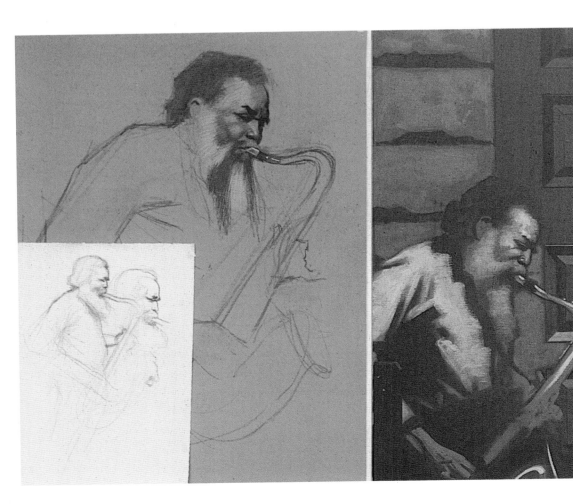

Pinpointing Contrasts and Counterpoints

Many artists look to the torso to establish a sense of action in their figures, especially the contrasting tilts of the chest and pelvis. Italian artists called this effect *contrapposto*.

We take this concept for granted these days. For thousands of years the early Egyptian cultures never did grasp the concept or rarely moved beyond thinking of the torso as one solid, straight form. Likewise, it took the Greeks many generations to move beyond the elegantly beautiful but static forms of the Archaic period, in which they perceived the torso as one solid and straight form instead of two contrasting forms. Finally they discovered their own form of *contrapposto*, and they used it with great gusto, but it disappeared with the death of the Roman Empire. It was nearly another thousand years before Western civilization rediscovered this simple and seemingly obvious principle.

Contrapposto literally means contrast or counterpoint. We see this all the time in the torso: If the chest tilts backward, as it usually does in a standing pose, the pelvis shifts forward. When a person is seated, the pelvis tends to shift backward, while the rib cage of a more posture-challenged person tends to slump forward. When you stand with most of your weight on one leg, the hip on the supporting leg angles up, while the shoulder above angles down in opposition.

The Renaissance and Baroque artists saw the beauty of this physical principle and put it to great artistic use. They frequently placed limbs in contrapposto to each other as Raphael did in his drawing *Back View of Michelangelo's David*. Here he draws one arm up and out, while putting the other arm back and down. Likewise, he draws one leg back and straight, while placing the other leg forward and bent.

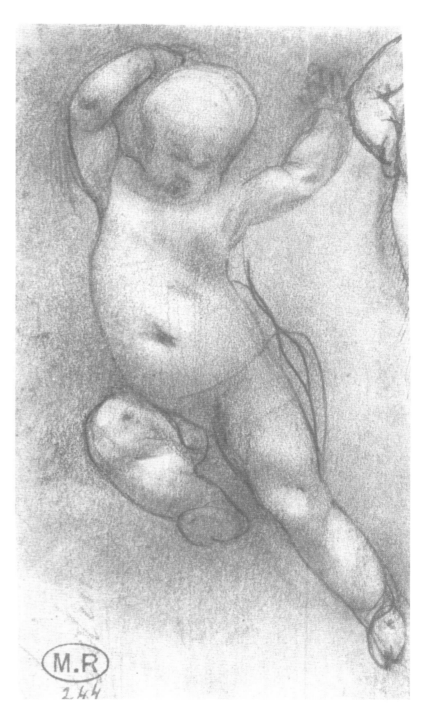

Nude Infant With Raised Arms
Auguste Rodin, graphite, 5½ × 3⅛" (14cm × 8cm), collection of the Musée Rodin, Paris, France

Back View of Michelangelo's David (opposite)
Raphael, 1507–1508, pen and brown ink, 28⅓" × 15½" (72cm × 39cm), collection of The British Museum, London, England

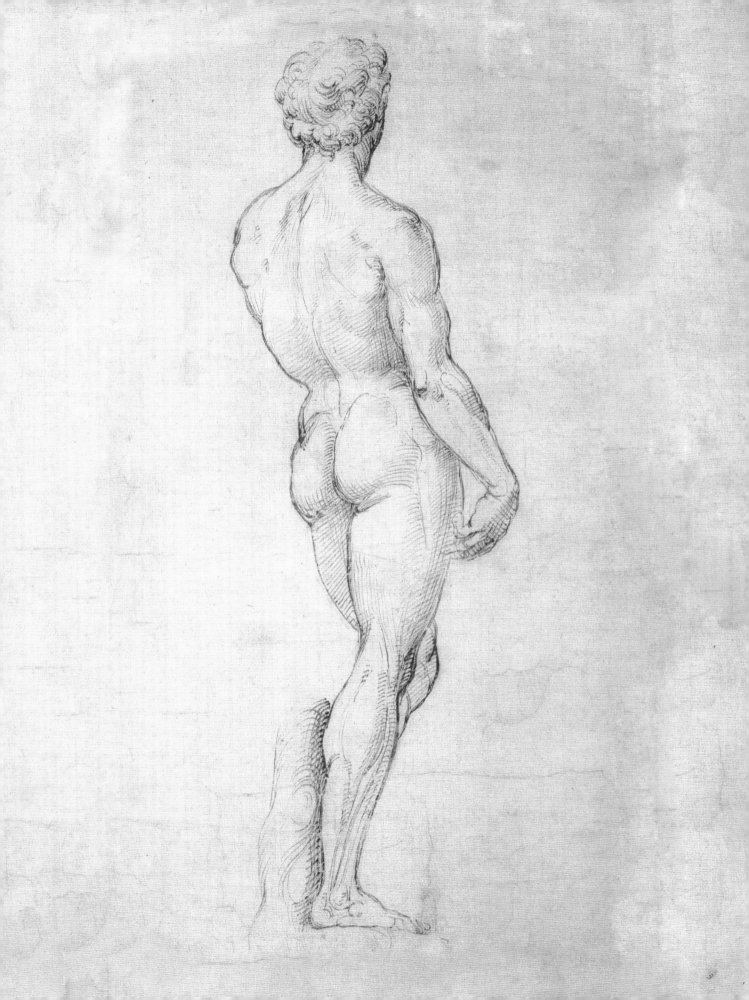

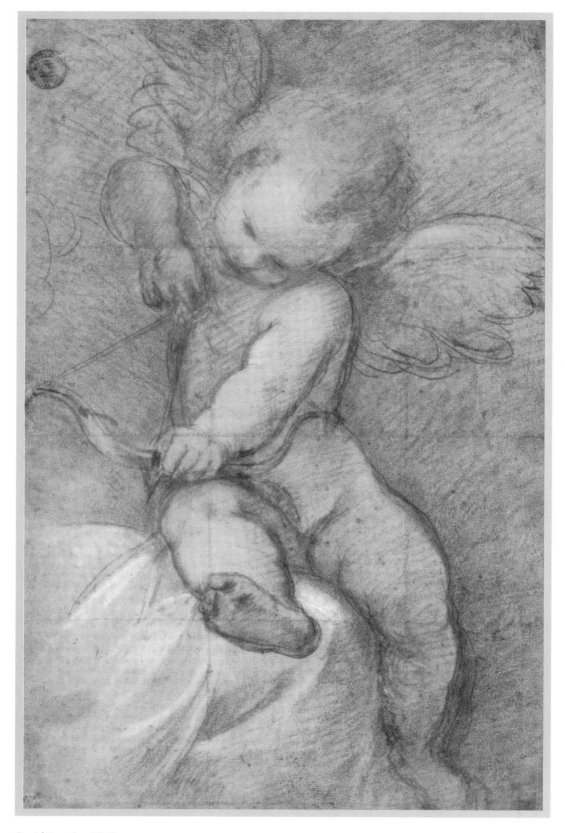

Cupid Drawing His Bow
Federico Barocci, ca. 1560, black chalk with pastel, 16 1/16" × 10 1/16" (409cm × 257cm),
collection of the Cleveland Museum of Art, Cleveland, Ohio

Incorporating the Line of Gravity

The line of gravity is nothing more than a straight line showing the perpendicular power of the Earth that pulls us to its surface, but this deceptively unpretentious line plays an enormous role in planning your gesture drawing. You've probably seen drawings with an ill-considered or crooked line of gravity at their gesture base. They feature standing figures that seem to hang listlessly off hooks.

Look closely—every pose, no matter how simple or bland, has a distinctive but subtle gesture and line of gravity. On a neutral, well-balanced standing figure, the line of gravity falls from the pit of the neck to a point directly between the two supporting feet. If the model moves most of his weight to one leg, the individual body parts of the figure shift back and forth like a spring until the pit of the neck and the line of gravity fall unswervingly over the supporting foot.

Even a slightly off-center line of gravity can destabilize the look of a calm, relaxed standing pose. However, try to grab onto some of that dynamic instability when you draw action poses. The more the figure leans over to one side, the more the line of gravity will deviate from the figure's point or points of support. The human body can hold these action poses for only a few minutes, so draw while you can before the model falls over. To hold an action pose for any length of time, the model has to grab onto something such as a stool or stick. This prop then becomes one of the model's points of support, with the line of gravity falling between the prop and the point where the model's feet or another body part touches the ground.

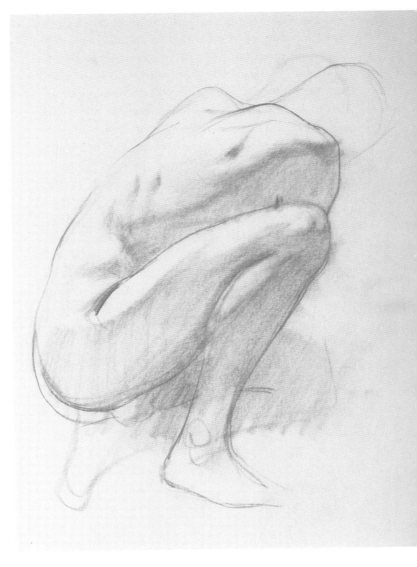

Bending Gesture
Dan Gheno, 1996, sanguine crayon on bond paper, 24" × 18" (61cm × 46cm), collection of the artist

Finding Rhythm in Your Figures

Composers struggle mightily to create rhythm in their music, looking for just the right combination of repetition and variation. Rhythm is equally important to a gesture drawing, but figurative artists don't need to look much beyond their subject to find direction.

The clothed and nude human body is filled with ready-made rhythms, its complex, intertwined forms offering inspiration for the artist's creative manipulation and interpretation. With study, you will notice the emergence of dominating, repeating patterns. You will observe several major body parts or plane edges moving into and out of the overall figure at similar angles, alternating with other secondary, contrasting forms.

Although the specific rhythms change with each new pose, you will frequently notice that many of these rhythms have an S-shaped, flame-like quality to them. I sometimes begin my gesture drawings with a sweeping S-like line of action (A). Then I often run other undulating lines (B and C) from one side of the shoulder down to the opposite side of the hip. More often than not, I simply imagine these lines in my head, looking for clues that can help me unlock the music of the human form.

Even smaller subforms crisscross musically throughout the legs: Notice that the upper leg is fuller toward the top on the outside and fuller toward the bottom on the inside (D).

You'll also find a similar pattern in the lower leg. You will see a fullness of form toward the top on the outside of the calf muscles, and a fuller form toward the bottom on the inside calf (E). Move your eyes lower, and you will find a perfect counterpoint in the ankles, with the inner ankle higher than the outer ankle (F).

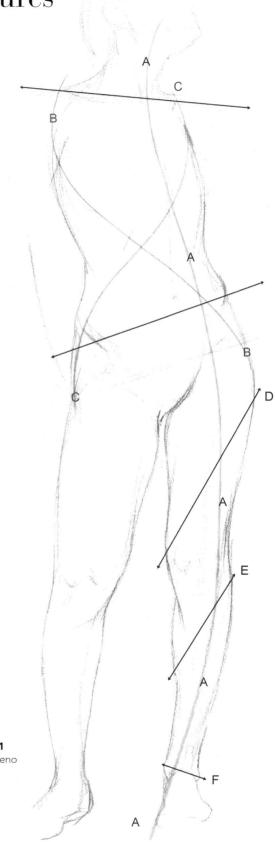

Figure 1
Dan Gheno

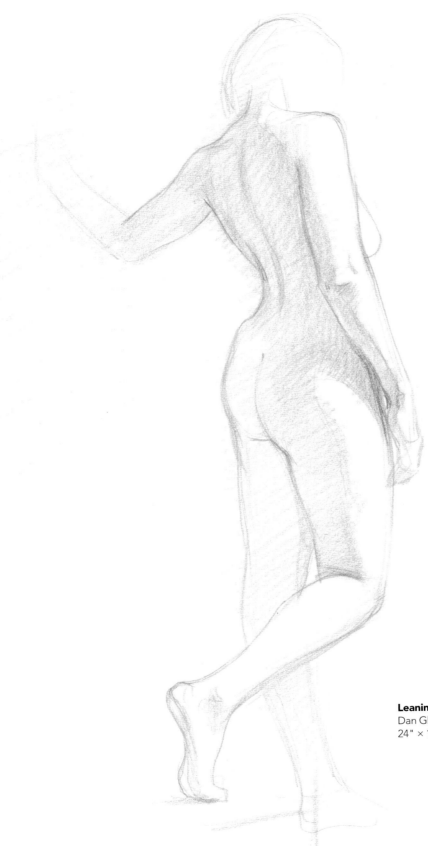

I tried to focus on many goals while drawing this quick, twenty-minute sketch. I tried to give a sense of physical and psychological weight to the figure as she leaned off her line of gravity and into the wall for support.

I aimed to create a feeling of atmosphere with the use of a hazy tone surrounding the figure, which implied the supporting wall and obscured the receding arm. I also sought to describe some of the alternating rhythms that seemed to crisscross through her torso and limbs.

Leaning Figure
Dan Gheno, 2003, oil sanguine on bond paper, 24" × 18" (61cm × 46cm), collection of Bob Bahr

Mastering Line Quality

The quality of your line is very important and can make or break a gesture drawing. Emphasize the complex rhythms of the figure by alternating thick and thin strokes, saving your strongest lines for the dominant rhythms. You can also reinforce the interlocking, sculptural quality of the shapes by emphasizing the lines on forms that cross over and in front of other forms. Arbitrarily varying the thick and thin quality of the line, as Taito II does in his study of *Men Hauling on a Rope*, imposes a cadenced, abstract line pattern upon your figures. Alternately, you can draw your figure with a deadweight, unmodulated line as Gustav Klimt and Ingres sometimes did—letting the shapes and attitude of the figures speak for themselves.

Your line work can range from the angular, as in some of Egon Schiele's work, to the curvaceous, as in all of Rubens's work. But notice how straight and curved lines alternate throughout their work as forms do in reality on the live, human figure. Whatever you do, avoid stylized or predictable curves.

Although you may feel a great deal of pride in your ability to draw even, geometric curves, those kinds of curves are too suggestive of the circle—they will have a self-contained quality, as if your figure were built from separate, disjointed bubbles. You want curves to evolve one into the other, not start and stop like a sputtering car.

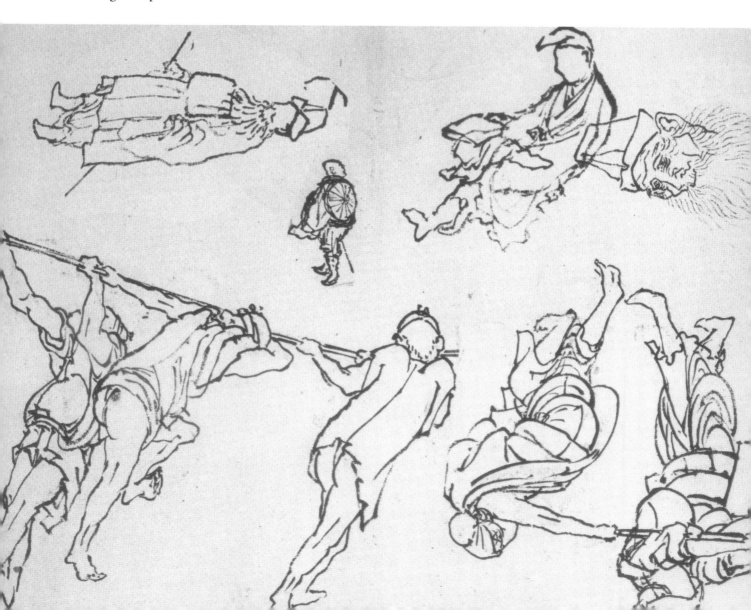

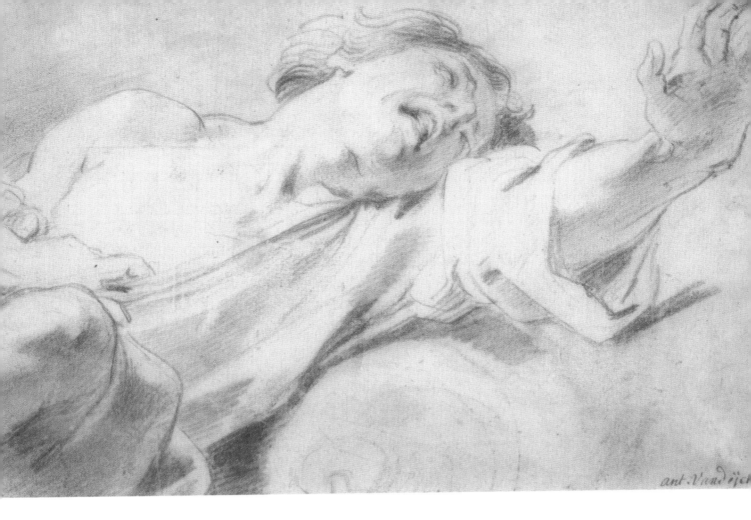

The Power of Foreshortening

If you have ever seen a late Renaissance or Baroque painting in person, you know the power of foreshortening. Their dynamic figures lunge across the flat surface of the paintings, but their foreshortened body forms also seem to pulsate into and out of space, piercing the picture plane. These artists worked out their plans on paper in their preparatory drawings, using the powerful shorthand of line to indicate space.

When drawing gesturally, use the masters for inspiration. Look for cornering effects; for instance, in the arm, an elbow joint might jump out into space. Perhaps you could emphasize it with a heavy overcutting line. Look for bones; sometimes you can use the shaft of the ulna in the lower arm or the thrust of the tibia in the lower leg to point the limbs back into space. Look for the separation of muscle functions, for instance charting lines through the valley where the flexor and the extensor muscle groups meet on the lower arm.

Study for Malchus (above)
Anthony Van Dyck, black chalk, 9⅗" × 14⅗" (24cm × 37cm), collection of Rhode Island School of Design, Providence, Rhode Island

Men Hauling on a Rope and Other Studies (opposite)
Taito II, 9½" × 13" (24cm × 33cm), collection of Victoria and Albert Museum, London, England

A master in his own right, Taito II's work is often misattributed to his teacher, Hokusai. It's no wonder—Taito II manipulates his linework in a similar manner. In this drawing, notice the fluid use of alternating thick and thin lines.

GESTURE DRAWING

MATERIALS LIST

Compressed charcoal dust

Cretacolor sanguine stick in holder #262 02 (oil-based)

Fine ballpoint pen

General's Charcoal Pencil 2H

Vine charcoal

Wolff's Carbon pencil B

Gesture Drawings usually take about one to three minutes or slightly more to create. Drawing quickly can often serve an artistic purpose resulting in expressive finished works of art, or it can simply be used as warm-up preparation for a long day of painting or drawing. The way it's used most often in schools and figure drawing groups is as a high volume, practice exercise to acquire a better understanding of the figure's basic rhythms and proportions.

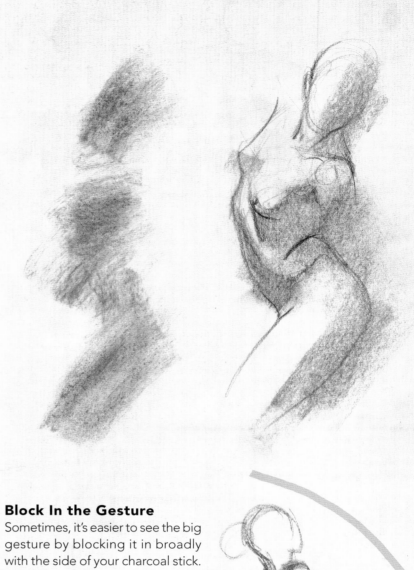

Rhythm vs. Proportions

Don't assume you must always capture the gesture of the pose as well as finding the figure's precise proportions in the same drawing exercise. It's helpful to spend time practicing one or the other—trying to simultaneously do both all the time can be frustrating and counterproductive to expanding your knowledge base of each discipline. Sometimes you have to exaggerate a pose to truly understand its gesture, whereas you often need to constrain yourself when exercising your sense of proportion in the short time allotted to a gesture drawing.

Block In the Gesture

Sometimes, it's easier to see the big gesture by blocking it in broadly with the side of your charcoal stick. Then work back into it with a few descriptive lines in the time you have left.

Find the Line of Action

When looking for gestural movement in a drawing, concentrate on the underlying line of action. Focus just on those forms which best express this essential, rhythmic flow and, given the time limit, try to draw only those lines that conform to this sweep.

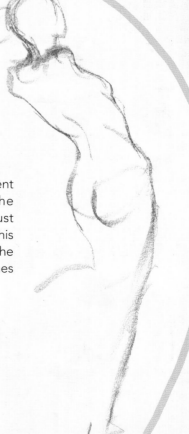

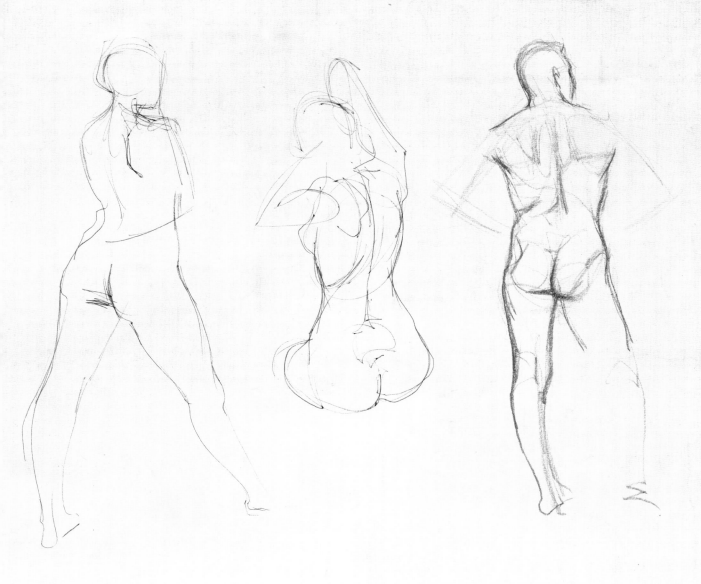

Use Few Lines

Take a sparse approach, working in a drier outline along the outside of the figure while using just a few lines to indicate interior detail.

Let Your Line Wander

Most of the time, I let my line wander through the form, trying to find rhythmic connections through the anatomical details, doing as much as I can in one or two minutes.

Work With a Stick Figure

Sometimes it's useful to begin your sketch with a loose, stick figure type approach—not stiff, rigid sticks, but a pliable, slightly curved armature, as evidenced in the unfinished arms and the right leg of this sketch. Then you can measure along these simple body lengths to correctly determine the proportions.

Using Positive Shapes vs. Negative Shapes

So far we've been looking at gesture drawing from the "positive shape" standpoint. That is, we've been dealing with the human body as a solid form that exists volumetrically and pushes positively outward into space. But what about the surrounding or "negative space" that pushes back onto and surrounds the figure?

Negative space is a very useful and constructive force. Notice how David Dewey uses background tones to establish the limits of his figure in *Figure Sitting With Blue Chair*. The chair masses seem to bump up against his figure, riding along the outside of his figure's form.

You can also use negative space to catch flaws in your proportions or in the action of the figure. Imagine that you are drawing a model who is standing with one hand on a hip. Look at the length and width of the space between the arm and the torso. Do you have a similar space in your drawing? If your negative shape is bigger, smaller, wider or thinner, this is a sure warning sign that you need to reassess the proportions of your figure.

As with all potent visual tools, don't use this approach casually or recklessly. Human beings aren't plaster casts, and while working from the live model, you will inevitably notice that the negative shapes shift one minute to the next. Sometimes this shift is subtle, but at other times, especially after the model takes a break and reassumes the pose, the negative shapes might morph radically.

I can't emphasize this warning too strongly! Quite often, the pose will look unchanged, but as you begin to zero in on the details and look to the negative shapes for guidance, you may notice that there is now less space between the arm and the chest. You might be tempted to move the inner line of the arm toward the torso, but if you don't move the outer side of the arm along with it, you will end up with a humongous arm that would impress the Incredible Hulk.

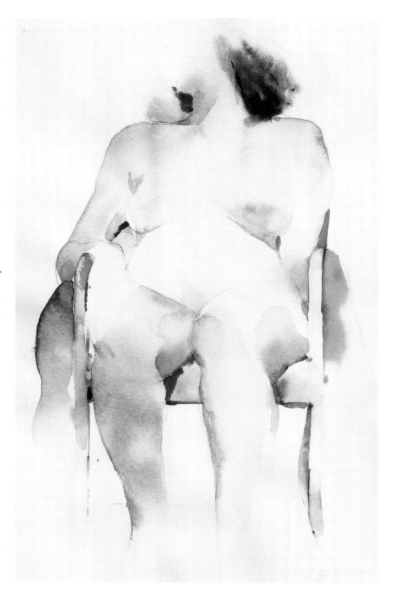

Figure Sitting With Blue Chair
David Dewey, 2005, watercolor, 15½" × 10¾" (39cm × 27cm), collection of the artist

Dewey found a dynamic balance between figure and ground shapes in this watercolor. Notice how the negative shapes seem to push up against the human form in places. Even within the female's positive shape, most of the visual activity—-color and value—-seems to collect at the juncture of the figure and ground.

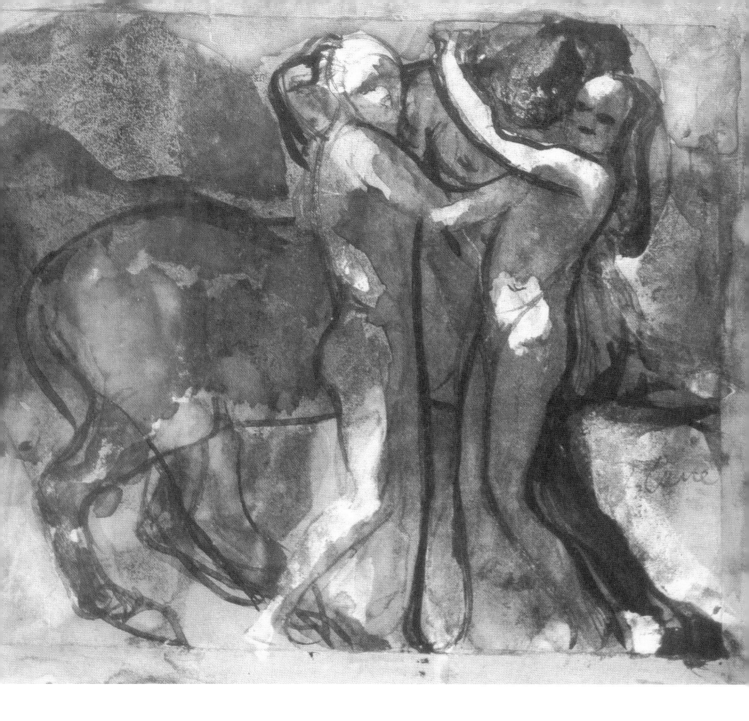

Even if you take an expressive approach to drawing, you need to monitor the widths and lengths of the positive figure forms as much as, if not more than, the negative shapes. After all, the atmosphere between the arm and the torso can measure any size, and although the artist may be the last person to realize it, the viewer quickly knows when an arm is out of sync with the rest of the figure.

You also don't want to needlessly "chase the pose," redrawing a well-proportioned arm just because the negative space has changed slightly. Even if you haven't finished the detail on the arm, you don't necessarily need to alter its position because it's now in a slightly different position or the negative shape has changed. Instead, take the value structures on the model's new arm position and tilt them to fit the angle of your originally drawn arm.

Centaur Embracing Two Women
Auguste Rodin, pen, wash, gouache, collection of Musée Rodin, Paris, France

Find the Expression of Your Composition

Art history shows us that the human body, particularly the nude human form, has enormous metaphorical and symbolic power. Don't squander its potential, and don't let your drawings—gestural or otherwise—become scholastic exercises. Ask yourself, "Why am I drawing this body in front of me?" Even if you are drawing someone for five minutes, the model's pose should suggest something to you.

Perhaps it's the conflicting emotions of happiness or melancholy that we sometimes find existing together in many of Egon Schiele's drawings, or perhaps the model suggests a sleepy, listless mood as in Rembrandt's *A Woman Sleeping* or a somber, heavy mood as in Rodin's *Centaur Embracing Two Women*. I often look upon the quicker gesture drawings as an opportunity to examine and draw the sheer beauty and emblematic power of muscles rarely seen in a more static pose.

It's important to place the germ of a concept in the back of your mind as you work. It may not magically solve all of your drawing issues, but you will find yourself more excited and motivated when you deal with some added issues that go beyond the visual.

Even though you are working quickly, you should still think about composition or give some thought to placing the figure in an environment, as Lois Dodd evocatively does in *Nude Hanging Clothes*.

Watch your energy level rise when you place your figures in the midst of doing something active such as hanging clothes. The activity is often inherent in the pose when the sketch is done as a study for a painting such as Tiepolo's drawing or the Taito II drawing. Some artists create an implied activity when they link multiple images of the same model across the page. Sometimes they use this simple grouping to create a pleasing pattern of shapes, but more often, they use it to suggest a sequential action in the figure as if the model is turning, twisting or moving back and forth through an implied space.

Whatever the model's activity, you can add vitality to your drawings if you always try to think of some underlying personal motivation as you work. However, stop when you've achieved your essential goals—don't overwork the drawing.

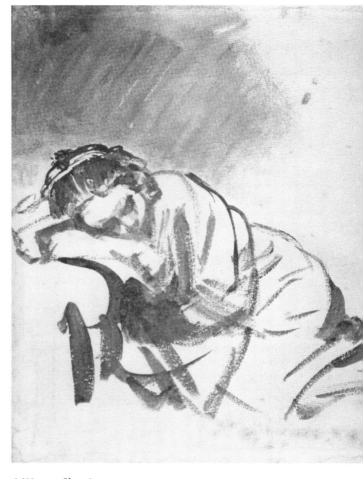

A Woman Sleeping
Rembrandt, ca. 1655, brush drawing, collection of The British Museum, London, England

Ask yourself why you're drawing the body in front of you. Even if you are drawing someone for five minutes, the model's pose should suggest something to you.

Refresh a Long-Term Drawing

There is nothing more exhilarating than getting a good start on a drawing. And often there is nothing more terrifying than watching your drawing evaporate in front of your eyes as it turns into a stiff, brittle echo of your dynamic beginning gesture.

It's very difficult to hold on to that initial gesture while working on a long-term drawing. I often turn my drawing upside down, sideways or hold it up to a mirror to check the gesture and proportions of the pose. I also do a lot of squinting to better gauge the equally important light-and-dark value contrasts that give vitality to the drawing. I'll do anything to maintain my objectivity. On some occasions, I momentarily put aside the sustained drawing, grab another piece of paper and quickly sketch the pose from an alternate viewpoint—trying to re-examine and reconfirm the gesture in my mind.

I often encourage my students to wait at least twenty minutes before beginning a long-term drawing or painting. Models usually settle into the pose during this time, sometimes slumping enough to radically change the underlying gesture. You can do many things in the meantime such as work on compositional sketches or lay in a very flexible, rough placement of the figure or figures.

Robert Henri put great emphasis on these early stages. He believed you couldn't get a good finish without a good start. Speaking to beginners, he told them it was more important to do a lot of starts, eventually learning how to set up a usable foundation for the completed artwork rather than spending a great deal of time practicing the finishes on failed images. For the more advanced artists, Henri reminded them that gesture was paramount, and he admonished them to maintain the same level of liveliness and vigor of stroke from beginning to end.

You must remain sensitive to the underlying gesture throughout the drawing process, forcing yourself to scan the model from top to bottom even as you home in on the fine details. The big, basic gesture always reigns supreme, but there are subtle gestures even in the details: the cant of an eye or the raising of an eyebrow, the pointing of a finger and the slope of a hat. According to Robert Henri, "If you want to know about people, watch their gestures. The tongue is a greater liar than the body."

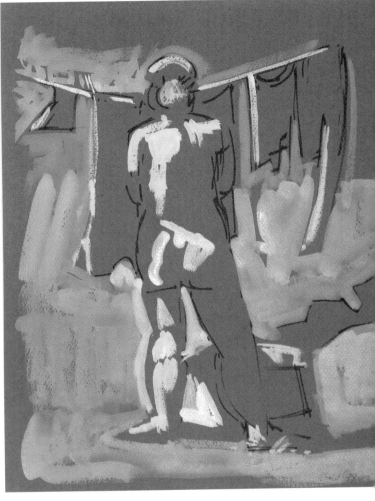

Nude Hanging Clothes (above)
Lois Dodd, gouache on paper, 9" × 12" (23cm × 30cm), collection the artist

Even though you are working quickly, you should still think about composition or give some thought to placing the figure in an environment as Dodd forcefully did in her image.

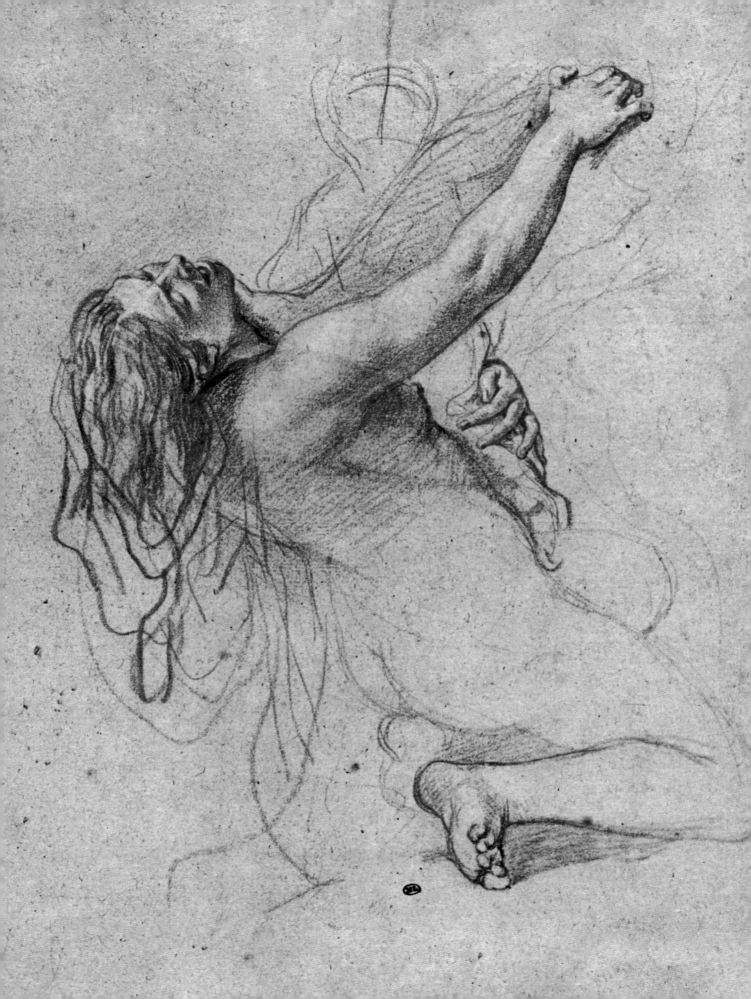

4 Making Better Lines

Lines—as outline, as hatching, laid down boldly or applied delicately—are the foundation of drawing. But when allied with mass and tone, lines become even more expressive.

Line has been around for a long time—ever since the prehistoric era when that first artist picked up a lump of wood ash from a spent campfire and outlined a hand on a cave wall. Lines have described forms of all types—human, animal and landscape. On its own, line is a very powerful force. A line can depict the simple silhouette of a form as well as its more complicated interior dimensions. When used in a hatching manner, it can even simulate value. And when joined with softer, smudged tones known as value masses, you have a combined unstoppable force—except, perhaps, by a good eraser.

Some artists will argue that you can most effectively render the human figure or abstract imagery with value-massing alone, that everything you can do with line, you can do with light and dark tonalities. That is true. Some of the most evocative drawings are indeed based on value alone. But at its core, all finely observed tonal shapes are bound by an implied "edge," or conceptual line, even if it exists only subconsciously in the viewer's mind. I'm excited by the explicit combination of line and mass in my own work. As I will explain in this chapter, why not use both? First I'll describe how to use line on its own, then I'll show you how to merge it into a dynamic partnership.

Kneeling Female Nude, Holding a Child
Charles Le Brun, red chalk highlighted with white, 10½" × 11½" (27cm × 29cm), Royal Collection, London, England

The Rythmic Importance of a Line

Line first starts quietly on the page as a dot. Then, to loosely borrow from the title of Wassily Kandinsky's book *Point and Line to Plane*, this potent mark or point transforms into a line and finally into a volumetric plane. By varying the thickness, darkness and texture of the line, you can simulate a movement in and out of human forms, especially if you let lines cross over one another, digging past the outside edges of the figure into its interior peaks and valleys.

Depending upon your subject or your aesthetic intent, you can use lines that are sharp like wire, lines that are rough like Brillo or lines that are so soft that they melt into the surrounding paper. Lines can range from the directness of Egon Schiele's often unmodulated outlines to the pseudo-brushwork of Anders Zorn or Charles Dana Gibson, or to the curvaceous, engraving-like quality of Dürer. Depending upon how you apply your pencil to paper, lines can have an emotional, psychological aspect and they almost always display some sort of a visual, rhythmic property in the way they dance around the page.

However, don't make the common mistake of thinking that line is nothing more than a conceptual concern. Throughout the drawing process, your line quality is dramatically influenced by your choice of materials, the texture of the paper, your drawing instruments, their sharpness and the way you hold them in your hand. For instance, I prefer to start my figure drawings

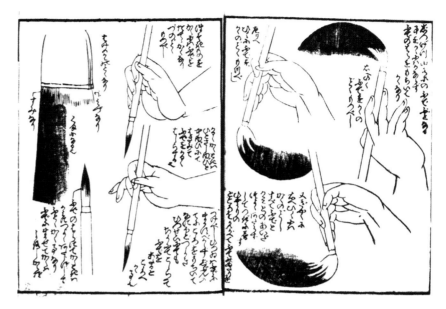

Illustrations From Ryakuga Haya-Oshie, (Method for Learning Rapid Drawing)
Katsushika Hokusai

Hokusai demonstrates how he holds his brush in the upper diagram. Below is a page from a series of drawing manuals he did for his contemporaries, describing his personal form concepts and other methods of approach.

with long, sweeping, lightly plied lines—an impossible task if I hold my pencil or chalk between my thumb and forefinger as I would when writing a letter. (Nevertheless, this hand position works splendidly when sketching in the final details, especially if buttressed by a mahlstick or a small, separate clean piece of paper under your drawing hand.)

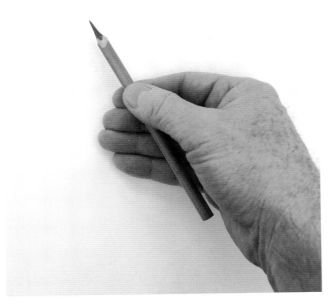

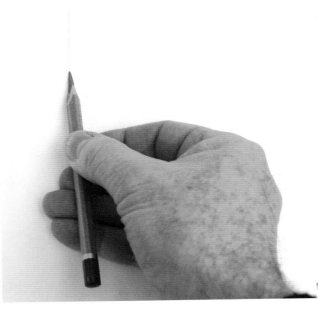

When starting out, I turn the back of my hand to the paper, loosely holding the pencil toward the end of the shaft and sandwiched between my thumb, palm and forefinger. I frequently change my hand position depending upon the intended direction of the line.

If I'm drawing downward, I hold the pencil from below, allowing gravity to firmly guide my hand's descent.

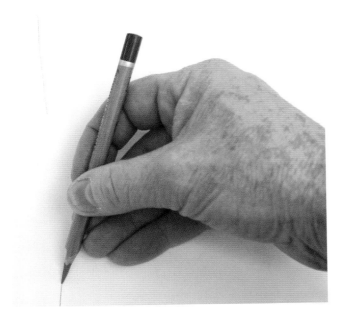

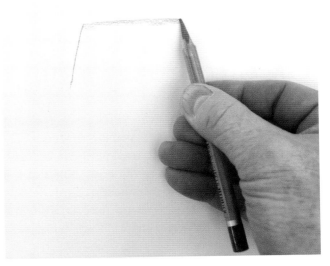

I hold the pencil from above if I'm drawing upward. Both positions allow for greater movement of the shoulder and elbow, putting less importance on the jagged actions of the wrist and fingers. You can also get a thin, clean line when you draw with the direction of the pencil lead, affected only by the roughness of the paper or the softness of the drawing instrument.

Notice how easily you can vary the thickness of line when you suddenly change directions, say, from the vertical to the horizontal. When drawing with the shaft of the lead instead of the point, that thin line suddenly turns thick. As you chart your way through the details of the figure, you will find your line automatically fluctuating with the direction of your hand and pencil.

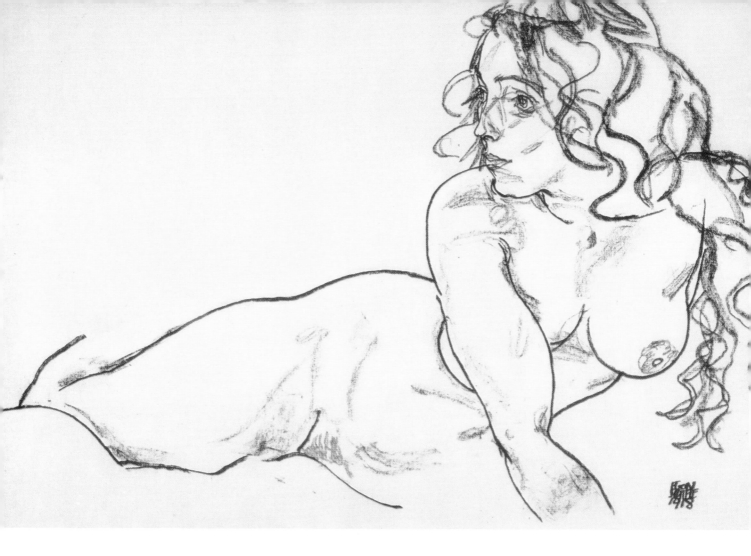

The Strength of a Pure Line

You can say a great deal even with a minimum of lines. When working from life, you can suggest a fully formed human figure with a simple line just by carefully observing and mapping the outer edges of the model. Look closely at your subject as Egon Schiele does in *Reclining Nude With Raised Torso*, charting the subtle variations of exterior shapes. Each bump suggests some bone or muscle.

You can certainly distort the proportions of the figure or exaggerate its perspective like Schiele does with his drawing of the woman lunging forward into the picture plane, but try to respond candidly and directly to the outside shapes. Your viewers will then sense the volumes within, based upon the experience and instinctual knowledge of their own bodies.

Reclining Nude With Raised Torso
Egon Schiele, 1918, black crayon, 11⅜" × 18⅛" (29cm × 46cm)

This drawing, so filled with life, was drawn by the prolific, young artist in the year of his premature death.

Creating Closure With Intermittent Lines

However, you don't necessarily need to wrap your figures with a continuous, rigid, bold outline. You can create a more profound sense of closure by marking the edges of the smaller human forms with intermittent lines in the manner Cézanne and Degas sometimes did.

Working this way, you can take a minimal approach: You can mark off the root, the base and the tip of the nose, and the viewer will intuit the rest of the line. But if you're interested in simulating form, don't reduce the number of lines too much. You should at least place a hint of a line at important high and low points along the perimeter of an object and where one important subform crosses another. The drawing will look incomplete or jarringly blank in places if you don't.

Twisted Torso
Dan Gheno, 2006, pastel and sanguine crayon, 12" × 9" (30cm × 23cm), collection of the artist

Figure Fragment
Dan Gheno, 2002, sanguine crayon, 24" × 18" (61cm × 46cm), collection of the artist

Adding Overlapping Lines

Although the outside shape is important and, as Plato seems to suggest in his theory of ideal forms, is essential to the very identity and recognition of the object, we eventually need to travel inside the figure with our lines. It's difficult or impossible for the beginner artist to do this when working from photos, but while working from life, you will see how forms continuously overlap one another as when the neck slides over and above the shoulder, or the deltoid runs in front of the collarbone and wedges into the upper arm.

In my drawing *Arm Swinging Back* note how I varied the thickness and value of the line to simulate the swelling of the underlying forms, particularly in the legs. Also, observe how I've portrayed the transition of the left calf into the upper leg with the "overcutting" forms, as sculptors phrase it, represented by overlapping lines. However, don't become dogmatic. Notice how I use these techniques in a discriminating fashion. I emphasized the darkness in the line along the near shoulder so the more faintly rendered far shoulder could recede. Even though the near elbow is closer to the viewer than the shoulder, I selectively chose to emphasize the overlapping, bony points of the elbow instead of the entire projecting shape of the arm to keep it from looking stiffly enclosed. I felt that the lines of the elbow were just dark and sharp enough to bring it ahead of the receding hand.

Arm Swinging Back
Dan Gheno, 2003, colored pencil, 24" × 18" (61cm × 46cm), collection of the artist

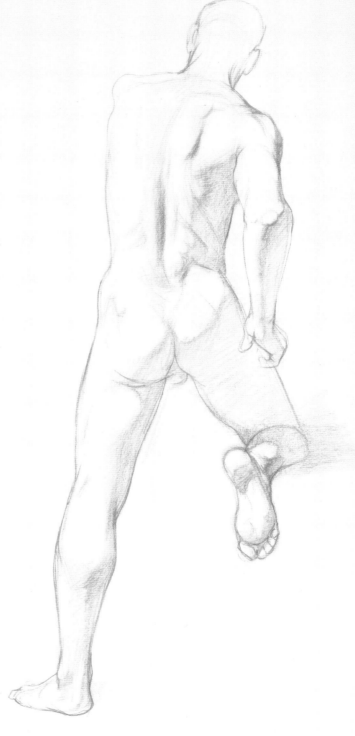

Manipulating Depth With Hatching

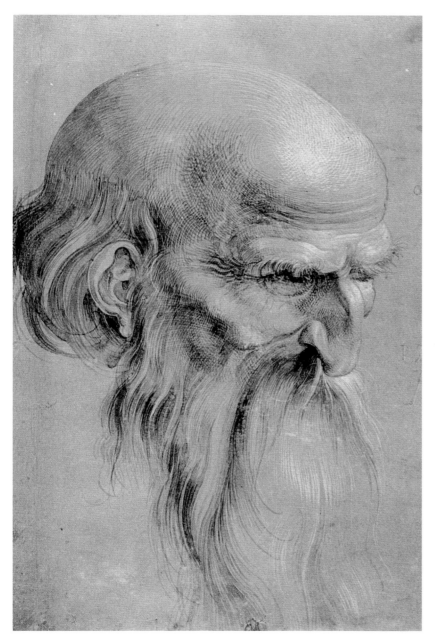

Study for the Heller Altar: Head of an Apostle
Albrecht Dürer, 1508, brush drawing with white highlights on a dark ground, 12⅜" × 9" (31cm × 23cm), collection of Albertina Museum, Vienna, Austria

So many lines and yet there is not a single example of the dreaded tic-tac-toe malady in the entire drawing!

Many artists like to take a topographical, hatching approach to their linework, such as in Albrecht Dürer's drawings. You can learn a lot from looking at the work of this Northern Renaissance artist.

In *Head of an Apostle* see how Dürer weaves his line around the forms, using longer, gradually curving strokes on the softer, more rounded form of the overall head. Meanwhile, he uses shorter hatching strokes, alternating in direction, to describe the smaller, more angular forms of the wrinkles and bony landmarks. Observe how he overlaps lines in a graduated manner in the detail; he never layers the hatching in a tic-tac-toe, right-angled way. Usually, one stroke gradually leads into the other, and as in the highlight rendered in white lines, the hatching can take on an almost spiral-like appearance.

In another example notice how the depth of Michelangelo's lines vary greatly and seem to become darker and more intense where they coalesce around the accented bony and hard muscle points on the figure in *Study of a Male Nude*. When rendered with pen and ink, his accents not only seem to turn darker but also appear to have an almost polished, burnished look.

Try spending some time studying or copying old engravings, as the students of the French Academy were required to do in the eighteenth and nineteenth centuries. It's also helpful to study comic-book artists such as Neal Adams or Mort Drucker for their smoothly interlacing crosshatching methods.

This will attune your eye to the nuance of line and help you develop a subtlety and syntax for your hatching technique. But don't overdo it, and don't become a slave to fancy pyrotechnical linework.

When working from life, spend as much time looking at the model as you do rendering the lines. Otherwise, your drawing will look simplistic and stylized, wrapped up in a convoluted mass of barbed wire or what an artist and influential art-techniques writer of the nineteenth century, Jacques-Nicolas Paillot de Montabert, called "wretched studies" and "the somewhat absurd patience of those individuals who . . . imitate exactly the engraving tool" instead of nature. According to the art historian Albert Boime, the teachers of the French Academy frequently whined about the tendency of their advanced students to draw in this mannered way, unaware that their early overemphasis on mindlessly copying engravings "fostered the cold and lifeless appearance which the Academy itself criticized."

Study of a Male Nude (right)
Michelangelo, ca. 1504, pen and ink, collection of Casa Buonarroti, Florence, Italy

Can you see yourself writing a grocery list on the back of this drawing and folding it up to fit in your hip pocket? Only Michelangelo could get away with such sacrilege, and he did just that. Luckily he didn't throw it away as he did with so many of his other drawings.

A First Night (opposite)
Charles Dana Gibson, ink

Gibson was a popular illustrator at the turn of the nineteenth century. He is notoriously responsible for the Gibson Girl image, but he also produced some wonderful social commentary. He was so sought after for his dynamically composed and energetically detailed visual critiques that he worked for both *Life* and *Collier's*, competing magazines.

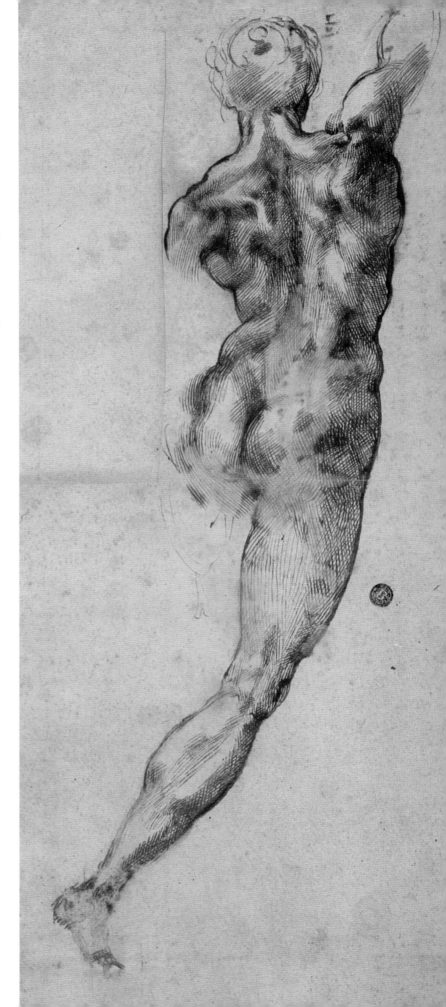

The Fusion of Line and Mass

For a counterpoint to this hard-line approach, take a long look at Charles Dana Gibson's drawings rendered in softer, broader and looser entwined strokes. Along with several artists and illustrators in this cross-century period, Gibson tried to emulate the flowing, painterly effect of value-massing with line alone. Although many of his freely curving and parallel lines seem to follow the volumes of his subjects, his goal seems less the tactile sensation of form that Dürer pursued and more an attempt to show the optical effects of light on structure.

Observe how Gibson evocatively creates shades of light and dark by varying the closeness and number of hatching lines to indicate value change. He applies a delicate weave of subtle lines to the paper when he represents the softer forms that appear to gradually darken as they turn away from the light source. He uses a greater quantity of harsher lines when he indicates the harder forms that sharply corner away from the light and turn dramatically into darker shadow masses.

It's not easy to draw in ink, but it is a great way to accelerate the learning process. You can't make any mis-

takes with pen and ink, so you quickly learn to observe and choose your lines wisely. There are many tools to choose for this torture, and you should try all of them until you find the one that suits you.

The Gibson generation used flexible dip pens and thin, pointed sable brushes to master their elegant thick and thin lines. Van Gogh made some of his own rudimentary yet effective pens out of common reeds and feathers. Today we also have a wide variety of fountain pens and even fountain brushes to take some of the torment out of the process. I used to draw with both in my early years, but now I find that a ballpoint pen serves my purposes just as well. Some contemporary brands of ballpoint pens are prone to frustratingly splotchy accidents, but if you try enough different manufacturers, you will discover a few that provide a sensitive and dependable line. You will find a ballpoint pen quite useful while on the move, when you want a fluid, sketchy look, or when you want to indicate a large value mass across the page with a cluster of rapidly hatched lines.

Lines as Expressions of Mass

If you pile enough fine, delicately rendered hatch lines onto your drawing, you can create the look of a soft, "lineless" tonal shape when viewed from a distance. I like to combine bold lines with these more delicate hatch lines. Sometimes I purposely use the parallel-lined texture of laid paper to enhance this effect, allowing my pencil to travel up and down with the direction of the grain as I did in *Seated Figure.* In some cases I smudge a little tone onto the textured paper with a stump so the contrast between the ridges and gutters of the paper isn't too jarring. In most cases, I try to find a fusion of line with tone, aiming for a gradual transition of line work into pure value mass. The more I move into these soft-blended passages, the farther back I grip the pencil on the casing. I find it easier to control the pressure of my line with my hand in this elevated position, allowing me to stroke in a broader and wider arching motion. At these moments I hold the pencil so gently that it often falls from my hand.

It takes a great deal of practice to manipulate line into tonal value mass. If you're just starting out, rehearse your line quality as much as possible. Even while watching television, you can pull out a pad and draw lines repeatedly in small square swatches, testing out different hand positions and varying the pressure. Try to practice blending your lines. Gently run lines parallel to one another, layering them closer and closer until they almost seem to disappear. Then try drawing lines in the opposite direction on this same swatch to get even more added subtlety and blending of line into mass. If you're an advanced artist, it's equally advisable to keep an extra piece of paper at hand when drawing so you can test out your hand pressure or rehearse a complicated tone before laying it onto your finished drawing.

Standing Gesture Drawing
Dan Gheno, 2005, oil-based sanguine pencil on paper, 18" × 11" (46cm × 28cm), collection of the artist

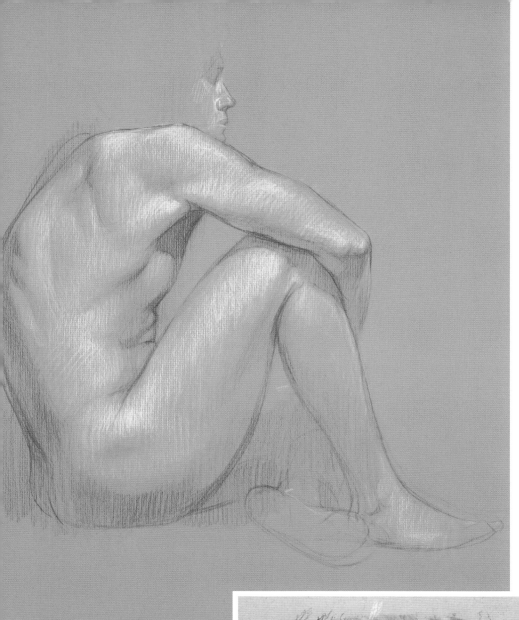

Seated Figure
Dan Gheno, 2005, colored pencil and white charcoal on toned paper, 18" × 20" (46cm × 51cm), collection of the artist

Sleeping Boy and Study for a Head
Käthe Kollwitz, 1903

There is nothing more powerful than the fusion of line and tone.

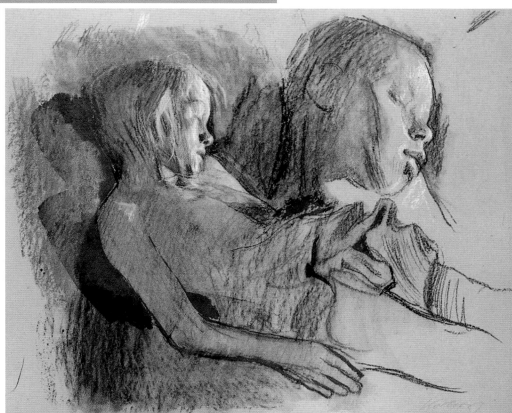

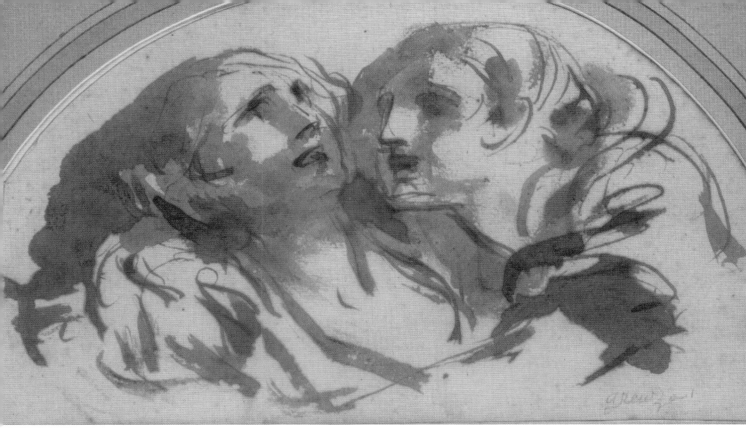

Woman Embracing a Recumbent Old Man, Study for The Father's Curse: The Punished Son
Jean-Baptiste Greuze, pen and brush with brown ink, 4¾" × 7¹⁵⁄₁₆" (12cm × 20cm), collection of the Dutch Institute, Paris, France

Sick Woman Lying in Bed (Probably Saskia)
Rembrandt, pen and wash, 5¾" × 6⅜" (15cm × 16cm), collection of the Musée du Petit Palais, Paris, France

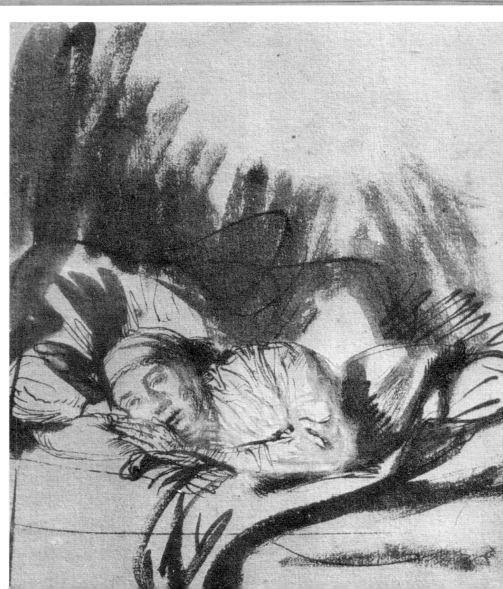

Implementing Wet Media

The ink-and-wash method is another effective tool in our quest to join line and mass, and because of its technical similarity to the watercolor medium, it even serves as a useful bridge between the artificial categories of drawing and painting. Observe how both Giovanni Battista Tiepolo with *The Holy Family* and Jean-Baptiste Greuze with *Woman Embracing a Recumbent Old Man* run loose value washes across their compositions, joining their figures into larger, painterly abstracted value masses. Notice, too, how the harder ink lines sometimes melt into the wet wash, turning rigid accents into softer, blended accents. Try this in your own work, using water-soluble ink. Often you don't even need to use an accompanying wash; you can use a brush loaded with water to drag some ink out of the line, creating an overlying value pattern.

Mass can sometimes dominate an image so thoroughly that line may seem a mere adjunct to its partner, serving to accentuate the deepest darks or the brightest lights, or merely containing the outside edges in places. Even when used sparingly, as I try to do in most of my drawings, line is still indispensable to my work. But remember that a little line goes a long way. In *Twisted Torso* (page 57), I confined most of my line work to the peripheral forms, overlapping and varying their weight to reinforce the interior, interlocking forms. I tried not to disturb the flow of the value gradations within, but in places I added a few strokes to accentuate some of the sharp bony points and areas of deep relief where action hardens the muscles. I retreated from tonal massing at the extremities of the torso, counting on the remaining solitary lines to ease the figure onto the bare paper.

The power of line and mass doesn't end with the sculptural representation and the natural effects of light on the human form. They can serve a formal, abstract design function as in the previous example or, as in the Charles Le Brun drawing, where line and mass rhythmically fade in and out of the blank page. Value mass and line almost become one abstract unit in some of Rembrandt's ink-wash drawings. It's hard to tell where shape ends and calligraphy begins in his drawing *Sick Woman Lying in Bed.*

We shouldn't completely ignore the other conceptual assets of these contrasting strokes. Notice how

Fragonard exploits both their emotive and expressive abilities in *The Pacha*. Known for his Rubenesque use of color and animated brushwork, he approached drawing with equal enthusiasm, here dragging a brush speedily across his textural paper in an impassioned, desperate script, and there filling the page with an almost modern, repeating pattern of rough marks.

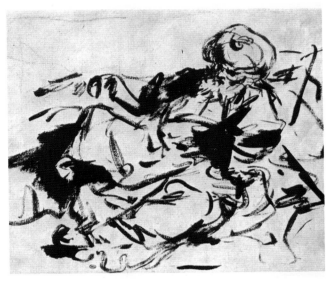

The Pacha
Jean-Honoré Fragonard, brush and brown wash, collection of the Louvre, Paris, France

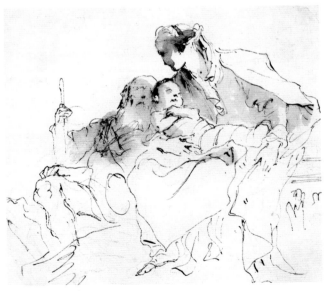

The Holy Family
Giovanni Battista Tiepolo, ca. 1762, pen and brown wash over black chalk, 7" × 7½" (18cm × 19cm)

The Use of Line in Painting

The use of line is not confined to the realm of paper and drawing. Even many mass-centered artists use line to start their paintings. I frequently begin my canvases with a vague charcoal sketch. Then I reconfirm and build upon my initial charcoal lines with paint, usually a blue or Permanent Alizarin Crimson. I dilute the paint with a lot of solvent so the color flows freely like ink. Thanks to the heavy proportion of solvent, the painted lines dry quickly, usually within five to twenty minutes. This gives me a lot of freedom, allowing me to move into the painting process right away. If I think I've lost control of the drawing, I can scrape off some of the top layers to retrieve the original drawing below. But take care when you use this approach. Oil paint becomes transparent with time, and you must avoid drawing with an extremely dark line, especially if you paint in thin layers.

I sometimes use lines to redraw a painting that's in progress, changing to a new color each time I make a revision so I can compare my changes against the previous incarnation. I sporadically do this in my drawn work, such as *Multicolored Figure*, just for the fun of it. I think it's also quite interesting to document the path of discovery with each decision or adjustment recorded by a different color. Even when I draw in my normal, monochromatic way, I never erase my mistakes until I've scribbled in a possible solution. It's easier to make a revision in either medium when you can see where you've been. That way, you don't make the same mistake twice (or three times).

Quite a few painters use line extensively throughout their work. Van Gogh is probably the most obvious

Sharon (opposite)
Mary Beth McKenzie, oil, 19" × 15" (48cm × 38cm), collection of Sharon van Ivan

Multicolored Figure
Dan Gheno, 1996, colored pencil, 18" × 24" (46cm × 61cm), collection of the artist

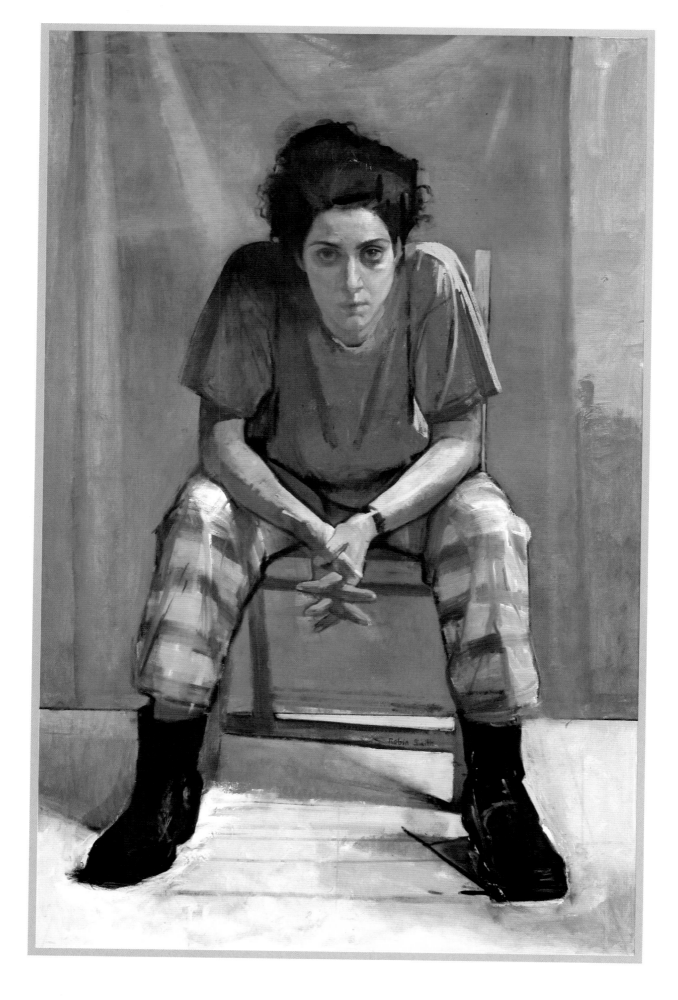

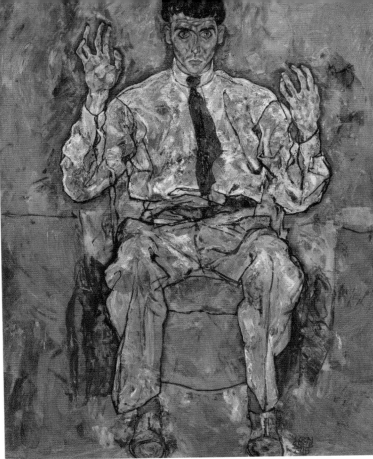

Readers in Silence (above)
Dan Gheno, 2000, oil, 30" × 42" (76cm × 107cm), triptych, collection of the New Britain Museum of American Art, New Britain, Connecticut

Portrait of the Painter Paris von Gutersloh (right)
Egon Schiele, 1918, oil, 55¼" × 43¼" (140cm × 110cm), collection of the Minneapolis Institute of Arts, Minneapolis, Minnesota

Jennifer (opposite)
Robin Smith, 1998, oil on canvas, 48" × 30" (122cm × 76cm), collection of the New Britain Museum of American Art, New Britain, Connecticut

example. He used a highly calligraphic hatching stroke in many of his paintings while, ironically, in many of his drawings he frequently emulated the textural aspects of brushstrokes. Like many other painters, I often use lines as an expressive outlet or as a way to imply forms overlapping just as I do in my drawings. Even a mass-oriented artist such as John Singer Sargent resorted to a heavy use of outline in much of his mural work.

Many muralists of the time including Kenyon Cox and, more recently, Dean Cornwell used line to make the imagery more recognizable from a distance, and along with Georges Rouault in his easel work, they often used distinct outlines in an avowed emulation of the leaden lines that support stained glass windows. In some ways you might even say these dark lines serve more as a color than a drawing end; they reinforce and enhance the hues within. Try to imagine Egon Scheile's portrait without the lines. It wouldn't work.

An expressive artist like Scheile had no fear of lines or drawing in general. Unfortunately, today many artists and critics decry the fusion of line and mass, and they vociferously argue against contaminating the purity of the painting impulse with drawing concerns.

This reminds me of another unfortunate time in art history when the Poussinistes, partisans of drawing and restraint, and the Rubenistes, soldiers of color and emotion, were at each other's throats. Each was adamant in its view. In fact, a popular teacher and artist of the Neoclassical movement, Baron Antoine-Jean Gros, committed suicide because he was unwilling to sacrifice his emotional Rubenist side to honor his patron and artistic father, Jacques-Louis David, a zealous Poussinist.

Today most people can appreciate both of those camps and can see their eventual fusion in the traditional art of the late nineteenth and the twentieth centuries. Think of how much potential was lost by these art wars. Life is too short to be deterred by another artist's dictums. Use lines when it serves your visual purposes, and use value masses when they are appropriate. Let someone else worry about the alleged aesthetic rules. Your job is to draw. If you stick to it, you'll be as unstoppable as the team of line and mass.

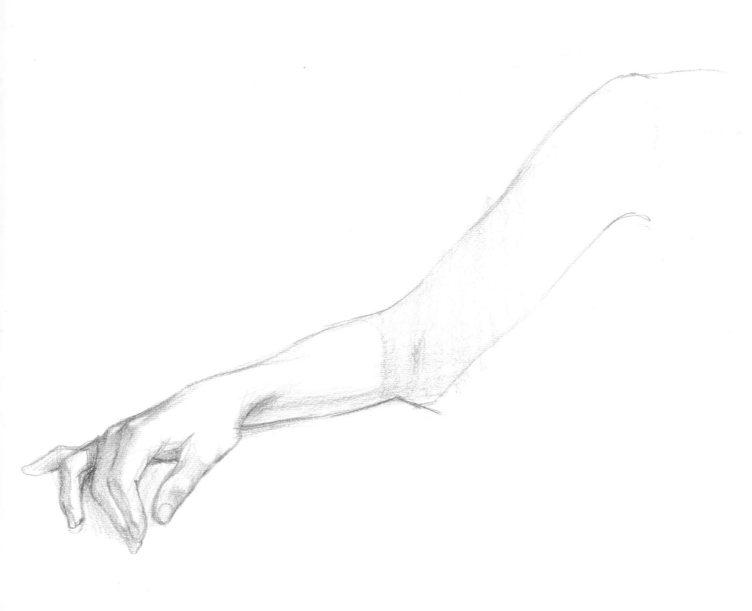

5 A Portrait of the Hand

Hands are not as complicated as they look. With a little study and attention to some rules, an artist can portray their psychological, emotional and expressive properties.

For me, hands and heads are equally important when I draw and paint people. Many artists believe that a good portrait or a firm likeness ends at the neckline. Leonardo believed that we could recognize people from afar—if only subconsciously—just by looking at their silhouettes and the rhythms of their gait.

Likewise, I believe that a good likeness extends throughout the body. The same proportional relationships that exist in the face course throughout the body. In fact, the portrayal of the sitter's hands is almost as important as the face, serving as both a physical portrait as well as an expression of emotion and psychology. A figurative artist should not miss out on the opportunity to express the character, emotion, psychology and demeanor of the sitter—through the careful depiction of hands.

Arm Study
Dan Gheno, 2004, graphite, 18" × 24" (46cm × 61cm), collection of the artist

Explore the Variety and Likeness of Hands

If a model has a thin, tapered face, the same proportions tend to occur in the torso and limbs, leading into thin, tapered hands. Likewise, a bulky, angular face usually finds repetition in a hulky torso and thick, squared-off fingers. Body likenesses, like facial likenesses, also tend to run in the family. Of course, there are always exceptions to every rule of thumb. Environmental and social conditions, especially our occupations, do play a decisive role. A broad-faced artist may end up with thinner fingers than his father the mechanic, but it's unlikely that you'll find humongous, chunky hands on a waif-like ballet dancer or extremely delicate fingers on a WWF behemoth.

You can see the importance that most artists give to nuanced, character-filled hands when you look at their notebooks. They are filled with sketches of hands, millions of hands rendered alone as preparatory stud-ies for paintings or sculptures, as anatomical studies or as stand-alone works of art. Hands are a seemingly limitless subject for new artists and old pros alike. I spent countless hours as a child trying to decipher the structure of the hand. To this day hands remain a passion for me: They are no longer completely intimidating, but they're always a challenge. I continue to learn something new every time I draw a hand.

You can help yourself get over the fear of this subject by spending some time with the Old Masters, drawing from reproductions of their hands and trying to decipher the strategies they used to conquer it. I made a big leap in my understanding of hands when I finally learned to appreciate the frequent utilization of construction lines and the simple manner in which the Old Masters set up their hands, almost like mittens.

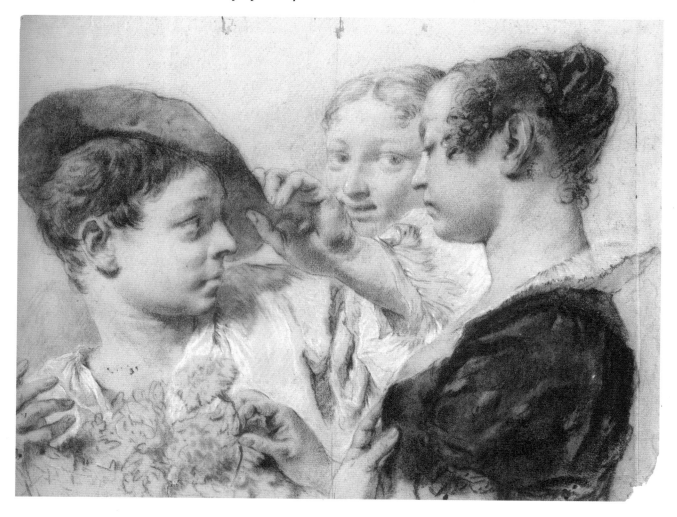

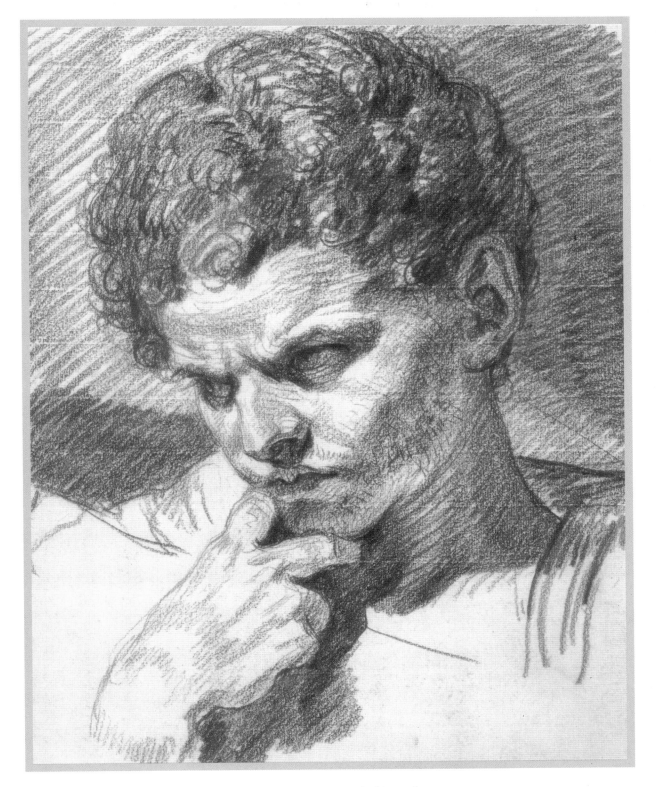

A Young Woman Buying a Pink From a Young Man (opposite)
Giovanni Battista Piazzetta, ca. 1740, black crayon and white chalk on tinted paper, 16¹³⁄₁₆" × 21⅝" (43cm × 55cm), collection of the Cleveland Museum of Art, Cleveland, Ohio

In addition to being a respected Venetian painter, Piazzetta was also a prolific drawer, renowned for a series of anecdotal drawings termed *teste de carattere* or "character heads," which particularly emphasized the use of hands and heads to advance his narrative.

Head of Caracalla
Jean-Baptiste Greuze, ca. 1768, red chalk on cream laid paper, 15¼" × 11¹⁵⁄₁₆" (39cm × 30cm), collection of the Cleveland Museum of Art, Cleveland, Ohio

Although this drawing is a study for his painting *Septimius Severus Reproaching Caracalla* from Greuze's earlier, more commercially profitable period, it's typical of his later drawings that primarily focused on the head and hands to describe various states of mind.

Construction Lines for Hands

Don't be stingy with your use of construction lines; you can employ them to find greater control over the size relationships of the hand. They won't gum up your drawing and you can erase them later if you sketch them in lightly.

Start with a pair of lines that drop from both sides of the wrist. Connect these lines to the knuckles of the index finger and little finger (see Figure 2, A and B). Ask yourself, "How much hand mass exists to the outside of these lines on the model?" Use these lines to determine the overall width of the hand compared to the size of the wrist. Look closely! The thumb side of the hand is usually not as large as we want to believe. The little finger side is even smaller, and from certain angles this side often barely exceeds the width of the dropped construction line (B). Proceed to map out the imaginary, width-spanning, curving lines that follow the arc of the knuckles along the back of the hand (C), and the plane breaks that occur within the mass of the digits (D). The result is a broadly drawn hand that resembles a mitten.

Mittens 'n' Mitts

In fact, it doesn't hurt to begin all hand drawings as if you were viewing the hands encased within mittens such as in Figure 2. It's important to establish the correct relationship between the mass of the palm or back of the hand (E) and the overall finger mass (F) before you can confidently work on the details of the knuckles or the creases between the fingers.

The arm slips gradually into the hand at the carpals (top F), that slight mass cradled below the ulna (A) and the radius (B). I've exaggerated the form of the carpals in my diagram to make my point. The most obvious plane breaks occur where the top and bottom planes of the hand meet the side planes. In this diagram, the top plane meets the side plane (E). A more subtle but extremely important plane break occurs at the apex of the curving back of the hand (F) that runs into the middle finger. Major value changes usually occur here, whether they are accents of highlight, shapes of halftone or heavy shadow shifts. The beginning of the thumb often starts about halfway down the back of the body of the hand (G). In a relaxed hanging position, the end of the thumb rides along the traverse construction line that separates the top segment of the finger mass from the lower two divisions of the finger mass (C).

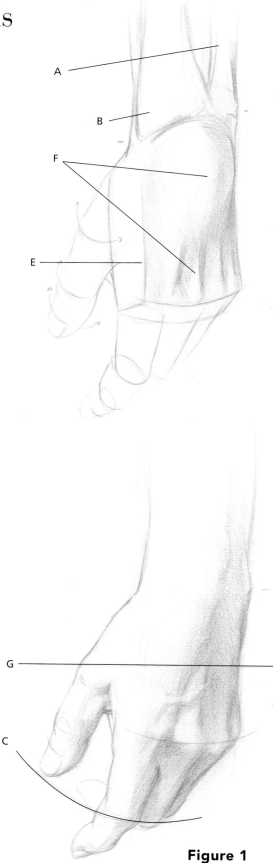

Figure 1

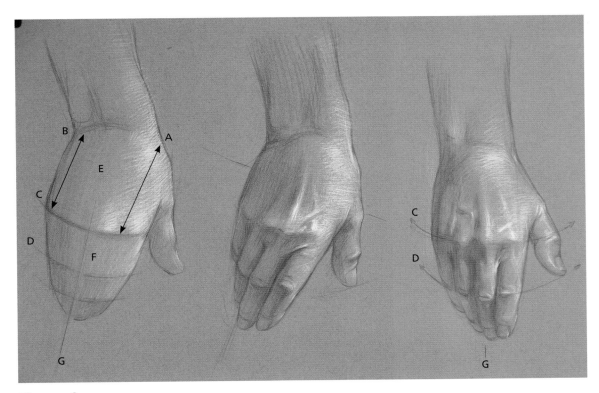

Figure 2

It helps to visualize the hand within a mitten. Notice that the last two lower segments of the fingers are prone to hang together in a relatively unified, combined plane, especially in a relaxed, limp hand. The total finger mass usually likes to cup inward toward the middle finger, even in a highly contorted hand. Indeed, the hand is very middle-finger-centric. When you finally get into the details, notice how all the wrinkles between the fingers point inward toward the middle finger.

At first glance the proportional relationships within the hand may seem daunting and impossible to decode. However, after some study, a logical and progressive pattern of halves is discernible throughout the length of the hand. The hand may be divided along the entire length into equal halves:

1. From the back, the first set of knuckles on the back of the hand sits along the midpoint of the entire length of the hand. Ignoring the thumb for now, these knuckles frequently divide the rear view of the hand into two equal parts: the lower finger mass and upper broad mass of the "body of the hand."

2. When you look at the overall group of fingers or finger mass, the first, upper segments of each digit match almost exactly the combined lengths of the bottom two segments of each digit.

The beginning of the thumb seems to start about halfway down the back of the body of the hand (Figure 1, at point G). In a relaxed, hanging position, the end of the thumb rides along the traverse construction line that separates the top segment of the finger mass from the lower two divisions of the finger mass (Figure 1, C).

Now, let's look at the overall width of the finger mass. Again, ignore the thumb at first and find the midpoint within the breadth of the four smaller fingers before considering the individual digits (Figure 2, G). Then divide the resulting two halves into quarters to determine the amount of space available for your four fingers. That way, you won't run out of space for the little finger or end up with fingers that are too small for the body of the hand. Don't forget to consider perspective when determining that midpoint break—the closer fingers must loom larger than the distant fingers. Don't be surprised if the nearest fingers take up all the space within the broad mass of the digits. You can just as easily use this approach to determine the proper placement of toes within the mass of the foot.

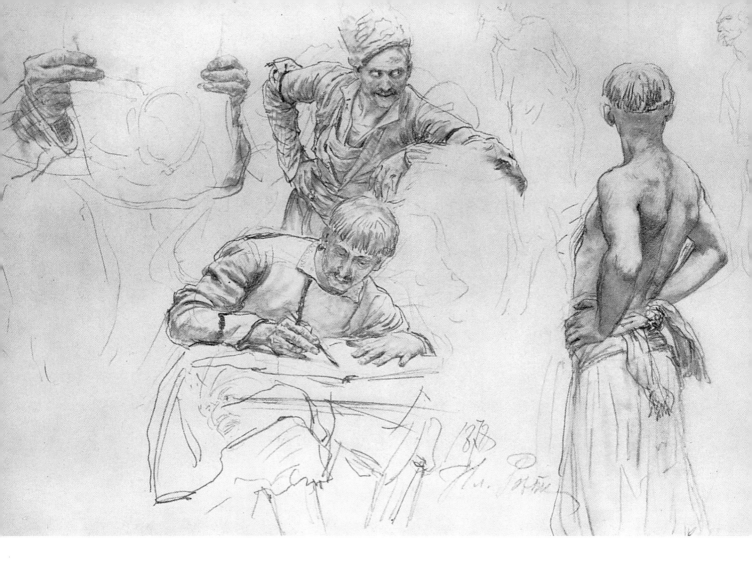

A Zaporozhye Cossack in a Fur Hat, A Cossack Writing, A Cossack Bared Down to His Waist, A Male Figure in Profile
Ilya Repin, ca. 1885, graphite, 9¾" × 13½" (25cm × 34cm), collection of the Russian Museum, St. Petersburg, Russia

We know Repin for his fluid and self-assured painting style, but we can see from this sketch that he didn't win his confidence easily or blithely. He spent a great deal of time drawing and analyzing details, rehearsing his heads, hands and other body parts with charcoal or pen before he put brush to canvas.

Studies of Heads and Clasped Hands (opposite)
Peter Paul Rubens, ca. 1610, black chalk heightened with white chalk on brownish paper, 15⁵⁄₁₆" × 10⅝" (39cm × 27cm), collection of the Albertina Museum, Vienna, Austria

Rubens loved drawings. He collected drawings by others, when few people bothered to save and stockpile them. He also did plenty of his own drawings, usually exquisitely composed and segmented details of the figure. Most of his drawings were done as preparation for his own paintings or as templates for his assistants to copy onto his less personal, large-scale shop paintings.

The Hand-Body Ratio

After some time, you may find it easier to draw the fingers and body of the hand in correct proportion to each other. Don't let your guard down with a little success—you also need to consider the general size of the hands to the body. I frequently measure hands against faces. The entire length of the hand usually equals or slightly exceeds the length of the features, from chin to just above the eyebrows or the middle of the forehead.

I vividly remember the lecture that anatomist and artist Robert Beverly Hale once gave in which he warned us not to make the hands too large. Taking the skeleton's hand, he shoved it into the skull's mouth, dramatically showing that the finger mass is no wider than the width of the mouth and just a little bit wider than the width of the lips. If you place the back of your hand sideways over your lower face, your hand mass, minus the thumb, will probably span the distance between your chin and the base of your nose. Some individuals have bigger or smaller hands, but these facial comparisons give us a convenient standard that we can measure against.

Don't dismiss Hale's warning too easily. The more you study the hand, the more likely you will fall prey to making the hands too big. This frequently happens to artists when they devote a lot of study to one aspect of the body or when they concentrate on a problem area of a body within a particular drawing or painting. It's one thing if you're Rodin and you're purposefully enlarging a hand for psychological effect, trying to show the relentless gravitas of responsibility that weighs down the figure, but it becomes a pointless, visual distraction when it's the unconscious

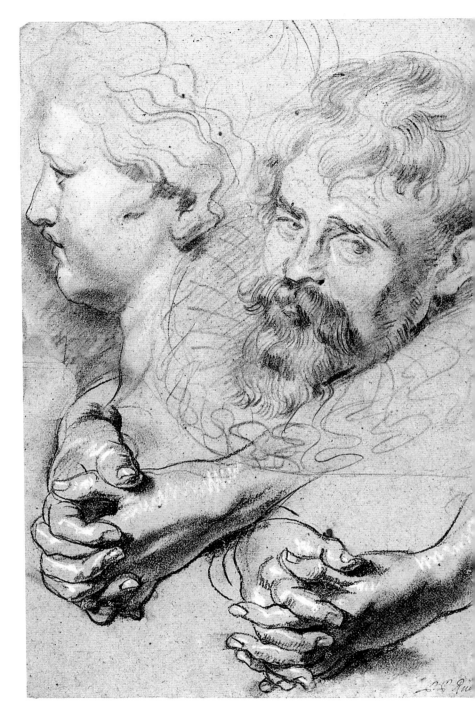

result of your enthusiasm for the hand and nothing else. Don't worry, this habit eventually becomes easier to control once you're aware of it.

It's particularly difficult for the artist to keep hands correctly proportioned when drawing, painting or sculpting plump or heavily muscled people. We have a tendency to make their hands and heads too big, as if we are trying to compensate for their larger body mass. Actually the hand-body ratio changes very little, regardless of the model's general body mass. It doesn't matter how much iron you pump—you'll never buff up your fingers or the muscles in your palm in any noticeable way. Although some fat deposits do build up on the hand—puffing up its overall mass and the fingers slightly—the hand will remain relatively small,

especially in the joints, compared to the rest of the body. For that matter, when observing a large figure, take a second look at the feet and most of the joints in the body such as the wrists, ankles, knees and elbows. They are usually smaller than you may initially think. The reverse is true for extremely skinny or emaciated models. Their joints, heads and hands look relatively large compared to their bodies.

There's no way to ignore the body when grappling with the complex intricacies of the hand. The most accurately drawn hand will look like it belongs on a monkey if you draw the arms too long or the torso too short. It's equally unsettling to do the opposite, with the torso too long or the arms too short. Notice that the wrist hangs at the midpoint (or pubis) of a standing

Seated—Leaning
Dan Gheno, 1997, colored pencil, 16" × 9"
(41cm × 23cm), collection of the artist

Lunging (opposite)
Dan Gheno, 2004, colored pencil, 9" × 14" (23cm × 36cm), collection
of the artist

You don't have to paint or draw the entire figure with
equal devotion or detail. I often choose to focus on a
select area of the figure, usually the nearest point, such
as the hand in this drawing, letting the rest of the body
fade out into the distance. There is no hard-and-fast
rule; you can selectively focus on any point of the figure.
The viewer's eye usually moves systematically across the
image, alighting first on the strongest point of focus or
contrast and then sequentially moving to progressively
less-focused or sharper areas of detail.

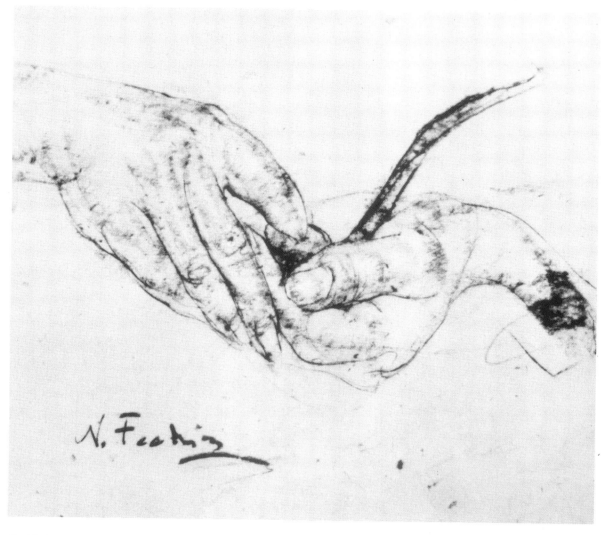

Untitled Drawing
Nicolai Fechin, image reproduced by permission of Fechin Art Reproductions, *The Drawings of Nicolai Fechin* by Galina P. Tuluzakova, Fechin.com

figure. The upper arm, from the shoulder to the elbow, usually equals the lower arm from the elbow to the first set of knuckles on the hand. Both of these lengths are about one-and-a-half heads long. Even though many of these individual lengths may seem to loosely approximate one another a great deal of the time, you should always trust your eye.

If you want to strengthen the power of your eye, estimate first with your unaided eye and then measure later. Like any preset "canon of proportions," all of the above suggestions are just convenient regions that we can use to judge comparative measurements.

Of course, there's nothing inherently wrong with exaggerating the size of arms and hands if you have some sort of artistic aim in mind, but don't ignore the rest of the figure. Create a purposeful rhythm to the exaggerations, preparing the viewer for your creative manipulations, with one exaggeration leading into another. Notice how forms interlock all through the body, and how the actions of the hand have a big effect on the rest of the body. Wherever the hand moves, the arm follows.

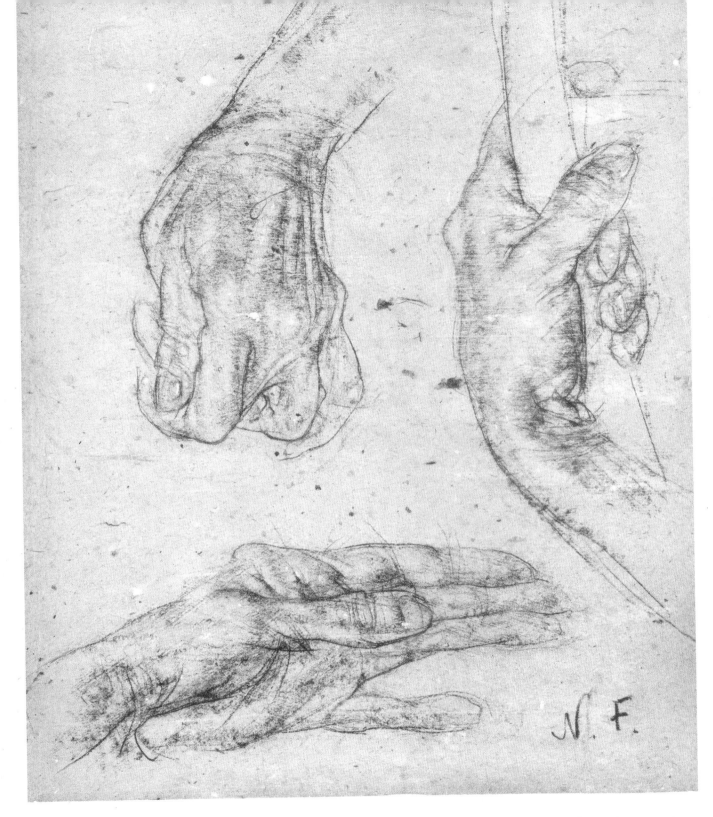

Study of Hands
Nicolai Fechin, C. 1940s, charcoal on paper. 17" × 13"
(43cm × 33cm), private collection, image reproduced by
permission of Fechin Art Reproductions, *The Drawings of
Nicolai Fechin* by Galina P. Tuluzakova, Fechin.com

Fechin pursued his art with a great love of gutsy color
and textural paint, but he also drew extremely delicate
and detailed studies of the human form throughout
his lifetime.

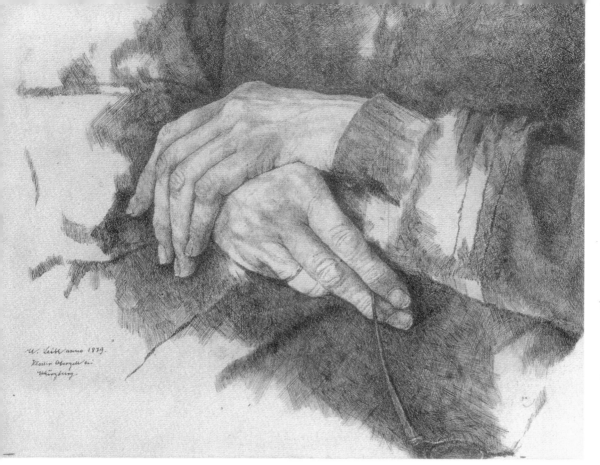

The Artist's Mother's Hands
Wilhelm Leibl, India ink,
collection of Bildarchiv
Preussischer Kulturbesitz,
Berlin, Germany

Wilhelm Leibl had
two divergent paint-
ing styles: tight and
smoothly finished and
loose, heavily stroked,
thickly painted.
Through both styles
this German painter
and drawer always
paid close attention
to detail and subtlety,
consistently imparting
a specific, individual-
ized character or per-
sonality to all his hands
and faces.

The Artist's Left Hand
Théodore Géricault,
black chalk, red chalk
and watercolor, col-
lection of Réunion des
Musées Nationaux,
Paris, France

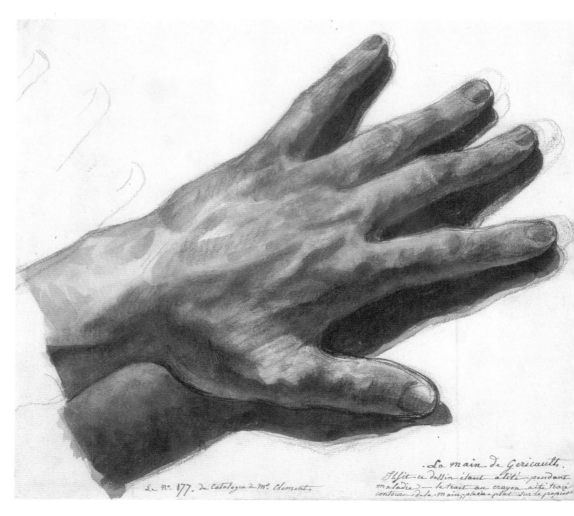

82

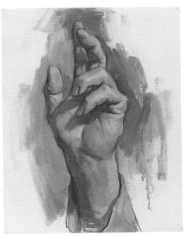

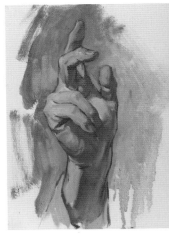

Self-Portrait Triptych

Dan Gheno, 2004, oil, triptych, 12" × 27"
(30cm × 69cm), collection of the artist

Hands and heads are equally important to me when I paint a self-portrait. In the 2000s I did a series of self-portrait triptychs, consciously pairing hands with heads, using the hands to reinforce and bolster the emotional and metaphorical content of the face.

Detail of Self-Portrait Triptych

Dan Gheno, 2004, oil, triptych, 9" × 12"
(23cm × 30cm), collection of the artist

Historically, hands have played an important role in religious imagery across many cultures, serving as a symbolic, metaphorical and, sometimes, coded spiritual form of sign language. My triptych has no religious meaning. But I purposely posed my hand in a manner that, combined with the religiously loaded triptych format, would echo some of the positions found in spiritual imagery and hopefully trigger some of the subconscious associations living in the viewer's mind.

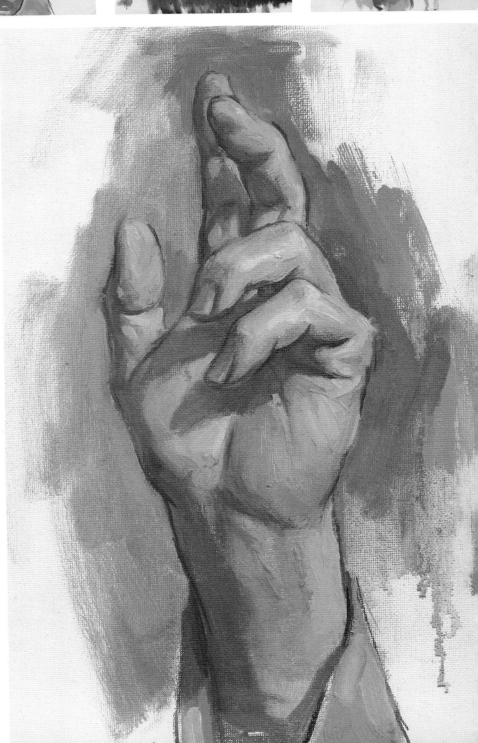

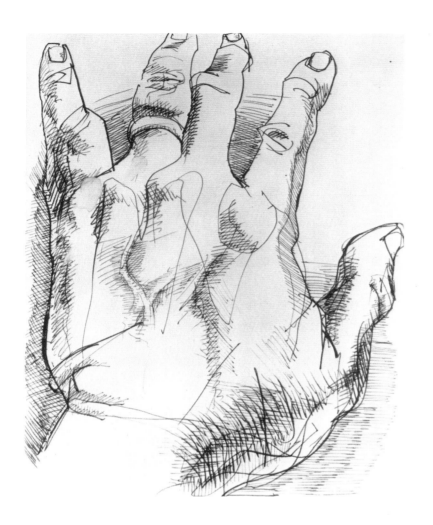

Hand

Howard Warshaw, sepia ink, 10" × 8" (25cm × 20cm)

Warshaw often treated his drawings like X-rays, looking beyond the surface of the form into its inner workings. Sometimes, as seen here, he used lines that rolled over the form and suggested the underlying bones.

Hand in Space

Howard Warshaw, ink and watercolor, 7" × 10" (18cm × 25cm), collection of Papa Devan and Mark Ferrer

Warshaw cuts across the form with linear cross-contours that reveal the overlying, topographical structure. On occasion he used tonal washes or a charcoal haze to hint at an atmosphere that fractures or spatially interrupts the subject matter.

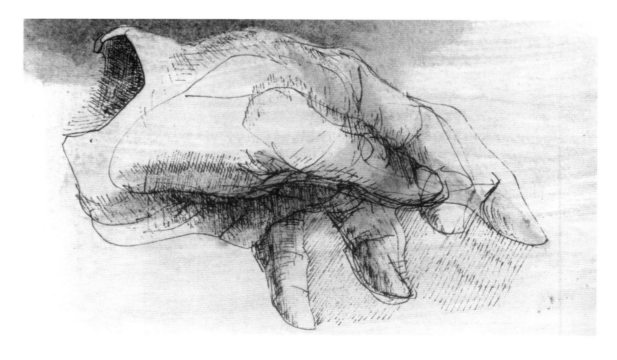

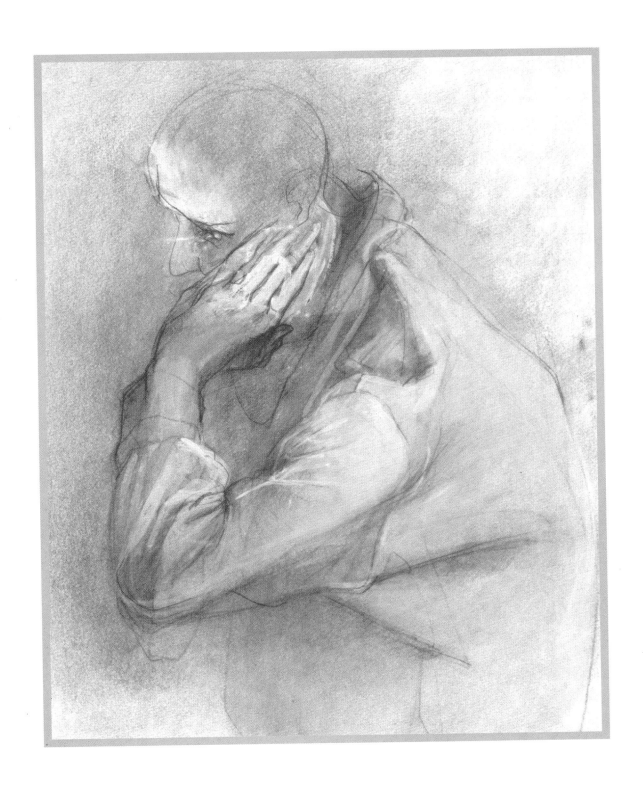

Figure Study
Howard Warshaw, 1961, gouache, graphite, Conté, 19" × 16" (48cm × 41cm), collection of Walter G. Silva

Mentored by his close friends Eugene Berman and Rico Lebrun, Warshaw showed their profound influence through his almost cubistic, visual splintering of the figure.

Dog's Eye
Robert Birmelin, 2003, acrylic, 36" × 48"
(91cm × 122cm)

On Being an Observer (from the book *In the City*)
Robert Birmelin, 2003, 8" × 10½" (20cm × 27cm)

Hands appear frequently in Birmelin's multi-layered painted and drawn work. His pieces are often spatially ambiguous, presenting a visual field or scene from many different viewpoints. Sometimes a head, an arm or, as in this image, a hand will appear in an extreme close-up view, while other objects or figures fade in and out in the distance. This image is one page from a published sketchbook of powerful, gritty city scenes that have a more journalistic or singular viewpoint than most of his other work.

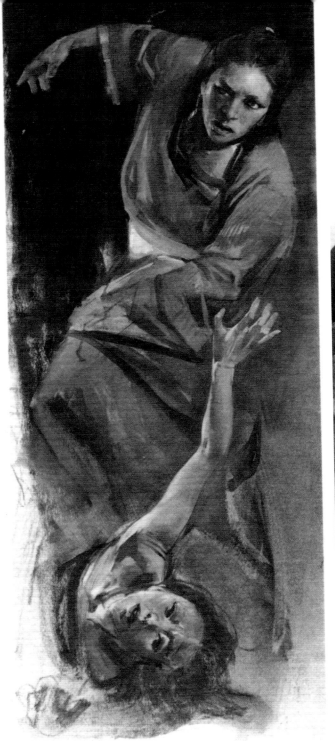

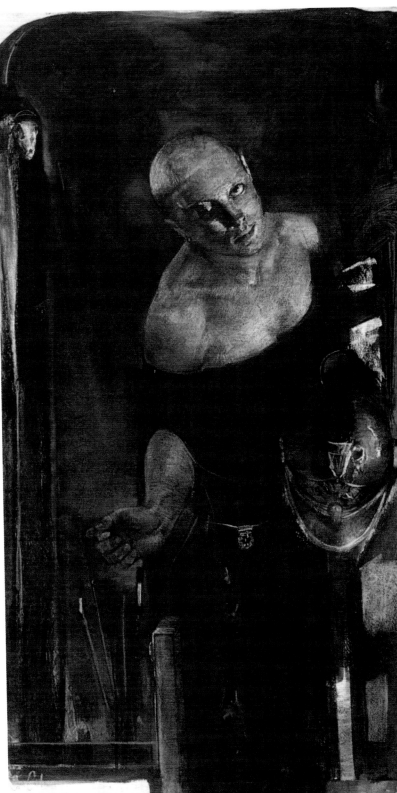

Untitled—Two Figures
Peter Cox, oil and charcoal on paper 42" × 14" (107cm × 36cm)

Peter Cox creates an intricately, surreal world in his work. He fills his compelling paintings and drawings with a great deal of complex metaphorical meaning that frequently hinges on expressively rendered figures and hands.

Untitled
Peter Cox, pastel on paper, 54" × 32" (137cm × 81cm)

Thumbs Up

Remember, wherever the hand moves, the arm follows. When the thumb turns down, the radius follows and the elbow in a standing figure tends to turn outward. When the thumb turns up or away from the body, the radius once again follows the thumb, and the elbow in a standing figure turns inward.

DRAWING THE HAND IN ACTION

MATERIALS LIST

Colored pencils

Oil-based sanguine pencils

It doesn't matter how complicated a hand position may be, it is always extremely helpful to visualize it within a broad mitten shape.

Create the Base

Start with the mass base of the hand, minus the fingers, and draw a line through the midpoint of its end plane (X). Later on you can use it to better align the individual fingers, two on either side of the centerline. Take perspective into account, leaving more space for the near fingers than the far ones. Draw this centerline lightly at first, so it can be easily erased later.

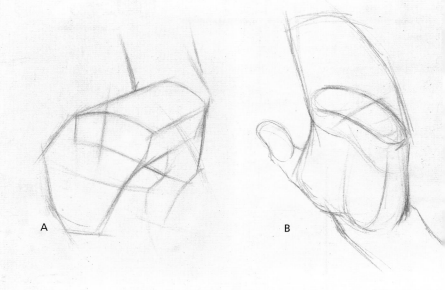

Create the Fingers

Add the rest of the basic mitten shape to give yourself a general area to work within as you start drawing the specific directional movements of each finger segment. When the fingers are heavily foreshortened, as in C, try to not make the fingers too thin to compensate for their shorter length. The fingers may be visually shorter, but the width remains comparatively wide and unaffected.

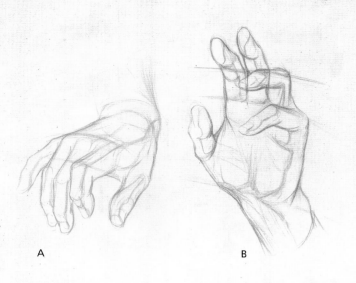

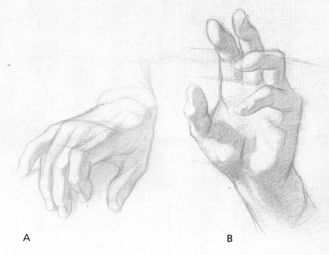

A B

A B

Add Details

Now you can start on the specifics of each finger form, visualizing them as cornered off cylinders, more geometrically as in A, or fleshier as in B. Make use of the curving guidelines to line up the relationships between the knuckles (B). Think of the individual fingers as transparent structures, drawing through their forms to better locate the placement of each digit (B). Don't forget that each finger tip has an end plane as demonstrated by the curving line on the end of the thumb in A.

Lay in Shadow Shapes

Before getting too caught up in the enticing details, you should lay in the major shadow shapes as large, simple masses. This gives you a reference point to better gauge the relative values of your dark accents, core shadows and reflected lights that will be established in the next stage.

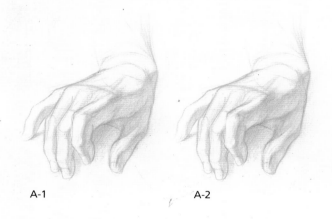

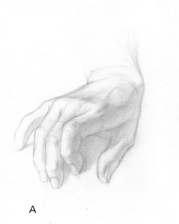

A-1 A-2

A B

Details in the Shadows

Darken the core shadow, which usually sits inside and behind the shadow edge (A-1). Once the overall core shadow is blocked in loosely, the rest of the shadow will suddenly look lighter in comparison, automatically creating a sense of reflected light. But don't make the core shadow too harsh. Once established, lay another broad tone over the whole shadow, to better merge, or blend the darker core into the less-dark shadows, or reflected lights (A-2).

Finishing With Details and Halftones

Start laying in the halftones within the light shapes, being sure that none of the light tonalities approach the darkness of the shadows. Emphasize all the little (but important) details that make a hand seem palpably volumetric. Shadow edges vary widely depending upon the hardness of the form. They're sharper at the bony points, mostly on the top of the hand and topside of the fingers and knuckles, and they're softer, smoother on the fleshier, pillow-like forms of the palm side of the hand and fingers.

The Psychology of the Hand

The hand's significance goes well beyond a physical likeness. Like the face, hands convey great psychological weight. Note the nervous tension in an Egon Schiele hand. Or look at the work of Robert Birmelin, Peter Cox and Jerome Witkin. All three of them approach their art with a personal, multifaceted, conceptual agenda in mind, but in my opinion they also seem to put special emphasis on the hand. They make clear use of the hand as a compositional device, moving the viewer's eye across their complex images, but more importantly, they appear to utilize the hand expressively as a visual conduit to our human emotions and the many other countless, internal workings of the mind. I could go on and on, citing examples from many other fine contemporary and historical artists to make my point. The list of artists that manipulate the hand as a tool of artistic, psychological and emotive expression is endless and extends back to the beginning of art history and the first stenciled hand on a cave wall.

We often look into each other's eyes when we want to connect with someone, and we can read a lot into another person's psyche when we study his or her eyes. The same is true of our hands. Next time you shake or draw someone's hands, remember that you are not just exchanging pleasantries or rendering a pair of mitts. You are opening a portal into someone's soul—perhaps your own.

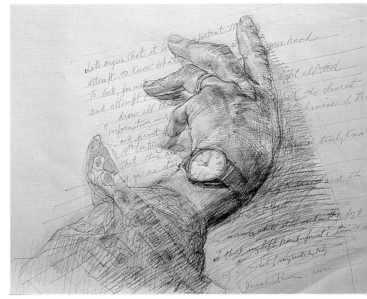

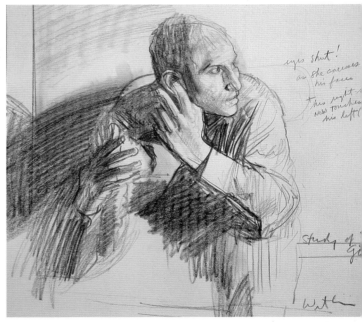

Untitled
Jerome Witkin, ballpoint pen on paper, 19" × 25" (48cm × 64cm), collection of the artist

An artist is never without a model as long as he has his own hands, face and a mirror. Jerome Witkin takes the hand self-portrait to another level in *Untitled*. The drawing almost becomes a mindscape, demonstrating his hand and mind working on visual and verbal pursuits simultaneously.

Untitled
Jerome Witkin

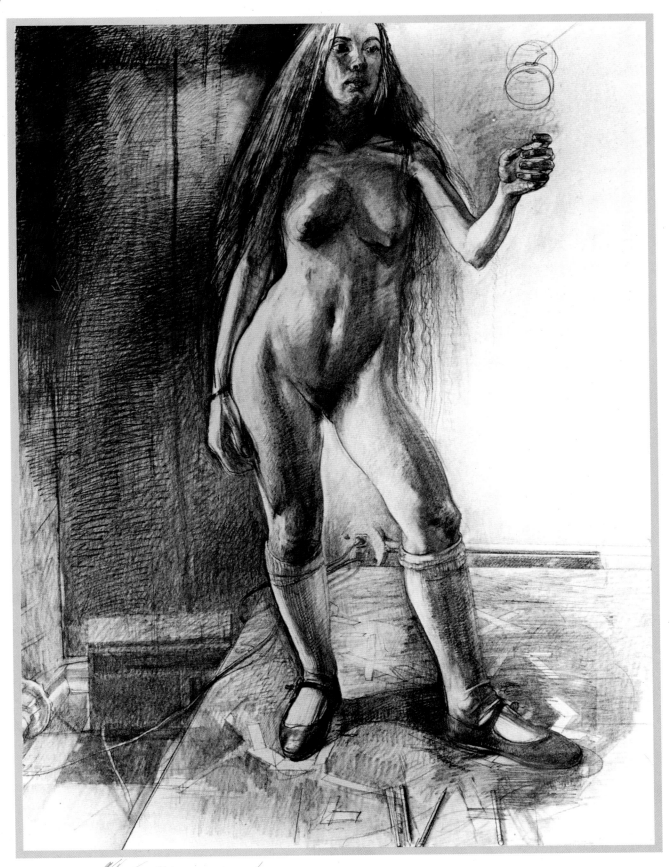

Eve
Jerome Witkin, 1983, graphite, 42" × 72" (107cm × 183cm)

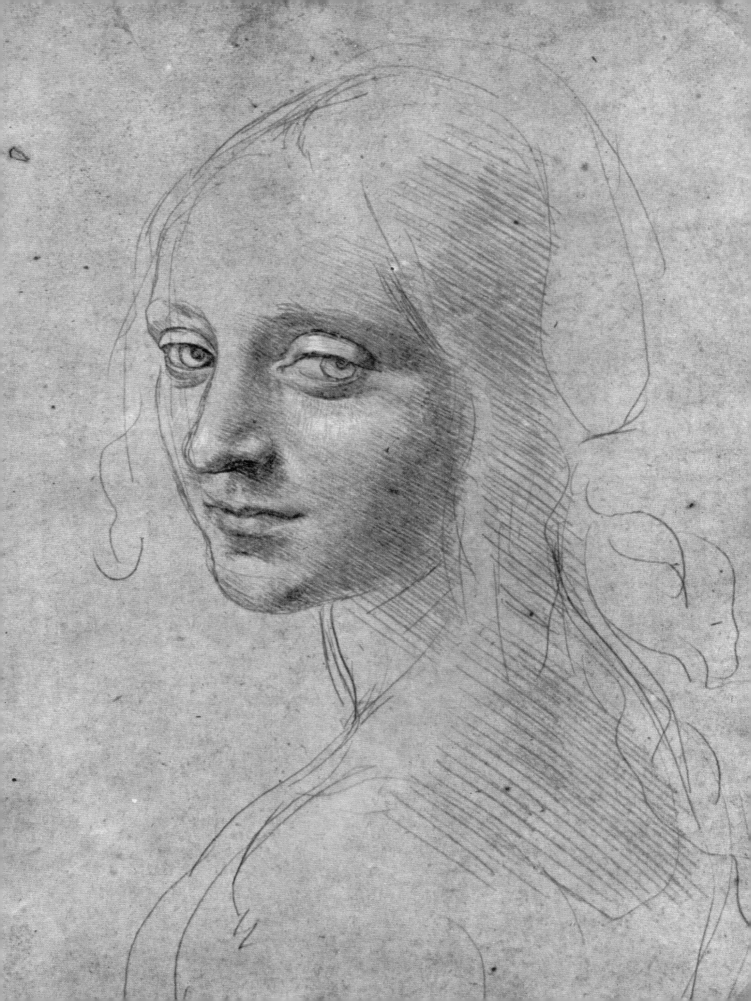

6 Dynamic Heads

Depicting features is only the beginning. Putting life into a head drawing requires assimilating it with the rest of the body, capturing an attitude and much more.

There are many ways to keep your figure drawings lively, fresh and dynamic. But there is one sure way to destroy an active and energetic drawing: by plopping a stiffly rendered, ham-fisted head on top of an otherwise nicely drawn figure. Too many artists, perhaps fearful of their subjects, treat the head as if it were nothing more than an inventory of features or an empty, block-like shape void of life, sometimes sitting straight and rigidly on its neck, contradicting the underlying gesture of the body and looking like a lifeless lollipop.

This eons-old challenge of how to put more life and energy into drawings, paintings and sculptures of the human head is easily answered once you get beyond the fear and the seeming complexity of the subject. I will outline many solutions throughout this chapter appropriate for both the beginner and the advanced artist. Some of the cures will seem deceptively simple. Others will reach beyond the obvious, studying the head from all sides, including top and bottom. And just about all of them will somehow involve the overall figure with the head serving as the crown of the magnificent machine that is the human body.

Study for the Angel in La Vierge aux Rochers
Leonardo, silverpoint, 1483, 6¼" × 7⅛" (16cm × 18cm), collection of the Royal Library, Turin, Italy

Portray Attitude in Your Portraits

Perhaps the most powerful key to a stronger head is the most obvious one, which even advanced artists often miss in their obsession to get the features just right—that is, give your head attitude. Faces need to look somewhere and their eyes need intensity and aim.

You've probably noticed how the eyes in some Old Master paintings and drawings often seem to follow you as you move around the room. This dynamic event occurs in the viewer's mind, usually when the artist depicts the head in a three-quarter view with the eyes looking off to one side as Leonardo most famously did in his *Mona Lisa*. In drawings such as Leonardo's *Study for the Angel in La Vierge aux Rochers*, observe how the irises seem to peer out of the corner of these eyes, gazing past the canvas or drawing toward the viewer. Remember, you can't move irises around willy-nilly. The upper eyelid bulges above the iris, so every time you change the direction of your model's gaze, you must also change the shape of the upper lid.

The tilt of the head is equally crucial to achieving attitude in your figure drawings. It should somehow complement or contrast the gestural movement that flows through the body from the toes to the neck and finally—and hopefully—into the head. In Ingres's masterpiece of a portrait, *Louis-François Bertin*, notice how some people seem to lean forward imperiously, head locked into their shoulders as they speak to you. Others lean back, their noses tilted up and their irises barely peering past their lower lids.

Pay close attention to body shapes and gesture, even when drawing a vignetted, seemingly isolated head. You don't want to draw a husky, muscular man with a pencil-thin neck or a young child with a fullback's shoulders. Look at the model intensely. Notice how the neck leads from the shoulder into the head. It doesn't matter if you are drawing only a small snippet of the neck—in fact, the shorter the line, the more crucial the correct angle becomes. If the line fragment angles outward or inward a little too much, the error will become magnified once you imagine the line extending outside the image, inferring an implausible body type for the head. Body postures and their relationships to the head are numerous, and they can be quite evocative of an individual's character, psychology and emotion.

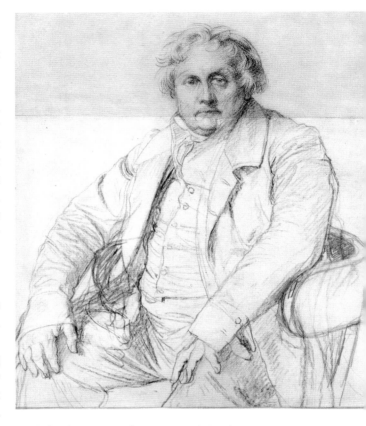

Study for the Portrait of Louis-François Bertin
Jean-Auguste-Dominique Ingres, 1832, black chalk, 13½" × 13⅞ (34cm × 35cm), collection of The Metropolitan Museum of Art, New York, New York

Although Bertin was one of his friends, Ingres portrayed his subject with all of the imposing imperiousness that this newspaper editor likely displayed to his employees, political adversaries and business competitors.

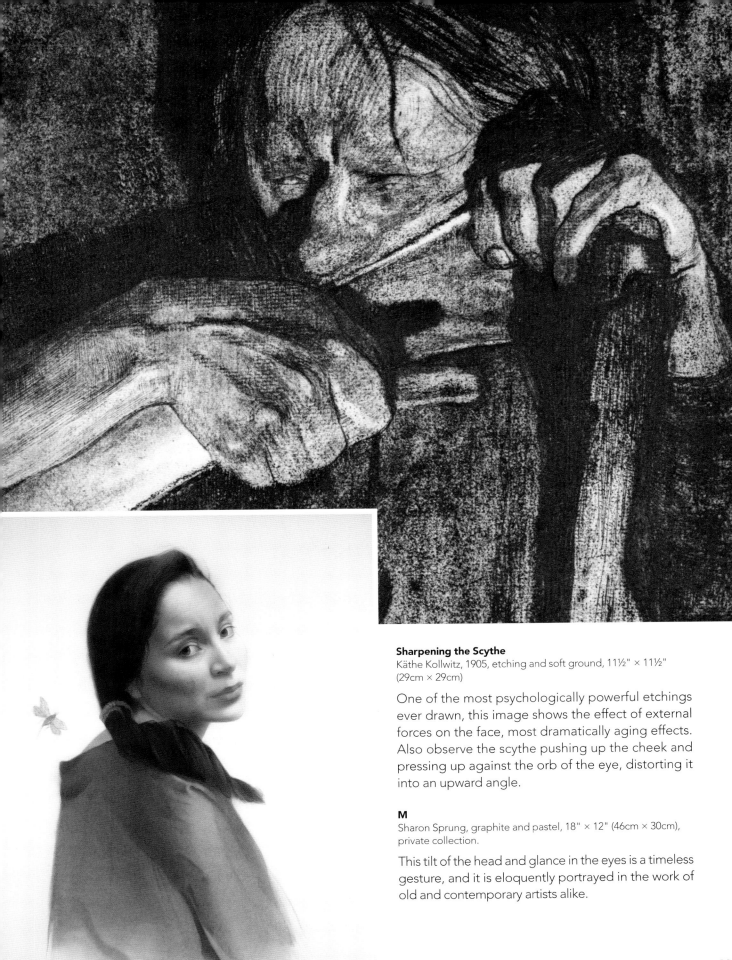

Sharpening the Scythe
Käthe Kollwitz, 1905, etching and soft ground, 11½" × 11½" (29cm × 29cm)

One of the most psychologically powerful etchings ever drawn, this image shows the effect of external forces on the face, most dramatically aging effects. Also observe the scythe pushing up the cheek and pressing up against the orb of the eye, distorting it into an upward angle.

M
Sharon Sprung, graphite and pastel, 18" × 12" (46cm × 30cm), private collection.

This tilt of the head and glance in the eyes is a timeless gesture, and it is eloquently portrayed in the work of old and contemporary artists alike.

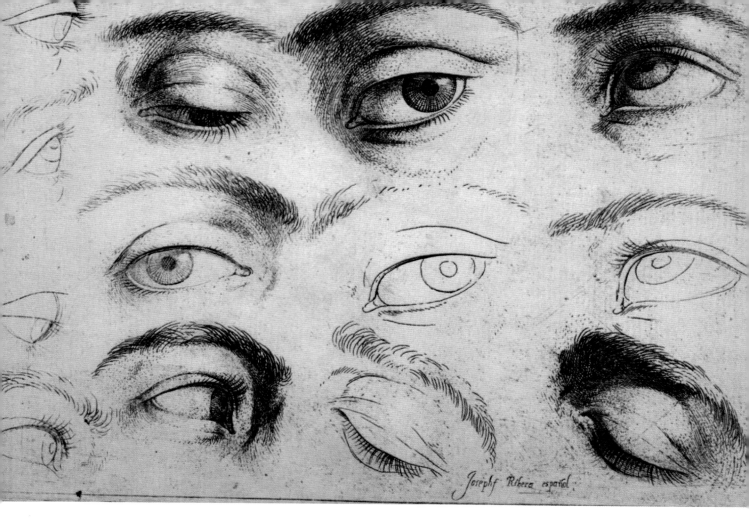

Joseph Ribera español

Achieve a Realistic Likeness

It may seem like a waste of time worrying about whether you've captured a likeness or not. It's unlikely the viewer will notice that something is missing while looking at a drawing of an unfamiliar sitter. But I feel it's imperative to always give it a sincere try. The pursuit of likeness keeps your concentration focused, the entire drawing process compelling and, in the end, the struggle leads to a more active-looking and vigorous drawing.

There is no doubt that the individual features are crucial to achieving a likeness and a psychologically animated head and figure. But, it's the overall shape of the head and the spacing between the features that play the most important role by far.

Feature-Measuring Techniques

To find the correct proportional spacing of the facial features, start by partitioning the features into three nearly equal divisions: The top partition runs from the hairline to the eyebrows, the second one from the eye-

brows to the base of the nose, and the third one from the bottom of the nose to the bony point of the chin.

This classically derived system of measurement has been used by artists to get their bearings since the Greek golden age, and it's nothing more than an averaging of our collective facial proportions. As artists, we need to look at models and determine where their particular proportions diverge from this standard. Ask yourself which of these three divisions is the largest, which is the next largest and which is the smallest. If you don't catch these divisions correctly in the beginning, it doesn't matter how elegantly you render the specific features.

Detailing the Features

Once you begin to render the individual features, you must be equally diligent about their peculiar likenesses. It's useful to draw numerous studies of the features, cataloguing and committing their basic con-

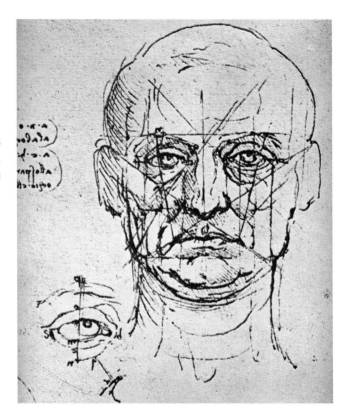

Study of Eyes
Jusepe de Ribera, 1622, etching, 5⅞" × 8½" (15cm × 22cm), collection of the Albertina Museum, Vienna, Austria

It's always a good idea to study the subforms of the face. Whenever you have a free moment, draw isolated views of the eyes, nose, lips and ears from every direction. Soon you will build up a subconscious understanding of each feature.

Study of the Face and Eyes
Leonardo, pen and ink, collection of the Royal Library, Turin, Italy

Notice that the overall width of the eye is roughly equal to the nose and that, consequently, the wing of the nose usually lines up with the inside of the eye. Meanwhile, the top of the ear lines up with the eyebrow, and the bottom coincides with the base of the nose.

struction to memory. At the same time, try to be sensitive to the bilateral symmetry that underlies the face and its features. Use guidelines to line up one side of the face with the other, but remember this very important caveat: As much as you may want them to, features do not conform to a simplistic rule of absolute symmetry. Look closely at any Old Master portrait. You will usually find that one eye is almost always a little bigger or a little farther from the nose than the other, one nostril a little taller or one side of the mouth a bit lower than the other. These artists' use of subtle asymmetry gives their subjects' heads and figures life and a sense of action—as if the features are in motion.

This asymmetry is vitally important from the likeness standpoint as well. It's been proven in psychological studies that when a photo is sliced in half, with one side reversed and pasted next to the other, the viewer finds it difficult to recognize the subject within the new-found symmetry.

Head Shape

No matter how enticing your subject's features, the hard truth is that the ratio of the head shape and size to the body is much more crucial to capturing a likeness or creating a dynamic impression. When look-ing at your model, ask yourself what sort of geometric shape typifies his or her head. Does your model have a triangular head tapering toward the bottom, with lots of hair and full cheekbones at the top sliding into a narrow jaw and smallish chin below? Or perhaps your subject has a wide, rectangular face with a broad jaw, full cheeks and a flat, closely cropped hairdo—or a tall, rectangular head, narrow but angular from the jaw to the top of the head. Maybe your model's forms are built on soft, circular shapes. Whatever your subject's essential structure, you can always distill it into a simple, quickly identifiable shape in your mind that will guide you through the complicated process of laying in the drawing.

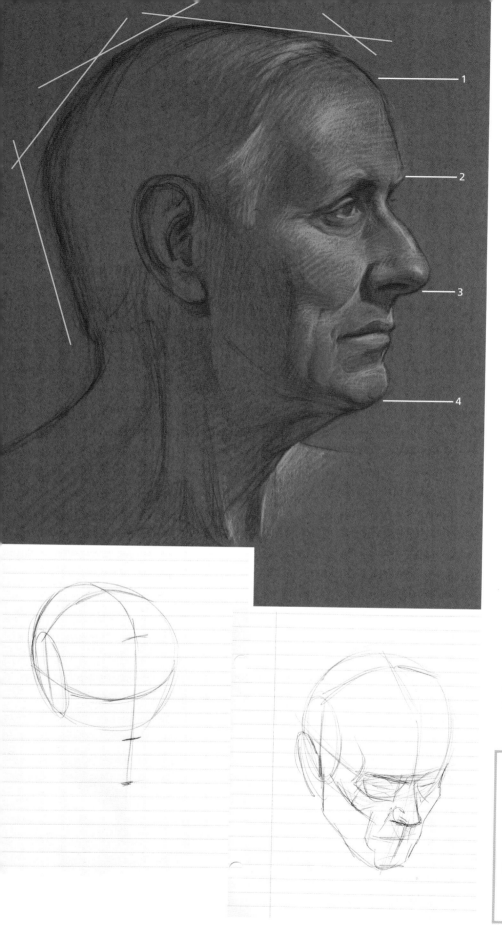

Drawing of Paul
Dan Gheno, 2006, colored pencil with white chalk on toned paper, 12" × 10" (30cm × 25cm), collection of the artist

Figure A

When judging a likeness, compare the distances that make up the forehead (1-2), the nose (2-3), and the space between the bottom of the nose (3) and the chin (4). Sometimes you might find it difficult to assess the top of the forehead if your subject has a high hairline. In that case, use the point where the forehead begins its transition into the top of the skull (1).

Copy of Andrew Loomis Diagram Published in *Figure Drawing for All It's Worth*
Dan Gheno, 1972, ballpoint pen, 11" × 8½" (28cm × 22cm)

As with many others of my generation, I drew incessantly from Andrew Loomis's drawing instruction books when I was a kid. This sketch is one of many that I did, trying to internalize his form concepts of the human head. Notice how his approach treats the cranium like a ball with its side sliced off at the temples. A line is dropped from the center of the ball to establish the centerline of the features. From a side or three-quarter view, the facial area is separated from the ear and the cranium by an imaginary line that runs in front of the ear and arcs lengthwise across and over the center of the ball.

Facing the Facts

Most often artists tend to make the facial mass too big, especially on a foreshortened head or bearded model. Governed by our species's psychological focus on the importance of the features, we seem eagerly predisposed to expect a large facial size.

Purge Your Facial Preconceptions

After determining the global shape of the head, assessing the facial angle is the next most important factor in getting a likeness and keeping your head drawing lively. Forensic specialists frequently use this technique to identify decomposed remains, and nineteenth-century phrenologists used it in a foolish attempt to catalogue racial intelligence.

You can discover the facial angle of your subject by drawing a line from the ear hole, at the base of the skull, to the bottom of the nasal aperture (Figure B) and then comparing that line to one that runs from the base of the brow ridge to the upper dental arch. Called the "muzzle," this protrusion doesn't project as far forward in humans as it does in animals, but it usually juts farther outward than most beginner and some advanced artists are willing to accept.

The real human head is quite unlike a Greek statue; it's very rare that all of your subject's features will line up in a straight, stagnant and vertical formation from forehead to chin. Unless you're trying to render some sort of classical ideal, look for this basic facial angle and then compare it to the usually receding angle that leads from the tip of the nose to the base of the chin. Or compare it to the angles that radiate off the forehead, across the top of the head and back down to the nape of the neck (Figure A).

Even if you get all the big shapes of the head correct, you're not out of the woods yet. You need to compare the facial size to the overall head size. Quite often even the most experienced artist will make the facial area, the space between the mouth and eyebrows, too big or too small for the rest of the head. Then they wonder why the head looks too big or small, even though they've measured the overall head size against the body a thousand times, and it adds up correctly every try. That's because we often judge the size of the head with our gut, and if the features are drawn too large or small, the head will seem likewise.

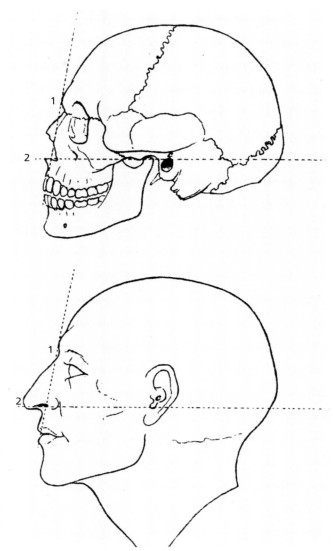

Diagram of the Facial Angle
Charlotte Bertuch-Froriep, ink

Figure B

To determine your model's facial angle, compare an angle that runs from the brow ridge to the upper dental arch (1) with one that runs from the base of the nose to the ear hole (2).

Calm Your Grandiose Tendencies

Many large-scale drawings have a built-in dynamism. Unfortunately it's often hard to feel good about a face that's drawn larger than life, especially when drawing a delicate person. Even if all the features and underlying angles are impeccably placed, the face will almost always seem off, or at least surreal, because it is larger than we have experienced in real life.

Perhaps you want to embrace that surrealism or want to capture some of the heroic power we see in such sculptures as *Head of Constantine the Great*. I do that a lot myself, as do many artists I admire. Perhaps you are doing a mural or altarpiece that will be seen at an extreme distance. Just be sure you are making it bigger on purpose and not because you got carried away. Usually this problem creeps up on artists. As one works on the features, or any detail of the body such as the hands or feet, one can become captivated, and if an artist doesn't step back often to gauge the relative size of the subject's face to the rest of the figure, those features will tend to grow. Artists then compensate by enlarging all the other features, then the entire head, until finally the rest of the figure must be redrawn at a larger size.

No artist is free from this malady. I know myself too well, and to counteract this tendency I draw lines at the top, bottom and middle of my figures when I sense my proportions going awry. Whether you are a beginner or an advanced artist who is continually dealing with this problem, draw these lines near the outset of the drawing process. Then if you find your face or figures expanding even a little beyond these lines, resolutely and bravely enforce a hard-love discipline on yourself.

With head drawing, this usually means first revisiting the size of the nose since all the other features radiate off this central point. Indeed, when initially laying in the proportions of the face, it's a good strategy to put more work into the nose once you start delving into the details. Of course, you don't want to spend all your time on the nose. To maintain your objectivity and a gestural quality in your drawing, always move around the face and figure when working on specifics. But once the size of the nose is set, compare all the other features to it. If you're vigilant, you will likely catch an improperly sized feature before its stealthy effect cascades throughout the features and body with increasing magnitude.

Head of Constantine the Great
Sculptor unknown, early fourth century, marble, 8"(20cm), collection of Capitoline Museum, Rome, Italy, photo by Jean-Christophe Benoist

This fragment is quite overwhelming when seen in real life. You can imagine its effect years ago when viewed in its full-figured whole. It towered over all visitors to the Basilica of Constantine where this colossal, powerful piece of art and propaganda originally stood.

Apply Purposeful Exaggeration

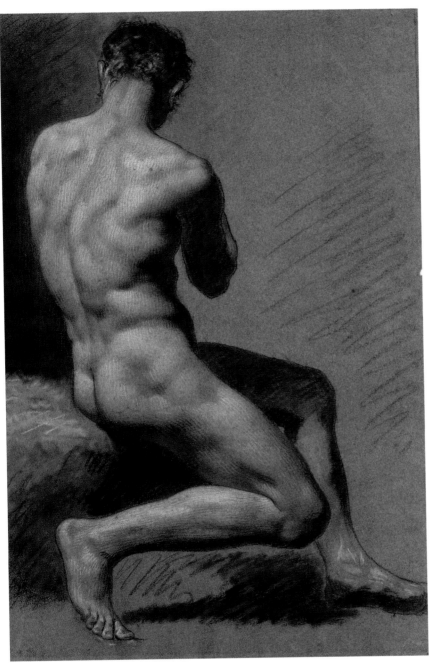

Académie of Seated Man Seen From Behind
Pierre Paul Prud'hon, black and white chalk on blue paper, 17³⁄₁₆" × 11³⁄₁₅" (44cm × 28cm), collection of Musée Bonnat, Bayonne, France

Notice how one form leads into the other. Take a close look at the values surrounding the spine and the way they progressively change direction and lead into the neck. Note how the ears, placed high on the head, effectively suggest the model's downward gaze, even though Prud'hon barely showed a glimpse of his face.

You might find yourself justifying an overly large head size by arguing "Well, some people just have large heads!" Think—and look—again.

Proportional relationships tend to reoccur throughout the body. There are no absolute rules, but when someone has a seemingly large head, many of their other subform proportions tend to be stocky as well. Among adults, our bodies can range anywhere between six to eight heads tall. If you wander beyond that limit, you surely need to take a second look at your subject to be sure you're not fooling yourself.

Like Sargent, you may purposely choose to elongate your figure by giving your drawing a small head—many of his figures are nine or ten heads tall and quite plausible. Like him, just be sure to equally lengthen all the other body subforms. Nothing looks sillier or more stilted than a tiny pinhead on a hulking body or inconsistently exaggerated body parts. On the other hand, don't fall prey to the opposite problem—making a head too large—to try to compensate for a heavy or muscular body type. Even if you want to embellish the muscularity or heaviness of the body forms, you must pay particular attention to the way the full neck tucks dramatically into the front of the diminutive head on a large, heavy model and the way the thick shoulders of a muscular model taper gradually into the back of the normal-size skull.

Elements of Head Structure

Light Source

The more you work in a representational manner, the more you need to consider the underlying structure of the head and figure to keep your drawing robust and exciting. Your choice of lighting is a crucial factor, particularly when working tonally with value masses. Other artists may make different, equally valid choices, but I deliberately place my light source off to one side and above the model for the maximum dramatic and form-making effect. I limit my illumination to a single source, and I position it so the shadows break decisively along the edge where the major front planes and side planes meet.

The Egg Effect

Shapes, proportions—everything seems to measure correctly, and you know for a fact that your drawing is not larger than life. You even take a second look at the relationship of the front plane to the side planes, but your head and figure still appear dull, flat, disjointed and not quite a likeness. So what's wrong?

Chances are you missed the "egg effect," the spherical form that underlies the more angular planes of the face. Close attention must be paid to the subtle play of graduating light as it crosses over the width and length of the egg-like head. The head doesn't just corner from the front to the side planes, it also curves within the big planes from top to bottom and side to side. It's sometimes hard to discern, but the light tapers subtly darker as the underlying sphere turns away from its source.

If you have a hard time seeing this for yourself when working from a live model, try cutting a couple of holes in a piece of paper. Hold the paper in front of the model's face, and keep moving it back and forth until one hole isolates the light of the forehead and the other hole isolates the light on the chin. When working from photos, you can usually discover this cascading light effect by turning both the photograph and your drawing upside down.

Necks

If heads are fundamentally egglike, necks are basically cylindrical. Try not to disturb their underlying

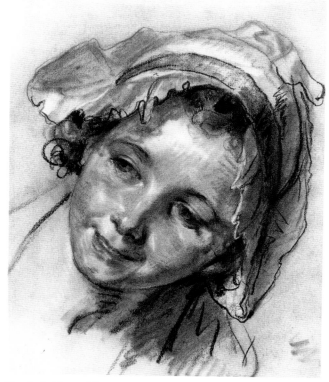

Head of a Young Woman
Jean-Baptiste Greuze, 1765, black and white pastel, charcoal, red chalk, 13½" × 10¼" (34cm × 26cm)

Greuze treated the shadow running through the young woman's face simply and graphically. He knew that light illuminates detail, while the absence of light obscures visual information and leaves the shadow in a relatively passive state. He reserved most of his subtle details for the light side and rendered the forehead in a dramatically bright highlight that tapers into progressively darker values, as the face gradually curves egg-like away from the light and recedes into the halftones of the chin.

shape by overplaying the sternocleidomastoids, those straplike muscles that straddle the throat and support the head. Like the subforms of the facial features, these muscles sit on the curving cylinder of the neck and should participate in its graduating value changes. Remember also that these two muscles are antagonists and work as a team. Immobility occurs if they both contract at the same time. This means you can't render both muscles in equal definition, at least if you're trying to show the head in motion. When one of them contracts

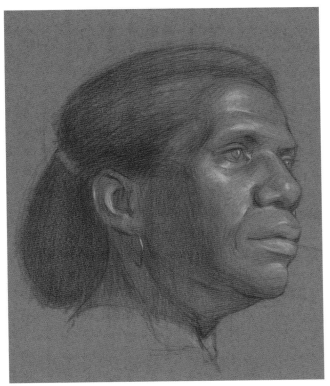

Drawing of Donna (detail)
Dan Gheno, 2006, colored pencil with white chalk on toned paper,
10" × 7" (25cm × 18cm)

It's important to study and understand the muscles of the neck, but don't let your interest in anatomy obscure the neck's underlying cylindrical form.

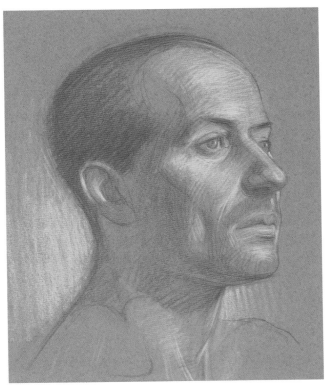

Drawing of Daniel (detail)
Dan Gheno, 2006, colored pencil with white chalk on toned paper,
11" × 10" (28cm × 25cm), collection of the artist

The muzzle is very small on the human face, but it exists nonetheless, growing out of the base of the nasal bone and encompassing the projecting area of the nose, dental arch and chin.

and bulges out, pulling the side of the head toward you, draw the other muscle more relaxed and less defined.

When working from life, you should also expect some movement in the pose if the model's neck is twisted to an extreme degree. Always anticipate some unconscious movement of the head and neck toward a more centralized position.

While paying heed to its cylindrical character, notice that the neck isn't a telephone pole shooting perpendicularly into the head. Observe how the neck projects diagonally from the shoulder into the base of the head, pushing the head forward. This dynamic, diagonal relationship is most clearly identifiable on a side view, but as you likely know from experience, it's much more difficult to grasp on a three-quarter view. You'll know only too well when you've missed the neck slant. The head will often seem mashed into the neck, and both the head and the neck will seem off center, placed too far over to one side on the shoulder. To correct this problem, try concentrating on the throat instead of the outside edges of the neck. Draw upward from the

pit of the neck, along the forward edge of the throat, until you reach the under plane or canopy of the chin, and add the outside lines of the neck later. Whatever you do, avoid the static, lollipop look that comes from drawing the front and the back of the neck reaching into the head at the same parallel level. In reality, the back of the neck intersects the skull much higher up than the front of the neck, often aligning with the base of the nose when the face is on an even keel.

Age and Folds

Age and weight play an important role in the dynamics of the face, its structure and its emotional expression. The older we get, the more our skin drapes, with creases occurring at right angles to the shape and action of the muscles underneath. The zygomatic muscles, running from the cheekbone to the corner of the mouth, have the greatest influence on the face, so when they contract, they also produce one of the strongest folds, the *nasolabial furrow*. Seen from behind, as in von Menzel's *Friedrich Karl, Prince of Prussia*, this fur-

row seems to visually connect with the cheekbone and partially eclipses the nose itself.

I've been fascinated by facial folds for most of my life, ever since I saw Stephen Rogers Peck's wrinkle chart in his book *Atlas of Human Anatomy for the Artist*. Using his seminal diagram as a base, over the years, I've tried to catalogue how these furrows interact with one another when the head moves and how they vary among different ages and weight types.

Like cloth drapery, facial folds follow dependable rules, originating at certain bony points and compressing and stretching at other dependable landmarks (Figure C). Then of course there are the effects of gravity on the face. If your model lies down to one side, the muscles and folds of the face will droop downward under the force of gravity. Even a wrinkle-free child hanging upside down on monkey bars will look quite different than when sitting up straight in a chair.

If you develop an interest in facial folds as I have, try not to overdo it. Sometimes folds are barely visible when a face is turned into the light, and that is especially true for younger people. As you work, keep in mind that there are no concave forms on the human figure. Don't cut inward when you draw one furrow meeting another or when bone meets flesh. Nothing ages a model faster than when an artist tries to emphasize a person's cheekbones by cutting inward under the bone or when drawing what appears to be a dip below the bone.

Bone Structure

The cheekbone, or zygomatic bone, is just one of many bones that compose the skull and serve as the foundation for the human head. Buy a skull and fill your sketchbook with skull drawings rendered from all standpoints: the top, back, bottom and sides. In fact, take off the skullcap and do some drawings from within.

You will probably learn something new each time you sketch the skull, including how it reaches its fullest, widest point in the back of the cranium at the parietal eminences above and behind the ear, or how the cranium takes up more than two-thirds of the skull. Don't worry about making the sketches finished, polished products. Any scribble will suffice, and any amount of time will do even if it's less than five minutes. The goal is to acquaint yourself thoroughly with the head's bony structure so you can attack the living, flesh-covered skull with more confidence and instinctual understanding.

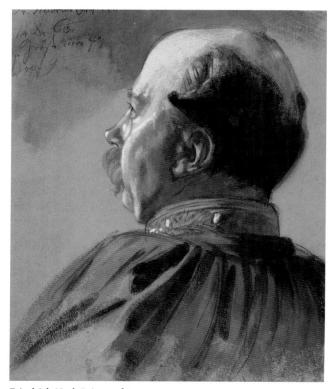

Friedrich Karl, Prince of Prussia
Adolf von Menzel, 1863, gouache over graphite, highlighted with white, 11⅝" × 9" (30cm × 23cm)

Notice how, from behind, the nasolabial furrow obscures some of the nose and mouth and seems to unite optically with the cheekbone and the rim of the eye. This connection helps to push the nose back and, along with several other overlapping shapes, reinforces the roundness of the underlying egg-shaped head structure.

Money shouldn't be an issue. Many art stores sell inexpensive, usable plaster and plastic casts; you can always visit a natural history museum to sketch one there; or, if you're truly strapped, you can buy an inexpensive model kit from the hobby store. At the very least, you can work from an anatomy book borrowed from the library.

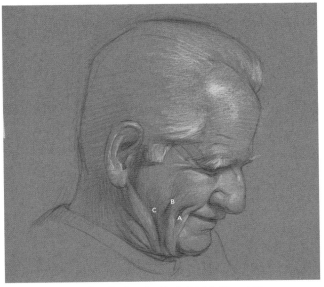
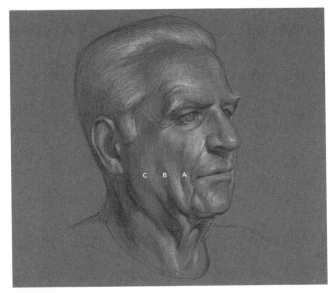

(Figure C) My Father Posing for Facial Folds (1 and 2)
Dan Gheno, 2006, colored pencil and white charcoal on toned paper, 9" × 12" (23cm × 30cm), collection of the artist

Facial folds occur at right angles to the direction of the muscles underneath, very similar to a theater curtain being pulled across the stage by a horizontal cord. The zygomatic muscle runs from the cheekbone to the corner of the mouth and, when contracted, creates depend-able creases in the face, the most important being the nasal labial furrow, the jugal furrow (A) and the accessory jugal furrow (B). Note how the shape of the large chewing muscle, called the *masseter* (C), becomes more defined when the chin is pulled in.

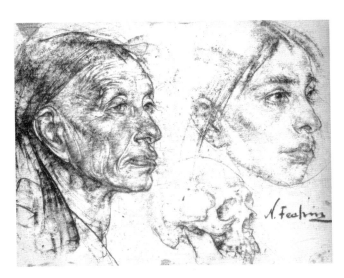

Heads and Skull Study, Indian Sketches
Nicolai Fechin, C. 1933-1955, charcoal on paper, 13" × 16¾" (33cm × 41cm), Galina P. Tuluzakova, image reproduced by permission of Fechin Art Reproductions, "The Drawings of Nicolai Fechin," fechin.com

In one eloquently composed drawing Fechin showed the underlying skull structure and the various effects of age on the human face.

Quick Drawing of Skull From Sketchbook
Dan Gheno, 1995, graphite, 9" × 12" (23cm × 30cm), collection of the artist

My sketchbooks are filled with quick sketches of bones, muscles and other anatomical details. It's important to learn about the head from the inside out starting with the bones so you have an understanding of the head structure from all viewpoints.

CONSTRUCTION OF THE HEAD

MATERIALS LIST
Colored pencils

Graphite pencils

Drawing a dynamic head is not just a matter of impassively transcribing the visual shapes your eyes see. It's extremely helpful to think of the head's underlying bone and planar construction as you draw those visual shapes. You can better educate yourself to the head's volumes by frequently drawing from a skull. A plastic, lifelike skull is one of the most important items a figurative artist can own—I have one on my desk that I regularly practice sketching from when I have a free moment. You should also draw from sculpture in a museum as often as you can, and consider investing in a simple block head, similar to the imaginary one in my demo sketch.

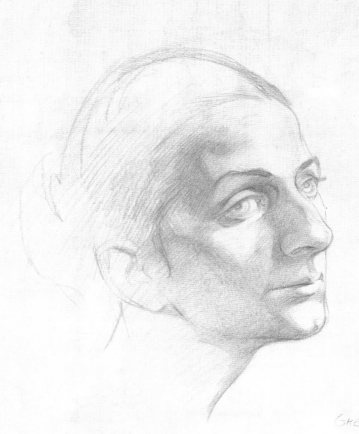

Watcher
Dan Gheno, colored pencil, 1990, 9½" × 8" (24cm × 20cm), collection of the artist

Getting a Likeness
When trying to seize a likeness, use standardized proportions as a jumping off point. The classically proportioned face can be divided into three equal parts (hairline to eyebrows, brows to nose base, base of nose to chin). Of course, the living human being will always differ from these proportions in some way. But starting from these generalized proportions, you at least have a measuring stick to compare your model against, to decide where your model's face diverges from the classical norms. Notice here, that the mouth unit or muzzle is slightly shorter than the other facial units and the nose unit is larger than both the mouth and forehead units.

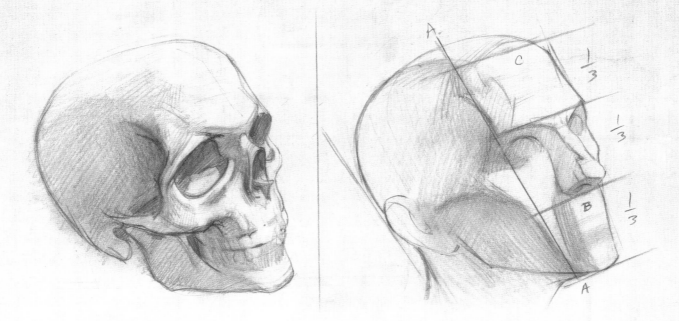

Identify the Planes

First, look for the big, important plane changes—front, side, back, top and bottom. Then look for the secondary plane movements that sit on these primary planes, like the cylindrical mouth unit (B), or the rounded frontal bone (C). Notice how shadows mirror plane or form changes. Where the planes corner decisively, the value changes markedly. Where the plane changes are softer, the values make a smoother transition. The highlights tend to occur at the plane breaks and bony ridges and specific features, such as the nostrils, eyes and lips stay subservient within their underlying planes and values.

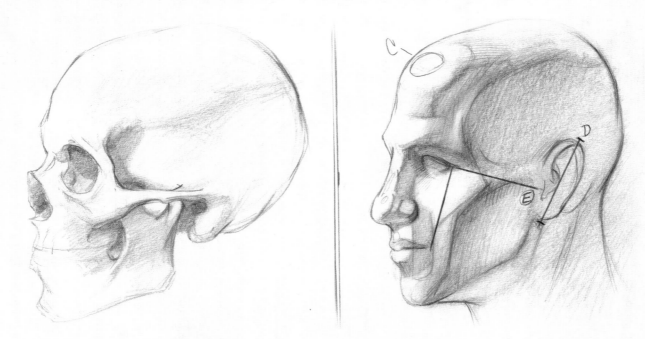

Find the Correct Distance

On a side view, the ear is usually located obliquely (D) and behind the mid-point of the head width. The distance from the ear to the outside of the eye is often the same as the distance from the eye to the outside of the mouth (E). From the front or a near front view, there is usually one eye's width between eyes. The outside of the nose usually lines up along a plumb line with the inside of the eye and the outside of the mouth unit usually lies directly below the center of the eye. Notice that the cranial mass takes up a great deal of the skull mass and reaches its peak in height and width a little behind the ear.

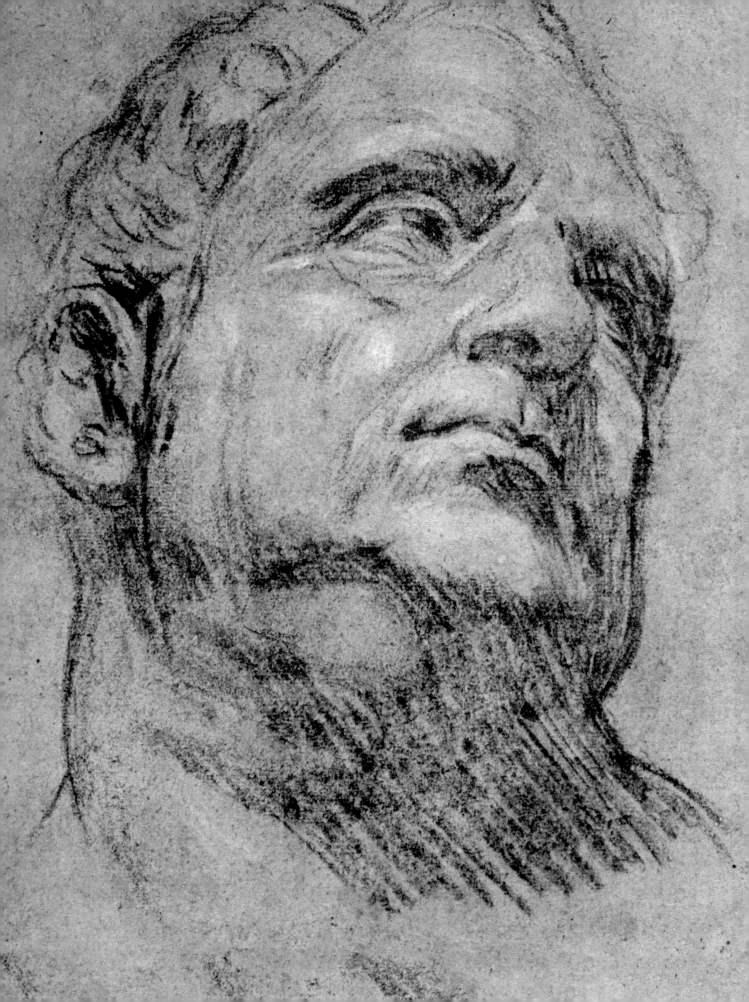

Consider Alternate Points of View

As admirable as doing so may seem, don't concentrate exclusively on the front of the face and its features in your studies. If you want to impart a dynamic look into your figure drawing, you need to understand all aspects of the human head as seen from all points of view. When drawing the head from behind, notice how large the back of the head looks compared to the face. When drawing a reclining figure that's head-first, you'll likely find the features mostly eclipsed by the brow ridge and the cranial mass above. The nose often extends far beyond the nearly invisible dental arch in this sort of extreme, foreshortened position. Ironically enough, when you draw a feet-first, reclining figure, you will frequently notice the nose extending far above the receding forehead. In any of these unusual positions, always make a comparative measurement of the features against the cranium to be sure that you are capturing—or, if you want, exaggerating—the correct proportional relationships.

<div style="border:1px solid #000; padding:1em">

Foreshortening Exercise

If you have a difficult time seeing and drawing the nose close to the eye, try this exercise: Find a photo of a foreshortened face and draw it freehand, concentrating on the eye-nose relationship. Then, trace the photo and compare the two drawings, noting where you may have inadvertently increased the eye-nose distances in your first drawing.

Keep repeating the exercise with other photos until you conquer your habit of distortion.

</div>

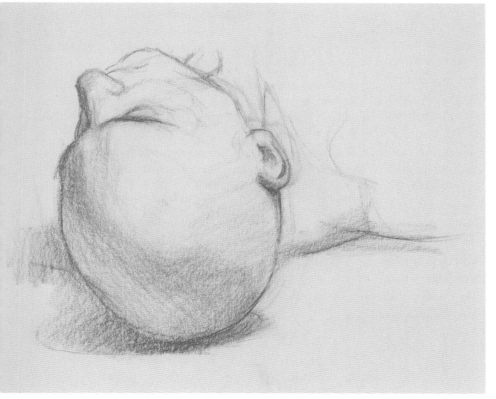

Skull From Above
Dan Gheno, 2006, colored pencil, 4" × 5" (10cm × 13cm), collection the artist

Purge your mind of preconceptions when drawing the head from an odd angle; for example, the face is barely visible when the head is seen from above.

Head of Vitellius (opposite page)
Jacopo Tintoretto, ca. 1540-1580, charcoal with white chalk, 13" × 10" (33cm × 25cm), collection of Pierpont Morgan Library

On the other hand, when the face is viewed from below, the chin and jaw loom large and the nose swings upward, sometimes nearing or overlapping the eye.

Express Emotion With a Head Tilt

As you know, you can use the features and contort them into all sorts of symbols to achieve emotion. This can get awfully melodramatic and lead to a visually flat image. A simple tip of the head can do so much more with almost no twisting of the features.

Admittedly this simple task is easier said than done. It's easy enough to see that when the head turns upward, the ear drops downward and vice versa. But many artists freeze when they look at a tilted head, unsure of how to use the other basic guidelines that help keep the features in their proper bilateral position. The answer is to tilt your measurement guidelines running along with the cant of the head. So if you want to judge the position of the mouth as it relates to the iris, draw a guideline slanted with the tilt of the head, from the iris to the mouth. If you want to measure the position of the eye, drag a tilted line up from the outside of the wing of the nose toward the inside of the eye, and so on.

A foreshortened arm or leg is difficult enough, but the most difficult body part—and probably the most dynamic of all the head positions—is the view of the head from below. Many artists draw the upper facial mass too large in this foreshortened position, usually increasing the distance between the nose and eyes, and often shortchanging the chin. You need to remember the underlying egg structure of the head. The chin is curving toward you, so it's much larger in this low-level view than you might imagine. Conversely, the forehead is curving away, so the head shrinks visually as it rounds out toward the hairline. Meanwhile, the nose swings upward off the underlying curve of the face, even in a straight-on view, and when it is highly foreshortened, the nose often seems to jut out in front of the eye in a three-quarter view. Foreshortened or not, it's helpful to compare the position of the eye to the junction point where the forehead dips to meet the nose. The upper eyelid is either above, alongside or just below this point.

Ethel Smyth
John Singer Sargent, 1901, black chalk, 23½" × 18" (60cm × 46cm), collection of the National Portrait Gallery, London, England

From a low, three-quarter view, the lower face looks quite large as the spherical shape of the head curves toward you. On the other hand, the forehead looks rather small and the nose jumps up in front of the far eye as the head rounds out away from you. Don't inadvertently lengthen the top of the head and shorten the lower area to conform to your subconscious preconceptions.

Old Man With His Arms Extended
Rembrandt, ca. 1628–1629, black chalk, 10" × 7½" (25cm × 19cm), collection of Kupferstichkabinett, Dresden, Germany

Don't just look for a likeness in the features; look for an attitude and gesture that runs throughout the body, culminating in the head.

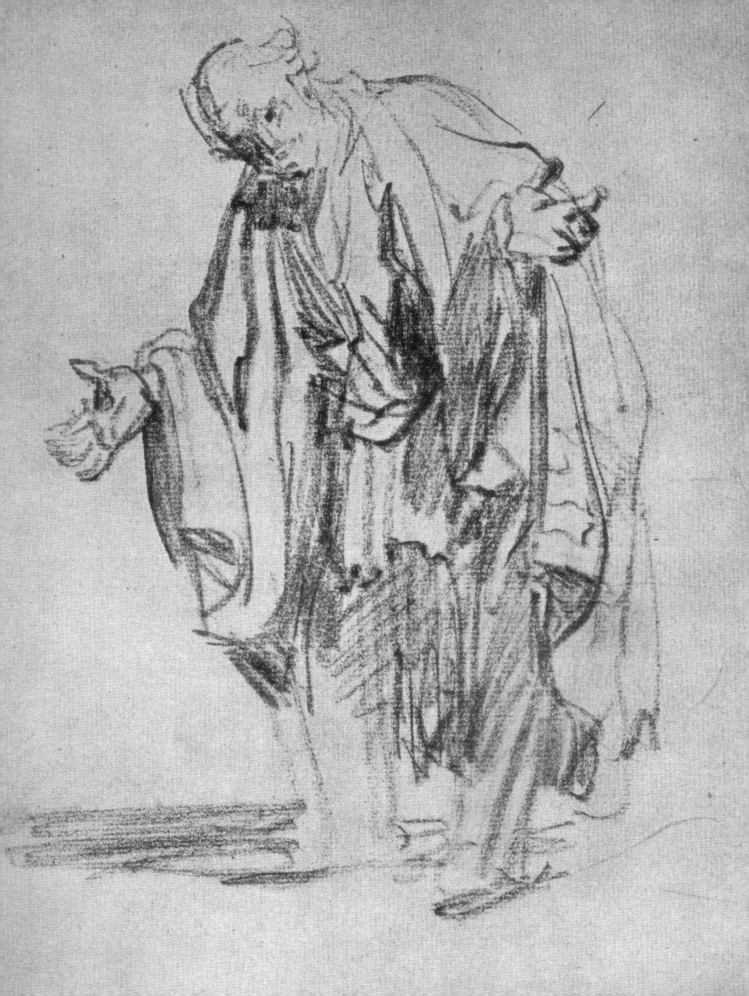

The Nobility of Head Drawing

Sometimes, when doing a full figure drawing, it's best to start with the body and gradually work up into the head. You can measure the size of the head against the neck by drawing some imaginary lines that lead upward, off either side of the neck. Ask yourself how much head you should draw to the outside of each of these two construction lines.

But don't let other artists chide you for concentrating on the head or—heaven forbid—"portrait drawing." You can say a lot with an intensely observed drawing of a simple, isolated face or head. The *Mona Lisa* or one of Rembrandt's self-portraits says more to me about the multilevel, universal human condition than any book I've ever read. You know the power firsthand: How many times have you shuddered painfully when a friend sarcastically rolled their eyes or slightly cocked their mouth to one side in derision? On the other hand, how wonderfully bracing it is to look into a loved one's dilated eyes and, to borrow from a corny song, gaze at their unconscious, subtle *Mona Lisa* smile!

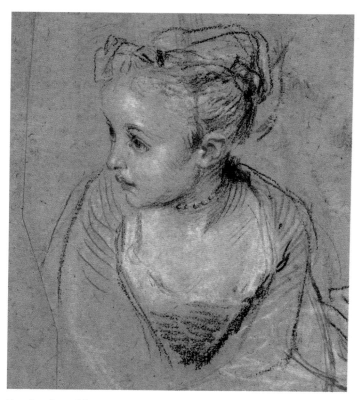

Two Studies of the Head and Shoulder of Little Girl (detail)
Jean-Antoine Watteau, ca. 1717, red, black, white chalk on buff paper, 7⅜" × 9½" (19cm × 24cm), collection of Pierpont Morgan Library, New York, New York

Always look closely at the periphery of the face. Study how Watteau drew the far eye and eyebrow in this drawing. Approach your own head drawings like he did, finding the subtle overlaps and the delicate forms that often lurk behind the horizon of a spherical face.

Stereometric Man
Albrecht Dürer, 8⅛" × 11½" (21cm × 29cm), from the artist's Dresden notebook

Put Your Head in a Box

Use perspective to better gauge the tilt of the head by trying to visualize the head encased in a box, as Albrecht Dürer illustrated in his notebooks. It's easier to imagine a box tilting in space, with opposite sides slanting at near parallel angles. This helps you remember that if the front of the face is angling down, the back of the head follows the same slant.

If you are imagining the head encased within a box, you'll also remember to tilt the top and bottom of the head as well. It also helps to use perspectival tracking lines to align the features as they recede into space. Keep in mind that these imaginary perspective lines converge downward if you are drawing the face from below and converge upward if your eye level is above the model.

Portrait of H.E.C.
Maximilien Luce, black chalk on buff paper, Robert Lehman Collection

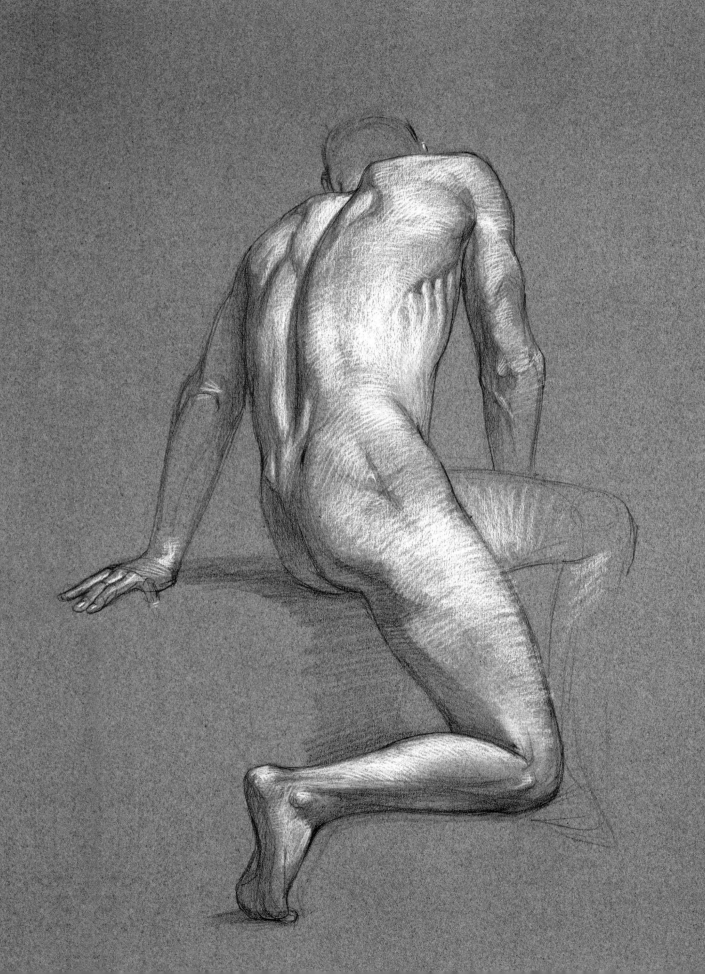

7 Putting Together the Human Form

In this tutorial overview of the figure, you'll learn how to analyze and correctly draw different areas of the body and then bring it all together.

You wouldn't build a house without referring to a blueprint or try to take a trip without consulting a map, anymore than you would set up your DVD player without looking at the instruction manual. Or perhaps you would—resulting in a clock that flashes 12 A.M. in perpetuity and a timer-record function that never seems to find the channel or program that you want.

Many of us approach figure drawing the same way, as if trying to reinvent the wheel each time we sketch the human form. A multitude of helpful guidebooks provide crucial information about the figure and its underlying structure and overlying surface features. Artists have compiled this hard-wrought information over several centuries of looking and analyzing, each generation of artists building upon the previous generation's discoveries. This knowledge can be found in the many artistic anatomy books on the market, but most of them go unread by the average art student and by many art professionals fearful of squelching their creativity.

It's true, a little bit of anatomical knowledge can be a very dangerous thing. A cursory study of the subject can result in stilted, overworked and muscle-lumpy drawings by an artist infatuated with new-found knowledge. I learned this the hard way when, at ten years old, I tentatively began my study of anatomy.

After flailing about for months, memorizing muscles and drawing rubbery, flaccid drawings, I realized that I needed to reboot my studies. I began concentrating on the skeletal underpinnings of the human form as all the anatomy books recommended. And soon I could see the results of my study: more rhythm and a sense of volume in my figure drawings.

It would be impossible to present all the art world's accumulated knowledge of the human form in one book, let alone in this one chapter. Whether you're interested in drawing the figure in a traditional or expressive manner, it helps to read as many different anatomy books as you can stomach. Every book repeats a certain core of information, but each book presents some surprises and reveals juicy facts missed by others. I hope the following serves as a road map that helps get you started on your own voyage.

Weighted Stasis
Dan Gheno, 2006, colored pencil and white charcoal on toned paper, 24" × 18" (61cm × 46cm)

115

Familiarize Yourself With the Core Figure

The core figure, as I call it, is the most important part of the human form. Built from the chest and pelvis, the core figure serves as the hub or the trunk from which all else emanates including the entire gesture or posture of the figure, not to mention the neck and head, the arms and hands, and the legs and feet.

As I've mentioned previously, it's extremely important to note that the chest and pelvis move in opposition to each other. They never sit straight, one above the other. In a standing position the chest usually tips backward, while the pelvis tilts forward. Meanwhile, in a seated position the pelvis usually tips rearward and the chest slumps forward. No amount of detail will save your figure drawing if you don't grasp this fundamental gesture of opposition.

It's sometimes difficult to perceive these relationships while drawing the human figure, especially if you're not familiar with the supporting skeletal forms. Many of my beginner students exclaim in frustration, "I hear what you say, but I can't see it—it looks like a jumble of bumps to me!" In response, I point out the visible, bony landmarks or muscle forms that can be used to analyze the tilt of these forms.

On a standing figure, notice how the stomach muscle turns dramatically inward under the belly button. In the rear, the posterior pelvic crest is often visible on a thin model, tilting forward in an almost parallel thrust to the stomach muscle. Even on a full-sized model, the upper buttocks, or gluteal muscles, tends to follow the tilt of this pelvic crest underneath. Next I look at the breastbone or the bony surface of the rib cage sitting between the breasts and pectoral muscles. On a standing figure this bony landmark always shifts backward toward the top. On the back of the torso you can almost always see at least an echo of the lower rib cage's structure underneath, even on a heavy model. This slightly curved form tips forward in near unison to the slant of the breastbone on the front of the chest. For both the chest and the pelvis, these front and back bony landmarks act like the parallel, vertical lines on a box. And when these two simulated box-like structures of the pelvis and chest are stacked in opposing angles to each other, they create a dynamic contrapposto.

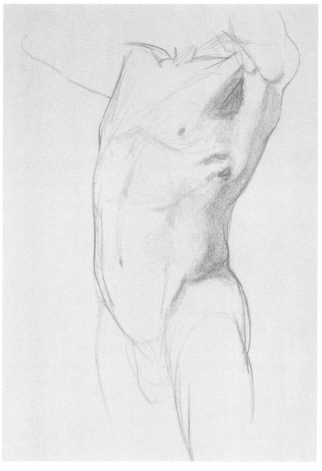

Outreaching Figure
Dan Gheno, 2005, sanguine crayon, 12" × 8" (30cm × 20cm)

Sideview of the Muscles of the Body (opposite)
Jan Wandelaar

The key to using anatomy in your figure drawing is to learn it so well that you can forget it. That way, it doesn't interfere with your creative impulse, allowing your subconscious to quietly and spontaneously provide the technical information when you need it. This chapter will utilize anatomical terms now and then, but you needn't worry, you won't find them at all intimidating if you refer to Wandelaar's elegantly simple diagrams.

Muscle names: A) serratus anterior, B) external oblique, C) pelvic or iliac crest with the posterior crest to the right of tag and the anterior crest to the left, D) deltoid muscle and E) extensor muscle group.

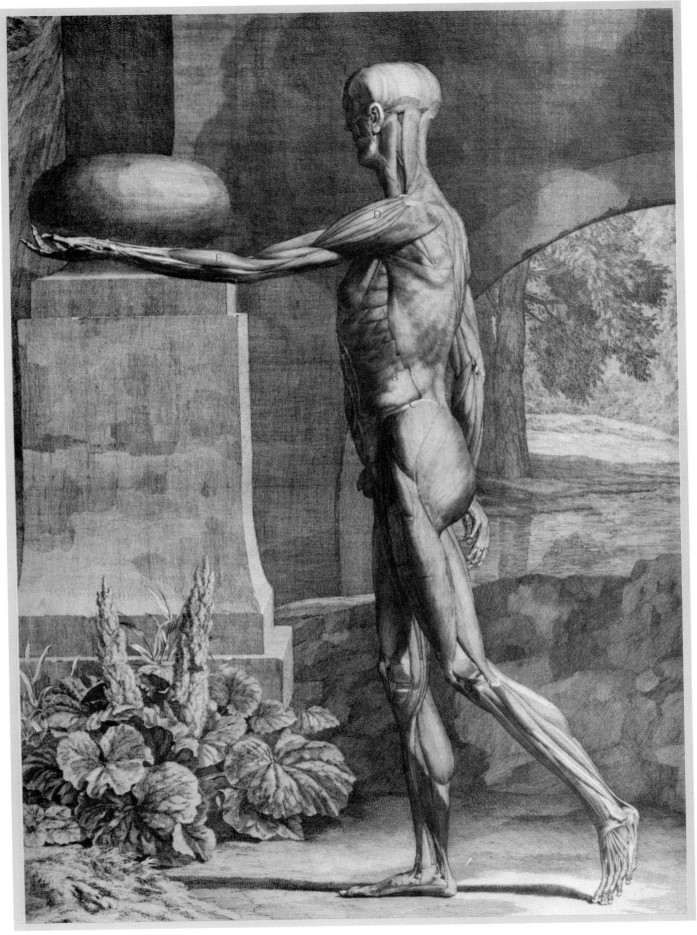

Front View of the Muscles of the Body
Jan Wandelaar

Wandelaar drew a series of anatomical plates for Albinus's influential book on human anatomy over the span of more than twenty years. Albinus gave great credit to the artist of the copper plate engravings that filled his book, *Tabulae Sceleti et Musculorum Corporis Humani*. But Albinus felt that he, himself, was the ultimate author of the images, explaining that the artist "was instructed, directed and entirely ruled by me, as if he was a tool in my hands, and I made the figures myself."

Muscle names: F) flexor muscle group, L) linea alba, N) infrasternal notch, P) patella, S) suprasternal notch and the top of the sternum or breastbone, T) inner end of the tibia, I) area near the midpoint of the body, close to the trochanter and slightly below where one of the major front leg muscles (rectus femoris) enter the pelvis.

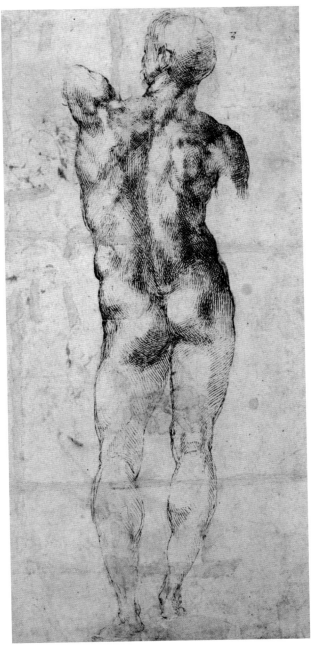

Standing Male Nude From Rear
Michelangelo, ca. 1501, chalk and bistre, 15" × 7⅜" (38cm × 19cm), collection of Albertina Museum, Vienna, Austria

arms or deltoids and, bordered by the collarbones, or clavicles, continues to descend toward the centerline. Along with the neck that sits obliquely upon its slanted form, this top plane acts like a natural cross-section that reveals the full depth and volume of the torso. It's also crucial to the overall gesture of the figure; it provides another reference point for the tip of the rib cage, just as drawing the top or bottom plane of a box helps to show the form's tilt in space. Too many artists draw the collarbones horizontally straight across the torso, cutting off the depth of the plane and producing a paper-thin, cutout version of the torso. About the only time the collarbones look straight or seem to curve severely upward is when you look at them from a lower angle or when the figure is leaning back away from your point of view.

Once you've established the overall gesture of the core figure, you need to look deeper into the supporting structure. Find the centerline first, whether you're drawing a front or back view of the torso. On a back view you can see the centerline reflected in the central structure of the spine itself. The frontal centerline is a little more difficult to find, but it is implied in the bony space between the breasts and runs down the middle of the stomach, or the rectus abdominus. On thin or muscular models you can often see the centerline running through a vertical line, the linea alba, that divides the stomach muscle. The chest and the pelvis are built upon a bilateral structure, which simply means that one half of the form mirrors the other. But be very careful when drawing the centerline. We usually see the torso in some sort of perspective recession. That means that the far side of the form, past the centerline, will take up less space. Even many advanced artists forget to consider perspective. Some of them think the centerline is too elementary to worry about, but in their haste, they often make the far side of the core figure too big. Nevertheless, don't worry if you fall into this trap. Your gut will tell you that something is wrong, and once you run a belated centerline through the torso, you're more likely to catch and correct your mistake.

So far, we have considered only the front and back planes of the torso. Most artists remember to draw in the side planes that run up and down the torso since the big light and dark shapes tend to break at this point. But although many of these artists know that the torso has a top plane, they frequently forget to draw it.

The top plane can be envisioned as a sort of sloping tabletop that begins at the top of the shoulder, or trapezius. It wraps downward across the top of the

Achieve a Realistic Likeness

Slumping Figure
Dan Gheno, 2006, colored pencil, 12" × 14" (30cm × 36cm)

In this slumping figure the pelvis tips backward and the chest tilts forward, which compresses the abdominal area in between.

Although these center guidelines will work on all figures, even still-life objects, there is no such thing as a generic core figure. Simply put, seeking a distinct, torso likeness is similar to drawing a facial likeness. Start by dividing the torso into three segments, estimating which distance is longest and which is shortest. If you can't find the likeness at this broad level, you never will, no matter how many details you throw into the torso.

The first segment begins at the pit of the neck, or suprasternal notch and ends below the nipples at the infrasternal notch. The second begins at the infrasternal notch and ends at the navel, and the final section starts at the navel, and finishes at the pubic bone. Once you establish this basic framework, you can go to town on the details.

But proceed with caution! Some artists get too hung up on the details, especially the breasts and shoulder blades. Most people have a tendency to draw the breasts too large or skimp on the rib cage so that the breasts seem to float outside of the torso with no base of support. With equal frequency, artists tend to draw

the shoulder blades too small and tight to the torso, not leaving enough room for the rib cage. I usually ignore these details when I first set up a drawing of the core figure.

Instead I concentrate on establishing the underlying curves of the rib cage, drawing through the positions of the breasts and shoulder blades. Then, with this supporting surface to work with, I add these superficial details on top. On your drawings of the female form, don't forget to add a little extra bulk for the pects above the breasts. Above all, trust your eyes! Even though the word *bilateral* implies an absolute symmetrical relationship between each side of the torso, there is always some variation from the norm with one breast usually a little

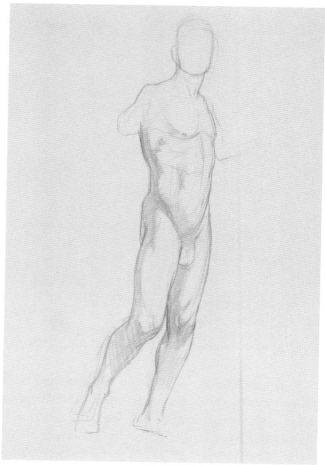

Gesturing Figure
Dan Gheno, 2005, sanguine crayon, 23" × 15" (58cm × 38cm)

In this drawing I first imagined the underlying structure of the core figure, or torso, before drawing the overlapping foreground arm.

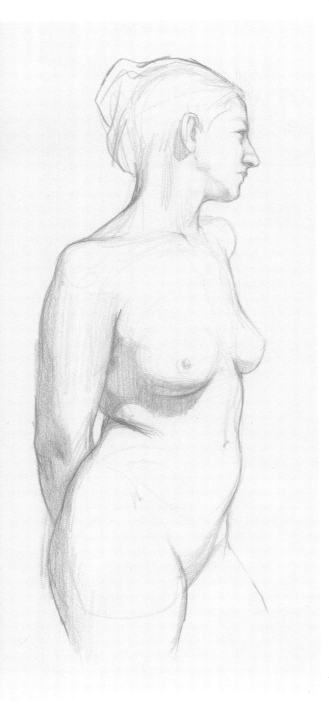

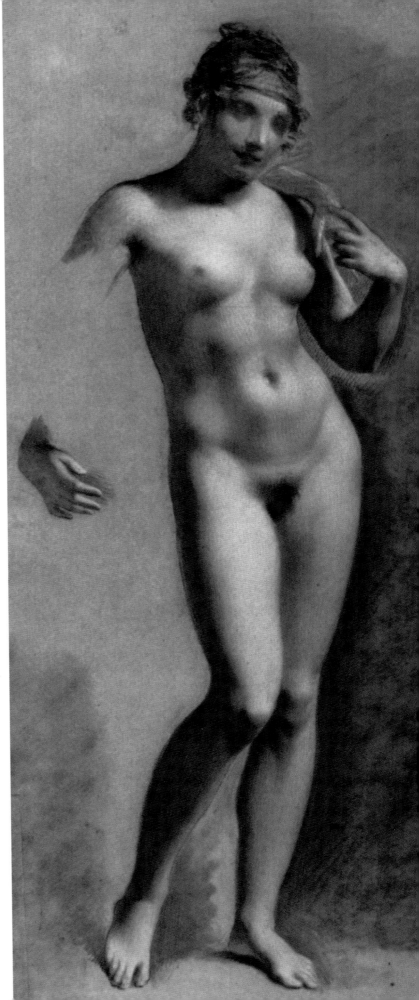

In the Distance
Dan Gheno, 2005, colored pencil, 11" × 8" (28cm × 20cm)

Female Nude Study
Pierre-Paul Prud'hon, 1809, chalk on blue paper, 23¼" ×
12½" (59cm × 32cm), collection of the Pierpont Morgan
Library, New York, New York

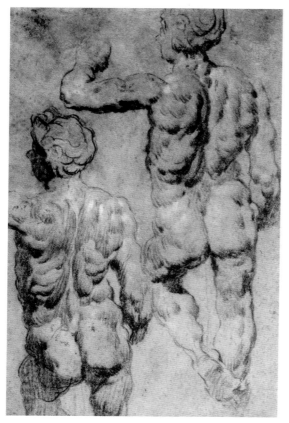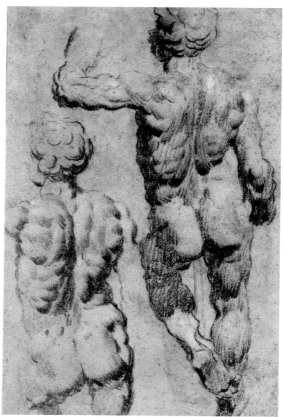

Two Studies of an Ascending Male Seen From Behind
Jacopo Robusti, il Tintoretto, ca. 1540, charcoal with white heightening, 10½" × 15¾" (27cm × 40cm), collection of Krugier-Poniatowski

Tintoretto drew the figure obsessively, often rendering a single pose or action several times on the same piece of paper. Perhaps this was his attempt at rehearsing his painted figures before he committed himself on the canvas, or maybe a means of cataloguing and memorizing a vocabulary of figure forms in his subconscious mind.

smaller than the other and one side or segment of the "six-pack" abs larger or more defined than the other.

The ribs are a particularly enticing and baffling detail. Many confused artists look at the ribs and see a mind-boggling webbing of details that seem to break into long and short shapes, sometimes angular, sometimes curvaceous, going in all different directions. You will find it easier to analyze them if you remember that the rib cage is basically barrel-like in structure, and that the individual ribs follow this form: starting high in the back at the spine and then curving downward toward the front, as you can see in Michelangelo's *Studies for Haman*.

The pesky complications start when you try to add two very elegant muscles to this simple mass: the serratus anterior, which grabs the ribs from above and the external oblique, which grabs from below. Luckily these seemingly complicated muscles have their own logic to guide your eye and pencil. The serratus is literally a serrated muscle with short finger-like segments that individually dig into the ribs. The overall muscle follows a dependable arc that runs from underneath the bottom of the shoulder blade and aims for the nipple in front before finally disappearing under the pectoralis. The external oblique is the form that sits so gracefully above the hips in athletic people and Greek and Roman statues. Unfortunately most of us experience this on our own bodies as "love handles." As its name suggests, this muscle rises upward toward the ribs at an oblique angle, and on well-developed individuals this muscle is also finger-like at the top. The external oblique muscle intersects the serratus above as if they were two clasped hands, folding into the same dependable, curving arc that guides the upper muscle.

Create Support for the Extremities

I like to begin my drawings of the figure with a *line of action*. This phrase, coined by Thomas Eakins, refers to a line, either imagined or actually drawn on your paper, that indicates the overall thrust and action of the figure.

The primary line of action usually runs through the entire length of the figure from head to toe, buttressed by more specific, tributary lines of thrust that run through the individual extremities.

As I move deeper into the drawing process, I concentrate on the core figure and then later move into the extremities that radiate off it. I usually shift into the supporting limb or limbs—the legs in a standing pose or an arm if the model is leaning back in a seated or semi-reclining position.

Studies for Haman
Michelangelo, ca. 1511, red and black chalk, 10" × 8" (25cm × 20cm), collection of the Teylers Museum, Haarlem, the Netherlands

When drawing a seated figure, it's helpful to compare the length of the upper and lower legs, and then compare each individual leg segment to the length of the torso.

In general, all of the body parts are well balanced with each other, capable of folding neatly into one another—with the arms and legs able to evenly tuck into themselves and the torso into the limbs.

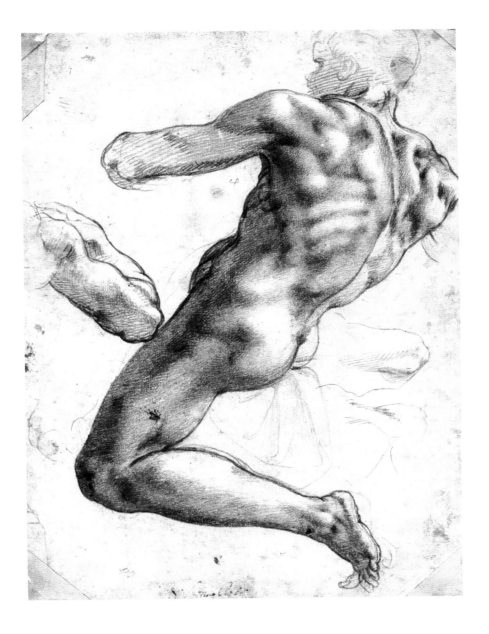

Attach the Arms and Legs

Many artists have a difficult time attaching the arms and legs onto the core figure so the limbs seem to grow naturally out of the torso in a secure, believable manner. There is an easy solution that will sound so elementary you may not want to accept it—but give it a try anyway.

In your mind's eye visualize the core figure as if it were a doll with its arms and legs removed, leaving empty, oval-like cross-sections where the limbs should attach. Then imagine the arms and legs attaching into the empty slots. This will help you visualize the relationship of the limbs to the torso's big planes.

In the arm's case it is firmly rooted into the torso's side plane, not hovering outside the chest as some people like to draw the upper limbs. The arm slides deep into the core figure and is embraced by "the shoulder girdle" with the pectorals in the front; the shoulder plane, collarbones and deltoids above; and the muscles of the shoulder blade, or scapula, behind. The arm can't move without taking portions of the torso with it. When the arm swings forward, upward or backward, it takes the shoulder girdle with it.

Notice how the shoulder blades almost touch when both arms swing back, or how the pects and the scapulas move upward when the arm does. It's interesting to note that the scapula is unaffected by an upwardly moving arm until just before the limb begins to move above the line of the shoulder.

The arm has a great deal of mobility thanks to this shoulder girdle, but when the arm hangs parallel to the body, the limb participates in the same light patterns that govern the torso, as you can see in *Indian Beggar* by Georges Seurat. And when the torso's side plane is totally in shadow, the entire arm often falls into darkness too.

It's vital to remember that arms and legs are basically cylindrical in nature regardless of their position or the lighting situation. However, the arm and legs are not simple, smooth tubular forms. Like the torso, the arms and legs are composed of many hard, sharply turning muscles and bones that cause the limbs to corner into decisive front, side and

Shadows tend to follow the exteriors of cylindrical forms, while on spherical forms, shadows cut across at right angles to the direction of the light. Arms and legs are essentially cylindrical, but they are covered by a combination of contrasting rounded and cylindrical subforms that are mostly spherical or mostly cylindrical with elements of roundness. But when you add up all the various movements of these subforms, the overall thrust of the shadow shapes tends to follow the outside of the cylindrical limbs.

Notice the dissipation of brightness as the leg gradually drops away from the source of light. Also, pay close attention to the rhythmic, back and forth movement of the upper and lower leg segments. From a side view, the upper leg projects forward in the front, while the lower leg projects backward in a kind of sinuous S or flame-like movement— never straight down like a rigid post. In a front view, the upper leg seems to cant inwards, while the lower leg seems to sit a little to the outside.

back planes, and split into equally decisive light and dark shapes.

You also need to be very careful when connecting the leg to the pelvis. Don't cement the leg to the top of the hip or pelvic crest like so many artists habitually do. This high placement of the leg doesn't leave a whole lot of room for movement in the limb. Some transitional muscles connect to the pelvic crest, but the greatest mass of the leg enters the pelvis much lower, near the halfway point of the body (I, page 118), where it has more flexibility and can pivot more freely.

Like the arm, the leg is constructed on a similar cylindrical basis subject to all the same planar and lighting effects—with one frequent exception: Most often we place the light source above the model, so on a simple, standing leg, the intensity of light usually dissipates radically as it cascades down over the long length of the limb. You will find the light much brighter at the top where the fuller mass of the upper leg turns toward the light than on the lower leg.

The foot, on the other hand, often rebounds into a little more light than the lower leg because the horizontally inclined top plane of the instep faces the light more directly than any form on the vertically oriented legs. Even if you place the light low on the ground, you will usually encounter the same effect of dissipating illumination, only reversed.

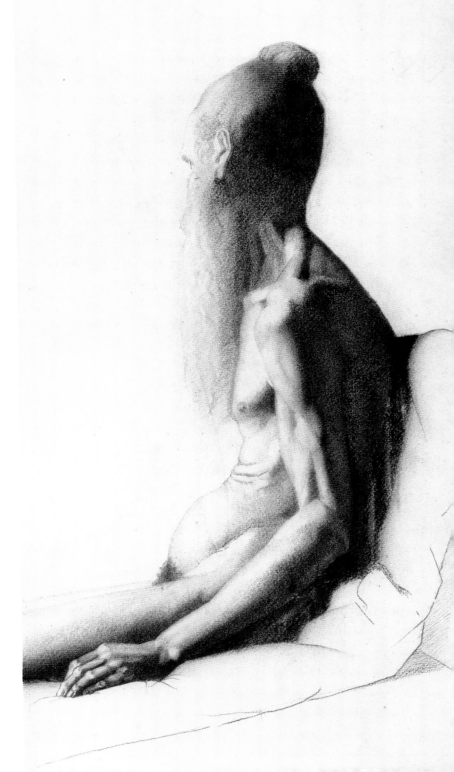

Indian Beggar
Georges Seurat, ca. 1878, graphite, 19" × 11¼" (48cm × 29cm), private collection

Note the shadow patterns on the arms compared to those of the torso.

Recognize the Underlying Bones

There is nothing rigid or straight about cylindrical arms and legs. Even so, it's sometimes hard to see the subtle, curving line of action that runs through the limbs even when they are bent upon themselves.

Looking closely, the underlying bones of the extremities curve subtly, taking the muscles on a ride with them. It can take a long time for some artists to give up their preconceptions and see these slight bends that run through the limbs. In fact, when told to look for the bowing, many artists inexplicably curve the limbs in the opposite direction. Then, when they finally grasp the concept, they frequently overdo it.

For instance, when drawing the lower arm suspended in midair, many artists look at the muscle mass that droops below the ulna and often exaggerate its appearance, drawing the overall forearm like a piece of overcooked pasta. If this is you, and you want to avoid this effect, try visualizing the bony structure underneath the

Studies of an Écorché (verso)
Théodore Géricault, 1749, pen and brown ink, 9½" × 13½" (24cm × 34cm), private collection

skin and muscle casing. Remember that in architectural terms, these bones of the limbs are essentially weight-bearing posts or columns. Built of delicately refined twists and turns, the bones coil just enough to deflect

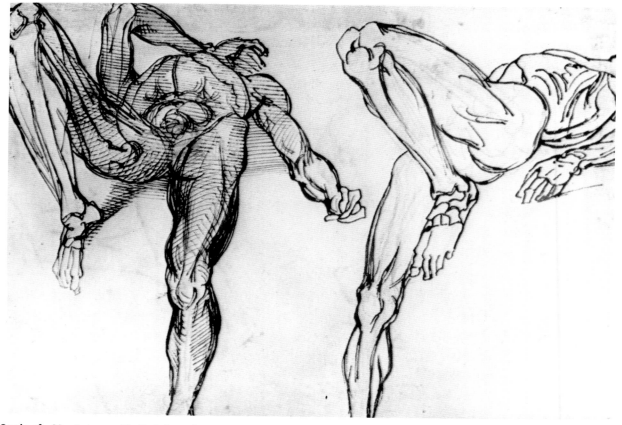

Study of a Man Lying on His Back (verso)
Théodore Géricault, 1749, pen and brown ink, 10" × 12" (25cm × 30cm), collection of Musée des Beaux Arts, Lille, France

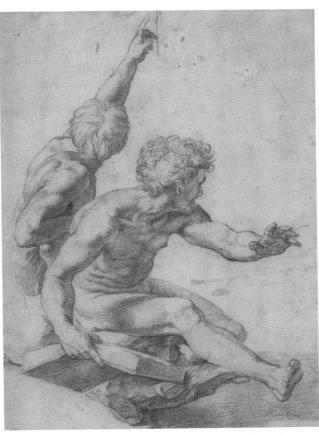

Nude Studies for Saint Andrew and Another Apostle in The Transfiguration
Raphael, red chalk over stylus on cream paper, 13" × 9⅛" (33cm × 23cm), collection of the Duke of Devonshire, Chatsworth, England

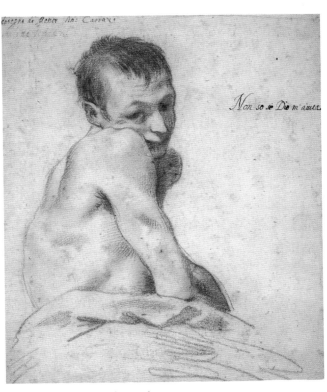

A Hunchback Boy, Half-Length
Annibale Carracci, red chalk with red wash, 10⅜" × 8⅞" (26cm × 23cm), collection of the Duke of Devonshire, Chatsworth, England

the stressful effects of the body's weight and actions outwardly away from the core of their long forms. They can't curve too much beyond their basic columnar structure, or they will snap like a twig. Another important architectural point: Avoid the equally annoying problem of drawing the lower arms and legs too thin, leaving barely enough room for one bone, let alone the two bones that support each of the forelimbs.

If you're having a hard time seeing any of this, put some tracing paper over one of your drawings and draw the bones underneath. See if your drawing makes sense and see if the subtly curving bones will fit your drawing without "breaking the bones" to make them fit a faulty shell.

Many artists loathe this exercise until they look at the anatomical sketches by Michelangelo, Leonardo and the studies for *The Raft of the Medusa* by Théodore Géricault. They knew that you sometimes have to build from the inside structure and work your way outward to find a better understanding of the surface forms and rhythms.

Depict Action and Movement

There are a lot of muscular and skeletal parallels between the arms and legs. But the legs present a much more dynamic and rhythmic silhouette, especially from a side view. The leg bones don't curve any more than the arm bones. In fact, one of the lower leg bones, the fibula, is straighter and doesn't swivel like its counterpart in the arm, the radius. But due to the massive, overlying muscles, the legs display a more dramatic back-and-forth visual relationship.

On the upper leg the larger muscles sit on the front, while in the lower leg the more massive muscles sit on the backside, creating alternating swellings that gracefully shift from the front to the back. Even the bones participate in this setback of forms.

When looking at the leg from the front, notice how the upper leg bone, the femur, angles inward, while the lower leg bones, the tibia and fibula, shoot downward in a more vertical manner. With the muscles fuller at the outside of the lower leg, this gives the impression that the lower aspect of the leg is set back, slightly to one side of the upper leg. The result is a spring-like structure that acts as a shock absorber when we walk. Visually this canted effect between the upper and lower leg becomes highly accentuated in an action pose when the figure is off balance or running.

Since animals depend more on the speed of their legs for flight or fight, the zigzag shock absorber aspect of their limbs is much more extreme and extends all the way through their toes. It is not as dramatic as in an animal, but the spring-like action of the human leg likewise continues down into our feet, through the arch of the foot and the toes, which swing upward and then downward as if they are grabbing the ground for dear life.

In your pursuit of anatomical and structural knowledge, don't ignore the dynamic effects of movement on the human form. This means that if you decide to change the position or gesture of the hand or foot, you must alter the entire arm or leg as well. Stand in front of a mirror and try to move your foot inward without at least slightly bowing your leg outward. You will even feel the twist pulling all the way up on your hip.

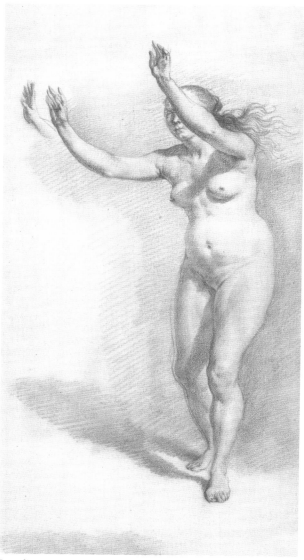

Standing Nude Woman With Upraised Arms
Adriaen van de Velde, ca. 1665–1670, red chalk, 11¾" × 7" (30cm × 18cm), collection of the Los Angeles County Museum of Art, Los Angeles, California

Note the springlike structure of the leg in this running figure.

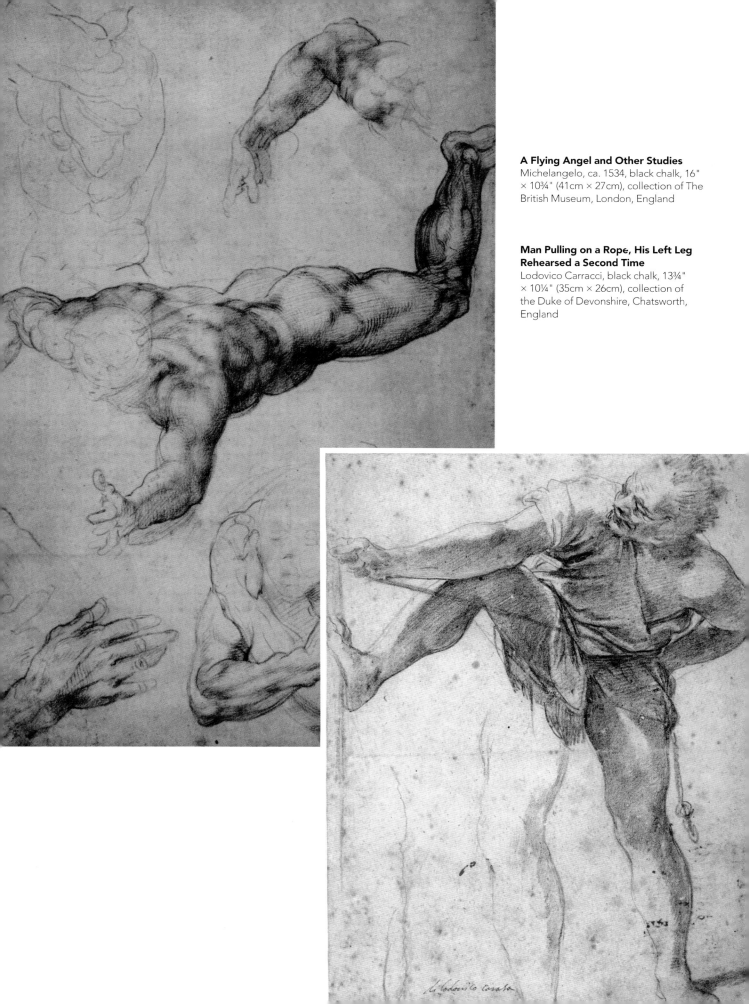

A Flying Angel and Other Studies
Michelangelo, ca. 1534, black chalk, 16"
× 10¾" (41cm × 27cm), collection of The
British Museum, London, England

**Man Pulling on a Rope, His Left Leg
Rehearsed a Second Time**
Lodovico Carracci, black chalk, 13¾"
× 10¼" (35cm × 26cm), collection of
the Duke of Devonshire, Chatsworth,
England

Put It All Together

As the previous examples demonstrate, you cannot study the parts of the figure without looking at its totality. How do we arrange everything into an organized, proportionate, fluid whole?

First, I begin my sketch in an improvisational manner, trusting my gut and eyes as I rough it in. Then, like many artists, I usually employ the head as my unit of measurement, judging it against the entire body and each major body part. After I've established that the parts work with the head, I countermeasure on a larger level by evaluating the major body parts against one another. To keep the confusion to a minimum, I look for body parts that are, on average, nearly equal in their measurements. I usually follow a checklist, first comparing the upper arm against the lower arm, then the upper leg against the lower leg and eventually each separate leg section against the torso.

For the arm, try to visualize it beginning at the shoulder and ending at the knuckles of the hand. On the back of the arm, you will generally find the midpoint at the elbow. On the front of the arm, you will usually find the midpoint at that large protrusion on the inner side of the arm called the epicondyle of the humerus (the culprit that causes the funny tingling feeling after you've hit it).

For the leg, think of it as beginning at the hipbone or trochanter (I, page 118) and ending at the base of the heel. You will usually find the halfway point of the leg just below the kneecap, or patella, on a front view, and on the back located behind at the faint flexion line on the back of the knee. Both of these leg segments are very similar in length to the vertical distance that spans between the iliac crest and the collarbone—a particularly useful set of measurements when drawing a seated pose.

All of these body parts are well-balanced with one another as you've probably already noticed if you practice yoga. Many of its parts are capable of folding neatly into one another,

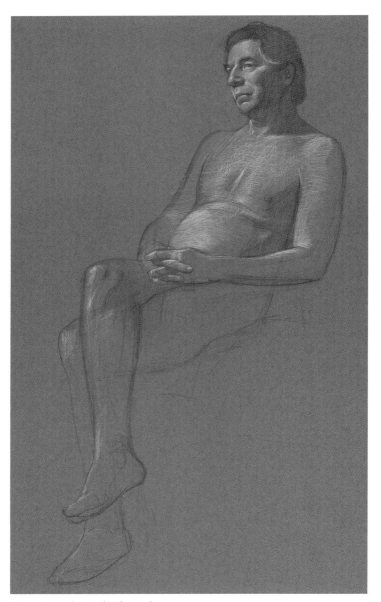

Harry Seated, Hands Clasped
Dan Gheno, 2006, colored pencil and white chalk on toned paper, 24" × 18" (61cm × 46cm)

It's helpful to compare one body part to another to gauge the proportions of the figure. But don't become an unthinking abuser of proportional guidelines, particularly when observing the figure from a foreshortened point of view. Trust your eyes—measure each body part against the head. Then measure each limb section freshly against the other as they appear at the moment to your eye, not according to a preconceived canon.

with the arms and legs able to evenly tuck into themselves and the torso into the limbs.

As always—and I can't emphasize it enough—this canon of measurements is only a jumping-off point, giving you a place to start and something specific to base your judgments against. While looking at the model, ask yourself where the figure and its parts deviate from the so-called norm.

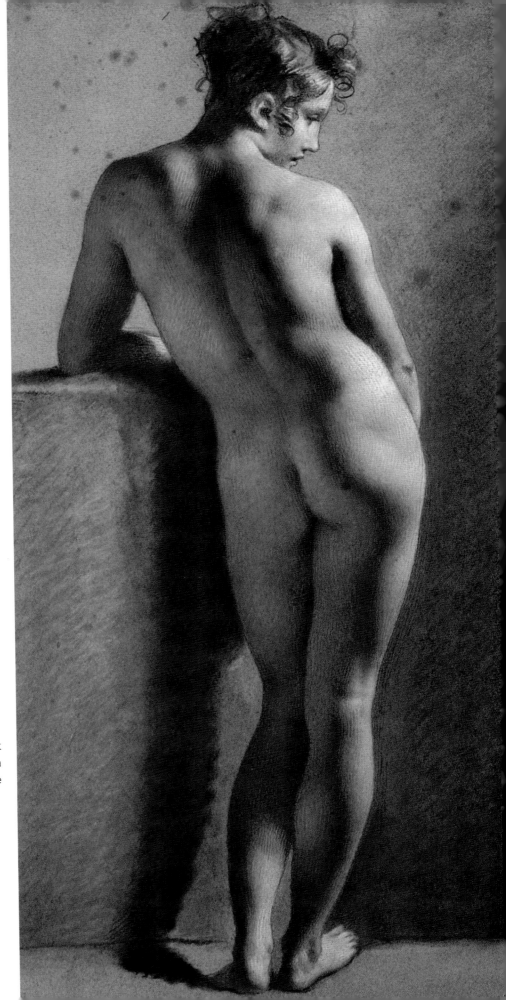

Standing Nude
Pierre Paul Prud'hon, charcoal heightened with white chalk on blue paper, 24" × 13¾" (61cm × 35cm), collection of the Museum of Fine Arts, Boston, Massachusetts

A faint flexion line occurs on the back of the knee where the femur and tibia meet, usually at the midpoint of the overall length of the leg.

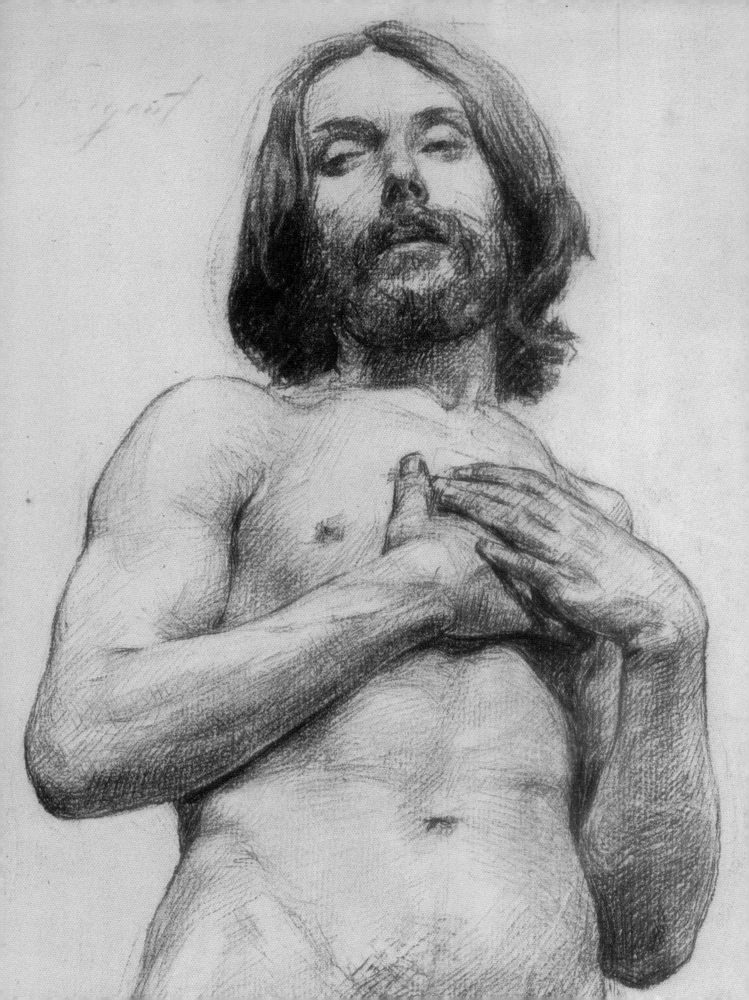

Trust Your Eyes

Even with the many great anatomy books that you can turn to, it's not enough to just work mindlessly from charts and texts. Do your own research from life and make the anatomical charts real to your eyes and mind. Carry a small anatomy book with you when you go to a sketch class or when you work in your own studio from the model. Refer to the book as soon as you discover a lump on the body that you don't recognize and can't identify from your previous studies.

However, remember the most important lesson you can learn from this series as you draw: Trust your eyes! Don't fall into the trap that tripped up many pre-Enlightenment lecturers who mindlessly recited Roman-era texts on anatomy as they dissected human cadavers for their students.

Researched by the great anatomist Galen of Pergamon when it was illegal to dissect humans, these texts were based on the dissection of animals, mostly pigs and sometimes chimps. Everyone in the lecture hall, including the lecturer, could see that the words didn't always match what their eyes saw. Unfortunately, for too many years they trusted the text instead. How many people died in these early times because doctors didn't trust their eyes? Don't let one of your drawings perish because you trusted a book instead of your own sight.

Nude Man (opposite page)
John Singer Sargent, graphite, 9⅞" × 7¾" (25cm × 20cm), collection of the Wadsworth Atheneum, Hartford, Connecticut

Recumbent Youth Posed Nude, Except for His Hose Pulled Down to His Ankles (above)
Annibale Carracci, red chalk, 9" × 15" (23cm × 38cm), collection of the Duke of Devonshire, Chatsworth, England

CONSTRUCTION OF THE BODY

MATERIALS LIST
Oil-based sanguine pencil

Look for the underlying action that exists in every pose, no matter how sedate or regardless of whether you're doing a long, sustained finished drawing or a quick gesture sketch. Particularly when doing a reclining pose, it's important to observe the angle of the figure or floor placement—it's usually oblique to your line of sight in a subtle or an obvious way, and is rarely perfectly horizontal and inactively flat to your picture plane. Use as many sketchy construction lines as you need to find the model's major proportions and gesture before getting into the details.

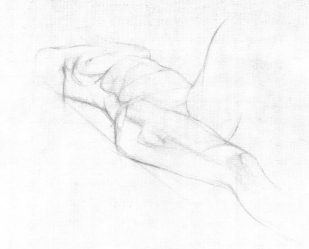

Create a Gesture Sketch
Start with a loose, gestural sketch, lightly mapping the edge of the shadow shapes with a thin, delicate line representing the terminator (where the light terminates). As usual, the shadow edge tends to follow the major plane breaks.

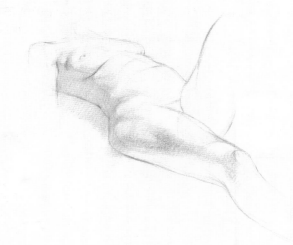

Block In the Shadows
Block in a broad unifying mass of shadow, not too dark or light, but an average of the specific value subshapes within. Adjust the line quality of your drawing, emphasizing some edges with harder, darker and thicker lines where you want the form to project forward and de-emphasizing others with more delicate lines where you want the form to recede.

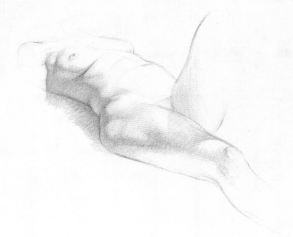
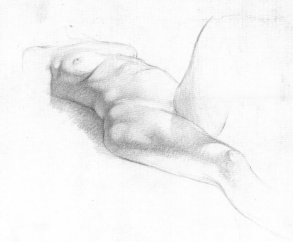

Darken the Core Shadow

Moving into the details, I start by darkening the core shadow—that's the part of the shadow which gets no direct light and very little reflected light and usually sits inside and behind the shadow edge.

Lay In the Half Tones

Lay another broad tone over the whole shadow, to better merge, or blend the darker core into the less-dark shadows, or reflected lights. Then start laying in the halftones within the light shapes, being sure that none of these light tonalities approach the darkness of the shadows.

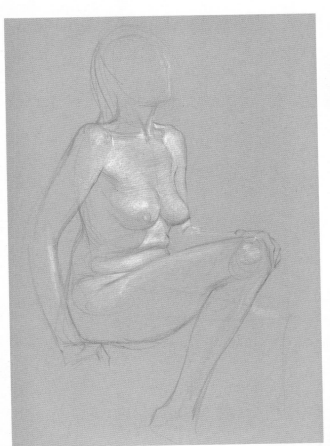

Apply Light Tones

When working on white paper, it's a good idea to lay in your broad dark masses first before committing yourself to the lighter halftones. However, when working on toned paper, block in a general, faint dusting of white pencil over the light shapes as a place holder. That way, you're not tempted to move into the lighter planes with a dark pencil, muddying up the contrast between the big light and dark shapes.

Later, block in the dark shapes and then go back into the details of the lights, building them up brighter with further use of the white pencil, relying on an interplay of the white pigment and the toned paper for the slightly darker halftones found within the light shapes. In this case, the paper was dark enough to work as a shadow mass, so it was left untouched.

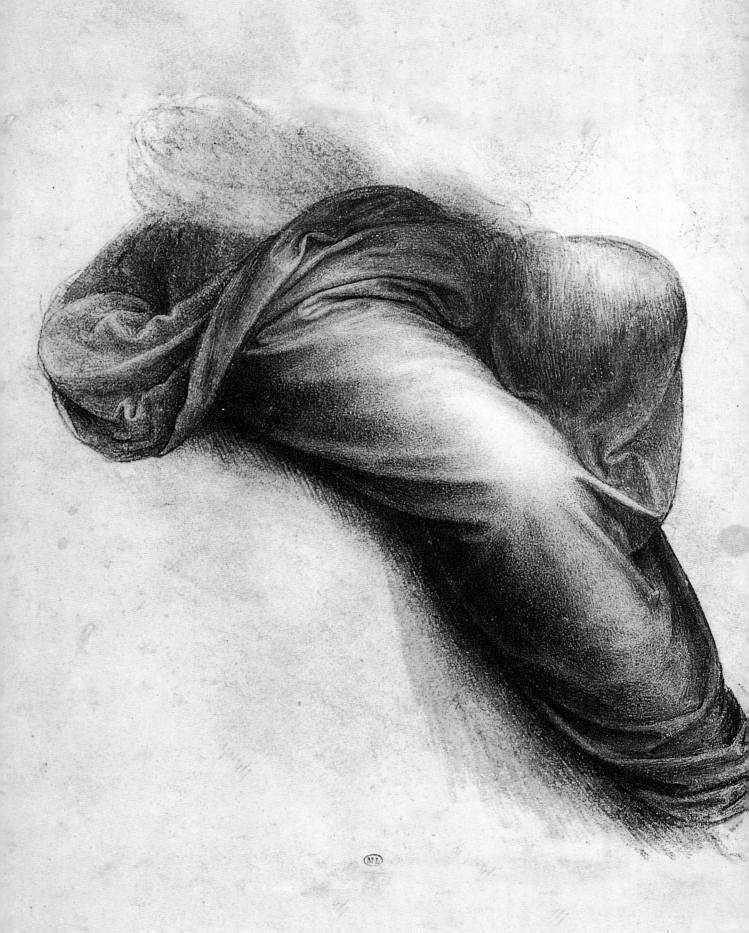

8 Drapery on the Human Form

Drapery has an anatomy all its own. Learn both the points of support on the body from which the folds fall and the consistent forms the folds make, and your figure drawings will become even more lifelike.

What could possibly be more difficult than drawing the human figure from life? Try drawing the human figure from life while he or she is draped in clothes. There is little variation in skin as it drapes over muscle, but wrinkles in fabric seem to vary endlessly from moment to moment as the model breathes or shifts minutely in the pose. You're lucky enough to get five minutes of uninterrupted study. Just as you're about to apply the final masterstrokes to a troublesome area of your drawing—the model sneezes or reflexively scratches an itch, scattering all your closely observed wrinkles to the wind.

Artists have learned to deal with their frustrations. Some soak the model's clothes in plaster, capturing the folds in perpetuity for calm contemplation. Many use fully articulated lay figures, commonly known as manikins, to draw or paint from at leisure, saving the live model for the fleshy bits. A few portraitists commonly employ manikins as sartorial stand-ins for their busy clients.

Numerous artists have written on the subject, trying to explain and systematize fold patterns on the human body. As a young artist, I didn't know about these writings. I obsessively tried to catalogue as many different types of fold patterns as I could discover. I photographed my family and friends in all kinds of dynamic positions in all sorts of attire and variety of shoes. I also clipped out photos from magazines and newspapers, drawing from these sources and trying to commit everything to memory.

Illustration from Figure Drawing: 377 Illustrations
Richard G. Hatton, Mineola, New York

Hatton's book is one of the best on figure drawing, covering everything from the bones below the skin to the clothes on top.

Drapery Enveloping the Legs of a Seated Figure (opposite)
Leonardo, ca. 1508, black chalk, black-chalk wash, and white and black pigments, 9¹⁄₁₆" × 9⅝" (23cm × 24cm), collection of the Louvre, Paris, France

Leonardo often drew intensely detailed studies in preparation for his finished paintings.

Use an Anatomical Approach

I soon realized that drapery has a dependable anatomy all its own. By itself, cloth is quite flat. But when draped on something like the human form, individual fold patterns can be categorized into four basic, repeating types, caused by the forces of gravity, tension, compression and pressure. These fold patterns are surprisingly consistent in all kinds of fabric—historical or contemporary, in male or female clothing. As with muscles, most structurally important folds have specific points of support on the human body and specific shapes that are determined by their position on the body and the actions of the model.

The Virgin Immaculate
Guercino (Giovanni Francesco Barbieri), ca. 1660s, brown ink and brown wash, 4⅞" × 10¼" (12cm × 26cm), collection of The Metropolitan Museum of Art, New York, New York

One of the greatest of the Baroque masters, Barbieri is better known by his nickname Guercino, which means "squint eyes." Get into the habit of squinting your eyes as you draw to better see the big forms and avoid overplaying the less important details.

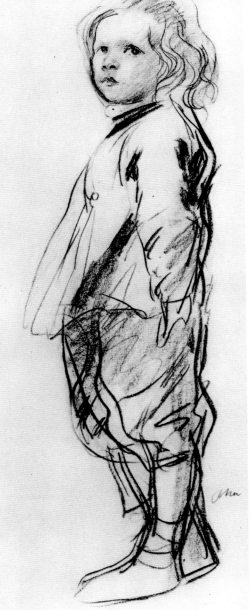

Mr. Mann (Henry Newnham Davis)
James McNeill Whistler, 1860, drypoint, 6" × 8¹⁵⁄₁₆" (15cm × 23cm)

Notice how Whistler used multiple lightly hatched lines to hint at the structure of the folds.

Child Study: Pyramus
Augustus John, 1908, graphite, 8" × 17" (20cm × 43cm), collection of Mrs. Thelma Cazalet-Keir

Lines describing folds needn't be rigid or overly defined—often it's more effective to hint at them with loose, spontaneous and airy strokes.

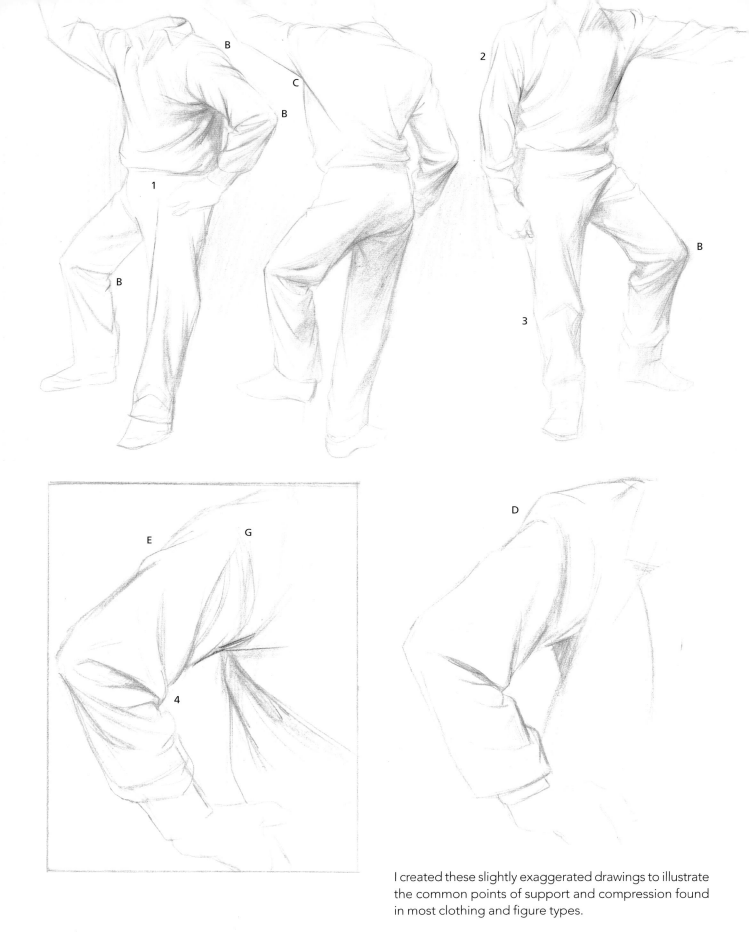

I created these slightly exaggerated drawings to illustrate the common points of support and compression found in most clothing and figure types.

Finding the Points of Support

There are several important landmarks or "points of support," to adapt Hatton's phrase, on the human figure that produce folds of gravity. You can usually find them at the hips, shoulders, elbows and chest. Sometimes folds can hang pendulously, unbroken from the hips (1) to the shoes, or from the shoulder (2) to the hand. At other times, the fold is broken by compression at the knee (3) or the elbow (4).

You can find compound folds of tension and compression (B) where limbs fold upon themselves and at the juncture of the limbs and trunk. The folds of tension (C) often help to dramatize the thrust or gestural movement of the limb as it is tugged from its point of support.

The human figure is in constant movement and so are the folds of the clothing. But with study, you will find that folds tend to group around these major landmarks or points of support. When drawing clothes, find these landmarks and major folds first, then draw the secondary, more transient wrinkles running off them.

The thickness of the cloth is an important factor. The folds on a thick wool suit will look bulky (D). The folds on a cotton shirt will grab or hang from the body in a more delicate manner (E). Remember that the same landmarks and forces bind both types of cloth. Also don't let your folds hang in an even, flat or parallel manner. Look for the oblique, twisting and turning quality in the pattern of folds. Often there is a common point from which these folds radiate (G).

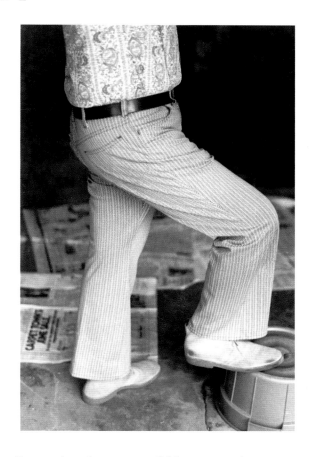

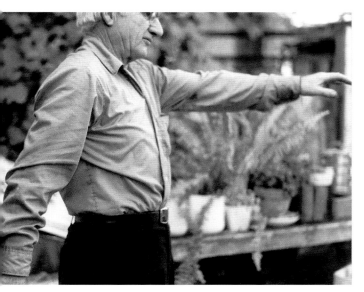

Remember that no two folds are ever the same size. Look for variety in the size of your folds, with some thick and broad, and others minute and delicate. Try to avoid overly containing or overly separating folds from the underlying mass of drapery unless you want your drawing to look as though it was rendered from a doll or figurine. You need to be especially careful while following a predominantly linear approach or working in ink. Look for inspiration from artists such as James McNeill Whistler and the incomparable Käthe Kollwitz, who often used multiple lightly hatched ink lines to hint at fold structure. Notice how artists such as Guercino barely suggest the existence of wrinkles. He frequently rendered them with short jabs of ink, suffusing them within a larger mass of wash that maps out the more important planes of the figure.

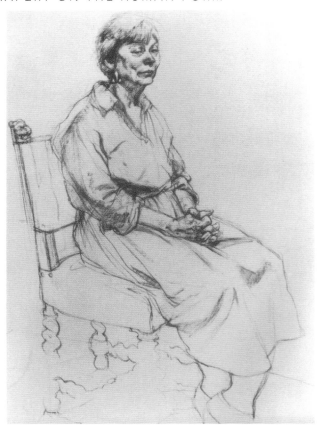

Seated Dutch Woman
Sigmund Abeles, ca. 1991, charcoal pencil, 15" × 11" (38cm × 28cm), collection of Bates College Museum of Art, Lewiston, Maine

Observe the folds that hang from and across the knees.

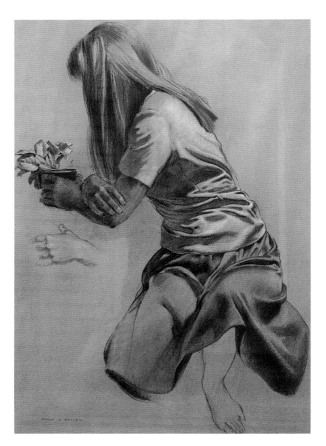

Tricia
Deane G. Keller, 1984, charcoal, 39" × 24" (99cm × 61cm), collection of Prof. Dorothy Bosch Keller

Most fold types are common to all periods and cultures, male and female subjects.

Courtroom Drawing
Mary Beth McKenzie, ca. early 1980s, charcoal, 7" × 5" (18cm × 13cm), collection of the artist

Alfred Brendel Rehearsing in Jerusalem
Sigmund Abeles, 1989, charcoal pencil, 11" × 15" (28cm × 38cm), collection of Alfred Brendel

Notice the artist's imaginative cropping in this drawing. He used the abstracted shape of the piano to focus our attention on Brendel's most important attributes in making music: his hands and his head.

Adding Detail

It is important to notice the surface detailing on drapery, for example belts, ties, the seams that run down the side of blue jeans, the stitching that runs around the sleeve cuffs, the partition that contains the buttons on the center of the shirt and countless other minutiae. Don't overdo it though. You don't want to flatten out the form with heavy lines unless you're purposefully trying to produce a design-like, graphic drawing or want to emulate a fashion illustrator. Remember that these details are barely visible when you squint your eyes to look at the model. Likewise, these details shouldn't jump out when you squint as you look at your own drawing.

At first glance it may appear drapery obscures the underlying form of the body. In fact, if you pay close attention to the way the important folds and the subtle stitching and decorative details grip the body, your use of drapery can enhance the illusion of form in your drawing.

If you apply them delicately, you can use these folds and details as cross-contour lines. Notice how these details—belts, cuffs and stitching—curve around the form, rounding outward where the form fills out or where the form recedes. Notice how these details, indeed all the folds, conform to perspective.

Don't get carried away with a lot of mindless, repetitive, curving lines. Look closely, make each fold unique with some sweeping fully around the underlying form and others only hinted at or indicated with a couple of delicate short strokes at the source of the tension point.

The variations are limitless. Look for your own voice, and don't settle for easy stylizations.

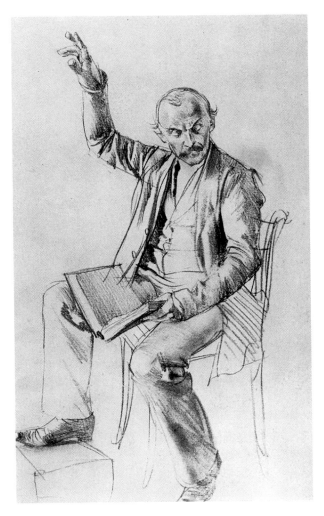

Seated Man Holding Book
Adolf von Menzel, ca. 1850s, graphite on brownish-yellow paper, collection of Nationalgalerie, Berlin, Germany

This dramatic drawing aptly depicts the points of compression at the knees, armpits and crook of the arm. Also notice the pendulous folds that hang from the knees.

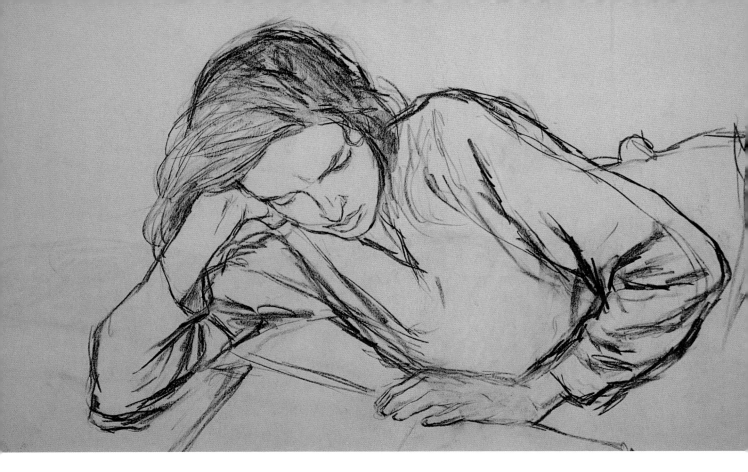

Working From Life

You will need to practice a great deal, working from life as much as possible, if you hope to develop a personal vision. Fortunately we're surrounded by a wealth of ready subject matter wherever we go. Sketch the other customers while seated in your favorite coffee shop. Draw people while waiting for your doctor or plane, bus or train. You can even try drawing on the train or bus if you can handle the movement. Many artists like to draw in concert halls, courtrooms and city council meetings.

At all times be discreet and sensitive to your subject matter. If individuals turn away or shield their faces, it's a clear signal that they don't want you to draw them. Don't intimidate others with an unbroken, intense stare. Try turning slightly away from your subject and observe the individual from the corner of your eye.

The best people to draw in public are musicians in concert, lecturers, lawyers delivering a summation, even politicians on the stump. They are accustomed to the scrutiny, and they may even get energy from your diligent attention. The audience is also a good target since their eyes are focused away from you and on the stage.

Photography might seem like an easy and elegant solution to your wrinkle travails. Indeed, it can be a valuable tool in your efforts to classify and amass a vocabulary of fold types. Remember, however, that photography reduces the subject to flat shapes of value and color. You need to constantly reinforce your subconscious appreciation of three-dimensional form by working from life on a regular basis.

Susan Reading (above)
Jerry Weiss, 1983, charcoal, 18" × 24" (46cm × 61cm), collection of the artist

Weiss approached his subject, the artist Susan Mazer, with a bold, lyrical and calligraphic use of line.

Leo Tolstoy at Work in Yasnaya Polyana (opposite page)
Ilya Repin, 1891, graphite and pastel on cardboard, 12½" × 9⅜" (32cm × 24cm), collection of the Russian Museum, St. Petersburg, Russia

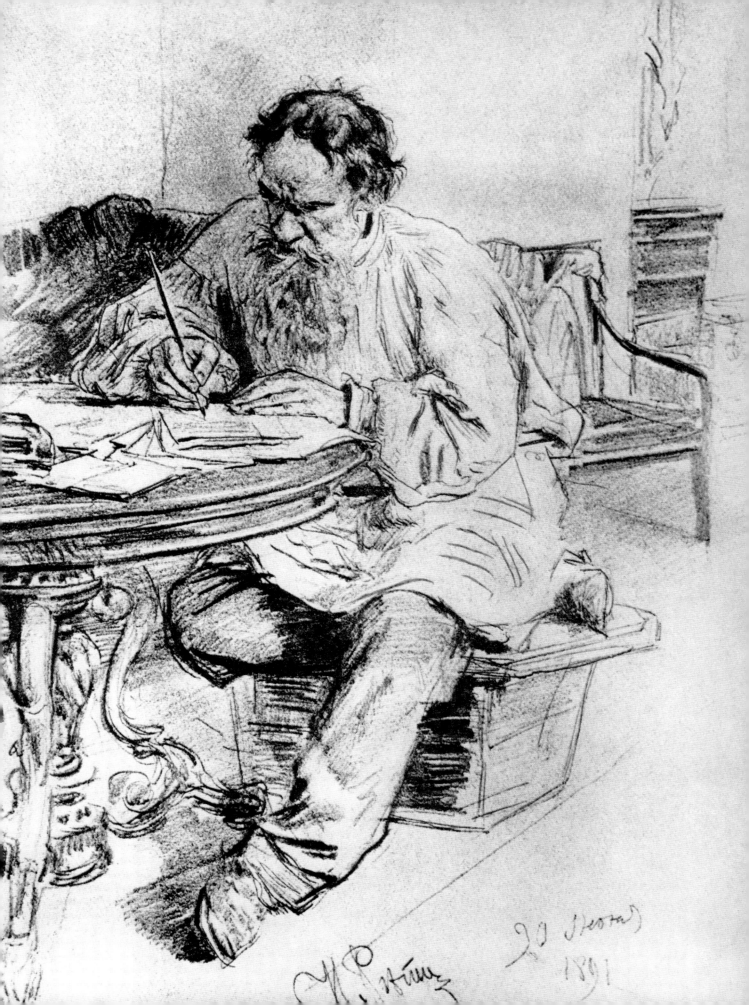

The Spontaneous Approach

The more you know about the structure and logic of folds on the human body, the easier you'll find it to paint from the draped figure. Some artists, such as the immortal Leonardo, revel in the study of drapery, doing highly finished sketches of isolated details before they begin a painting. I admire the logic behind this approach, and I greatly enjoy gazing on such works, but I personally prefer to work out my fold issues on the painting itself.

Looking at the first-stage detail of my painting *Triptych: Going to Work, Stop, In Memory*, you can see that I start my paintings very loosely, briefly indicating all the major folds and the important points of support, compression, tension and hanging folds. Next I loosely block in the major slabs of value contrast, looking for the big patterns of light and dark.

I could have drawn detailed studies beforehand, but I like to gradually sneak up on the details of the folds and other areas of the figure, trying to maintain a sense of discovery and excitement. You have to be very careful when working off the cuff like this since the secondary folds will change greatly from one moment to the next.

I try to focus on those major folds that tend to recur. One moment a structurally important fold may appear a little higher and thinner; the next moment it may appear a little lower and fuller. But the major folds will always have the same point of support or compression. I try to avoid moving these important folds back and forth. Instead I attempt to work within my original drawing, fitting the secondary wrinkles into the allotted space.

An artist can get into trouble or lose control of a painting, whether the artist maps out everything in advance with a multitude of preparatory studies or takes a more spontaneous, seat-of-the-pants approach. When I see this happening to my students, I usually recommend that they stop work on the painting or long-term drawing and spend some time drawing a few quick, throwaway sketches.

It doesn't matter what area is giving you problems—wrinkles, hands, faces, anything at all. I advocate moving around your subject, drawing the problem area from several different vantage points, trying to absorb

Charcoal Sketch for Triptych: Going to Work, Stop, In Memory
Dan Gheno

I rarely make preparatory sketches, drawing little more than a few scribbled lines for compositional purposes.

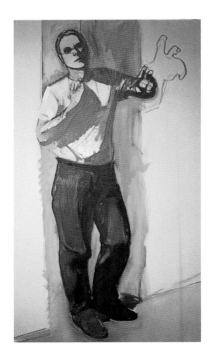

First-Stage Detail of Triptych: Going to Work, Stop, In Memory
Dan Gheno

It's important to block in the strongest colors first so you can better gauge the difficult subtle colors against more obvious areas.

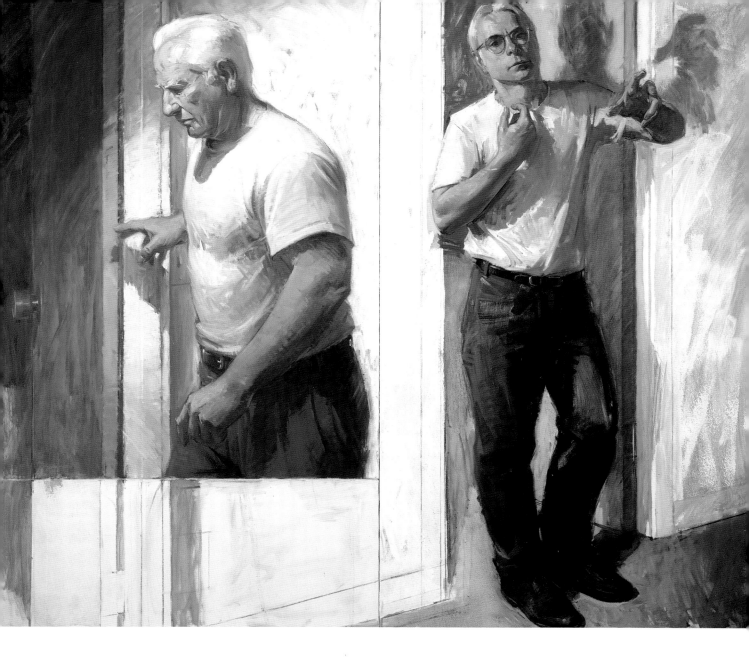

the three-dimensional aspect of the form. Then I recommend doing a quick sketch of that same problem area from your original position as depicted in the painting or drawing. This often breaks the mental or artistic logjam that's holding you back, allowing you to proceed with greater objectivity and clarity. I lost count of the number of times I had to stop and draw quick studies of the upraised hand in my triptych painting.

Although it's important to study the anatomy of drapery on the human form, don't let it become your white whale, dragging you like an artistic Ahab into the depths of the ocean. Drapery has its own beauty, but it shouldn't overwhelm or supplant all the other compositional goals within your painting or drawing. I

exaggerated the fold patterns in my drapery diagram to make an educational point. It's usually better to understate folds while in the pursuit of artistic expression.

Triptych: Going to Work, Stop, In Memory
Dan Gheno, 1998, oil, 50" × 60" (127cm × 152cm), collection of the New Britain Museum of American Art, New Britain, Connecticut

This triptych is a large sequential image that addresses my childhood memories of my father and my desire as an adult to hold on to the past.

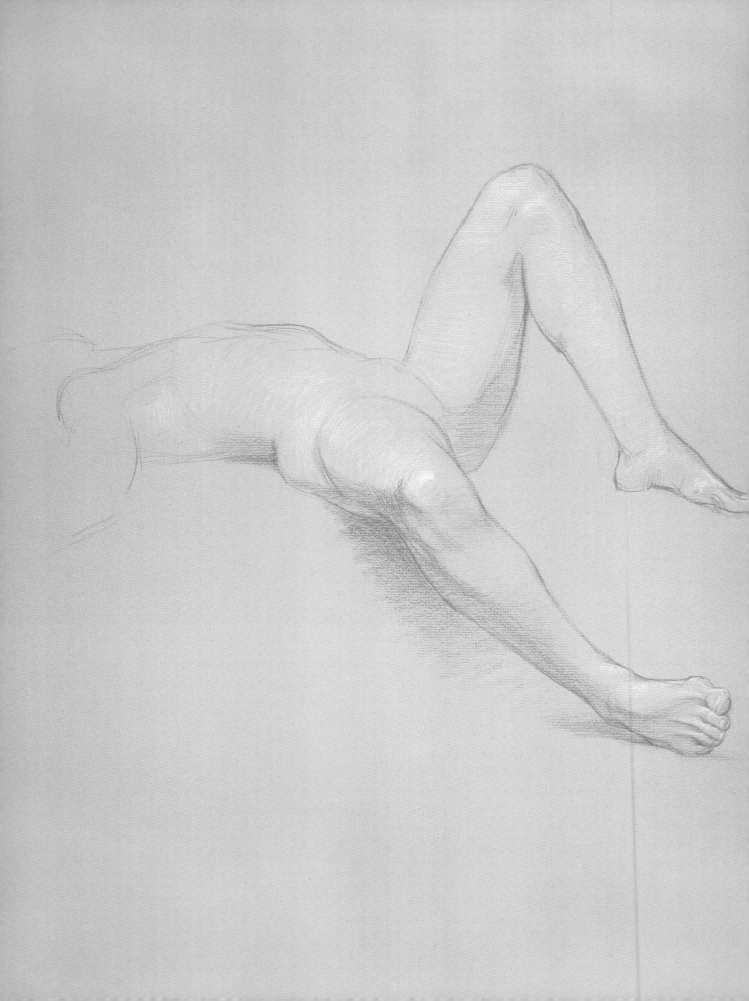

9 Composing Your Drawings

■ Learn how to achieve balance, rhythm, variety and contrast in a drawing.

With all the care lavished on Old Master drawings today, it's difficult to believe that many Renaissance and Baroque artists treated their own figure drawings with a great deal of indifference. More than a few masterpieces, in fact, were folded, torn, sliced and used as scrap paper or shopping lists by their own creators, since many of the Old Masters considered their figure drawings as nothing more than tools or preparatory work for their more significant paintings or sculptures. Even those who did not neglect the safety of their drawings often discarded them once their perceived usefulness was over. Michelangelo, for one, regularly burned his drawings, fearful that they might fall into the hands of his competitors.

Today among both artists and collectors there is no question that the drawing medium deserves the same respect as any other art form. Indeed, much of the same agonies and ecstasies that apply to painting and sculpting also apply to drawing. Artists can inject most of the same formal, psychological and emotional concerns into their drawings. Drawing artists adhere to many of the same compositional rules and expectations, knowing that—as in every medium—good compositional theory involves collaboration between balance, rhythm, variety and contrast.

Reclining Figure in Space
Dan Gheno, 2004, colored pencil and white charcoal, 18" × 24" (46cm × 61cm), collection of the artist

Creating Dynamic Visual Balance

You can create immediate visual balance if you plop the human figure in the center of the picture plane. But this safe approach gets boring after a while, and it lacks the other important elements of composition. Try a more daring approach by moving the figure or focal point slightly to one side, somewhere between one-third and one-fourth of the way across the girth of the image, to a position more commonly called the *Golden Section.*

The term *Golden Section* intimidates most people—except perhaps mathematicians. One of the more important compositional schemes, the Golden Sec-

tion is an elegant but needlessly complicated mathematical formula that dates back to the classical Greek era. According to some interpretations of Euclid, this formula, $1/x = (\sqrt{5} + 1)/2 = 1.6180339887498948482 \ldots$, allegedly defines the essence of beauty and is a road map for identifying the best division of shapes within any image. Bernard Dunstan reduced it in *Composing Your Paintings* to a more useful and less imposing formula, 5:8, as seen in the diagram below.

To apply it, divide your image into eight equal parts along both the width and length of your rectangle. Now count out five parts—put the important focal

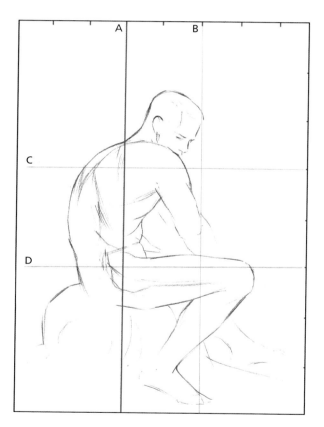

Diagram of the Golden Section
To determine the approximate position for the Golden Section, divide the vertical and horizontal image borders into eight equal parts. Then count off five bits and locate the Golden Section where the fifth portion meets the remaining group of three parts. There can be multiple Golden Sections but only one should dominate.

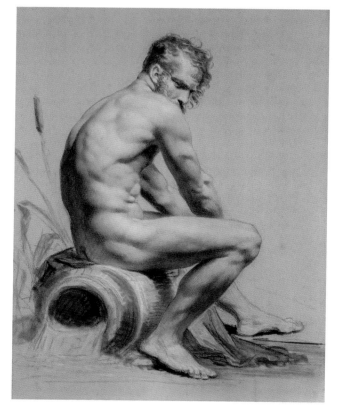

Study for an Allegory of the Rhine River (Un Fleuve)
Pierre-Paul Prud'hon, ca. 1801, black and white chalk on blue paper, 23⅞" × 16¼" (61cm × 41cm), private collection

Prud'hon placed many of his focal points along some of the Golden Sections. The main bulk of the figure lies along the major Golden Section A.

points of the figure in the general area where the group of five parts meets the group of three parts.

Euclid is usually credited with this formula, but there is evidence that it was spontaneously formulated long before his birth and courses through the prehistoric, collective unconscious. We are surrounded by plants, landscapes and living animal or human forms that break down into a 5:8 proportional relationship, and some philosophers and aesthetes have speculated that our species is hard wired to appreciate them.

If you are a glutton for mathematical punishment, you can take the principle much further. Beginning with a 5:8 proportioned image format (the 35mm format is very close, at 5:7.5), you can use the Golden Section to divide your compositional space into ever smaller, harmonious, dynamically balanced shapes. But as Dunstan points out, the artist doesn't need to delve into the intricacies of the principle to put it to good use and, in fact, most artists already use it instinctively.

All you need to remember is that the Golden Section hovers somewhere between one-third and one-fourth of the way across the length or height of a composition. Don't become too phobic about the center of the composition; something important will always land there. Just be cautious about putting your most important focal point on the composition's bull's-eye.

You don't need to overpopulate your composition with an array of props and figures to make good use of the Golden Section. You can do just as well with a simple figure and a few surrounding lights and darks. Pierre Paul Prud'hon made frequent use of the Golden Section in his many detailed, single-figure drawings or *académies*. A technically neutral term, *académie* is sometimes used derisively by art historians to describe a similar type of tightly rendered, single-figure drawing or drawing exercise that was regularly performed by students in the early drawing academies. Like other professional artists in his time and now, Prud'hon transformed the solo-figure drawing exercise into a sensitive, complex art form. Prud'hon approached his drawings with a great deal of vigor. He put a lot of focused energy into his observation of detail, using a sensitive, hatching line to sketch volume while paying close attention to the face and personality of the model.

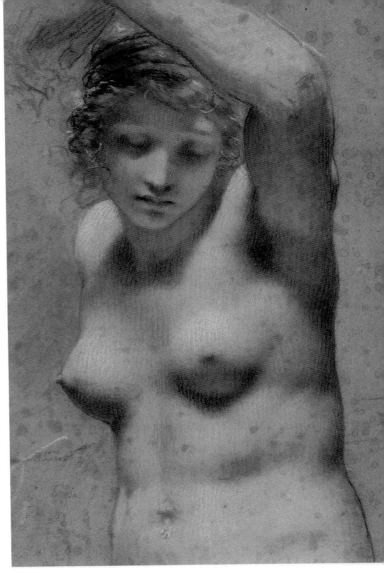

Bust of a Female Figure (Académie de Marguerite)
Pierre Paul Prud'hon, ca. 1814, charcoal and black and white chalk on blue paper, 11" × 8¾" (28cm × 22cm), collection of the Philadelphia Museum of Art, Philadelphia, Pennsylvania

Observe how Prud'hon placed all his important focal points on the various Golden Sections in the drawing *Study for an Allegory of the Rhine River (Un Fleuve)*. The overall figure is situated below the Golden Section (A) that runs across the horizontal thrust of the image. Other important landmarks coincide with Golden Sections at (B) through (D). Prud'hon manipulates the viewer's eyes with value shapes as well, locating most of the dramatic light and dark contrasts near important Golden Section crossroads.

Some very traditional artists occasionally eschew background altogether, treating the figure as an abstracted shape or silhouette. Their drawings have the same type of beauty and sense of volume that you might find in a freestanding sculpture. At the same time the artists are mindful of the picture plane, their figure shapes bursting like an explosion against the outside boundaries of their images.

I first experienced the power of the singular figure as a youngster while drawing from the sculptures of Rodin and the Mexican artist Francisco Zuñiga. At the time, I was only interested in analyzing the anatomical power and structure of their work, and I concentrated on sketching simple figures isolated on empty backgrounds. I was not focused on creating art, but I noticed that their elegantly designed sculptures made beautiful abstract shapes on the paper, no matter what direction I drew them from.

I learned from these artists that the human figure, like most earthly forms, is intrinsically well designed. It's filled with effective use of the Golden Section, harmonies and contrasts. There are no static forms on the figure so with all its moving parts, the human figure is inherently dynamic, especially within the contrasting, opposing tilts of the chest and hips. I quickly learned that a well-cropped human figure has as much visual, metaphorical and emotional potential as the most complicated history painting.

Since then, abstracting the figure has become one of my passions. I sometimes like to segment the figure, concentrating on isolated forms that make interesting shapes in my mind. With *Reclining Figure in Space* (page 148) I attempted to find some internal, dynamic balance by contrasting the abstract shapes of the zigzag legs against the volumes of the hips and chest. I tried to hint at a sense of space by leaving the far reaches of the figure vague, and I intentionally let the dark value masses bleed loosely past the figure forms to hint at an enclosing atmosphere beyond.

Nude
Valentin Serov, 1900, charcoal and chalk on brown paper, 27½" × 17¾" (70cm × 45cm), collection of The State Russian Museum, St. Petersburg, Russia

Nude
Valentin Serov, 1900, graphite, chalk, and sanguine, 27 ⅓" × 18" (69cm × 46cm), collection of I. Brodsky Memorial Museum, St. Petersburg, Russia

This Russian artist approached figure drawing with composition firmly in mind, filling all corners of the image with both a physical and psychological presence.

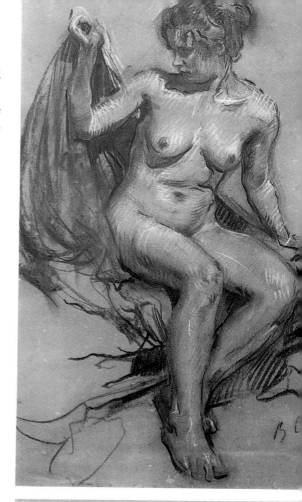

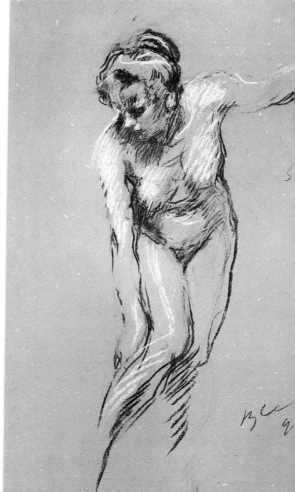

Working With Visual Gravity

The picture plane is a powerful playing field filled with inherent visual forces that you can unlock with lines and values. According to Rudolf Arnheim in his book *Art and Visual Perception*, the picture surface is divided into several gravitational hot spots. As you might guess, the strongest point of visual gravity lies in the center of the picture with the other lesser hot spots located at the four corners of the image, the middle of the outer edges and halfway between the pictorial center and the corners of the picture.

It's best to place your figure or focal point somewhere between the major hot spots, not too close to one or the other, where the many gravitational tensions balance themselves. You can maintain a dynamic pictorial balance or gravitational stasis if you push your focal point as far across the picture plane as the Golden Section. However, if you place your figure or focal point too close to one of the outside edges or gravitational hot spots, your subject will appear imbalanced as if falling out of the composition.

Our intrinsic awareness of gravity tends to weight the lower edge of the composition, particularly the lower right-hand corner. The lower right-hand corner attracts the eye with an enormous amount of force in societies that read from left to right. Beware of any lines or body parts leading to this corner. They act like arrows, forcing the viewer's eye off your image, pointing them to the next drawing hanging on the wall.

This theory of visual gravity that Arnheim describes in his book also explains the logic and power of another compositional device that many artists call the "Steel Yard" composition. A small form placed near the gravitationally charged outside edge of the paper can easily counterbalance a stronger shape that's nestled deeper inside the less charged interior of the composition.

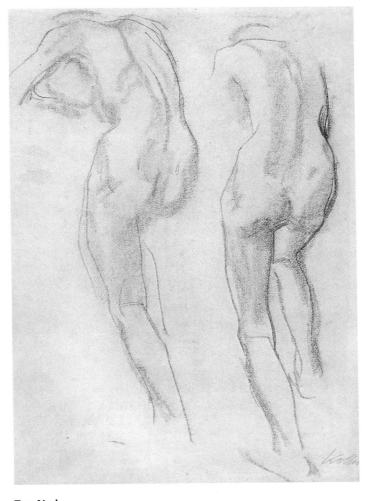

Two Nudes
Käthe Kollwitz, charcoal, 24" × 19" (61cm × 48cm), collection of the National Gallery of Art, Washington, DC

There are few artists as passionate as Kollwitz. Here she drew the same figure twice in a rhythmic echo that activates the picture plane and implies a sense of pathos in the evocative shapes of the figure.

Recognizing the Tools of Composition

Figure placement demands a great deal of thought, but we also have many other tools to achieve balance, rhythm and contrast in our figure drawings. A few of them are the use of psychology, perspective, foreshortening, overlap, value patterns, the push-pull effect and improvisation.

Psychology

The Golden Section is powerful, but psychology is the figurative artist's most potent tool. Remember that emotionally important forms such as faces, hands and feet immediately attract the viewer's eye. Distribute these forms across the image surface so the viewer doesn't become bogged down in any one area. Even the glance of the model's eyes can play a role in your composition. You can place a figure completely off to one side, and by turning the model's face toward the empty area, you can activate the remaining space with the psychological weight of the model's stare.

Perspective

Many artists consider linear perspective another form of mathematical torment, like the use of the Golden Section. Unless you're doing architectural rendering, you don't need to cling strictly to the rules of perspective, but you can loosely use its converging lines to manipulate the viewer's path throughout your composition. Notice how Alex Zwarenstein lines up the parallel planes of his figure in *Contour of a Woman Relaxing* (page 156), with all of the major forms angled toward a low eye level. Zwarenstein uses linear perspective—even to the point of retaining some of his converging tracking lines—to create a deep sense of space and give a powerful, looming sense of form to the figure. On the other hand, many artists intentionally choose an extremely high vantage point, to emphasize the environment's floor plane, thereby creating an inviting and enveloping space for the eye.

Foreshortening

Notice how an odd or highly foreshortened view of the figure can imply enormous space, dragging the viewer into the picture plane and throughout the composition.

You enter Anthony Antonios's drawing *Rhythm in Red* (page 158) at the forward arm, skull and shoulders

Nude 1
Nathan Oliveira, ink, 12" × 15" (30cm × 38cm)

Bold, unmodulated lines, drips or strong calligraphic marks tend to rise to the picture plane. Notice how Oliveira's expressively, heavy linework pushes to the borders of his image, activating the empty background or negative shapes almost as much as the figure.

Nude 2
Nathan Oliveira, ink, 10" × 12" (25cm × 30cm)

These nudes are part of a book project that resulted in the title *Why Draw a Live Model?*

Nude 3
Nathan Oliveira, ink, 12½" × 16" (32cm × 41cm)

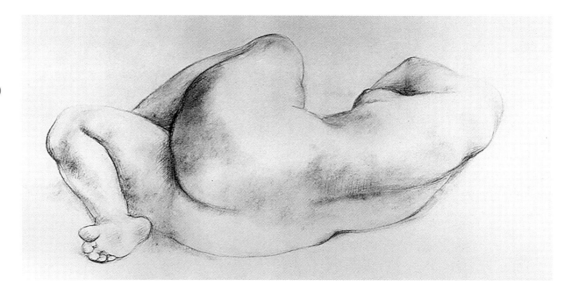

Esther
Francisco Zuñiga, 1972, sepia, 19¾" × 25½" (50cm × 65cm)

that loom in the foreground. Each succeeding, overlapping form pulls your eye rhythmically into the figure, past the middle ground of the far hand, until you're thrust beyond the distant leg in the background and finally pulled back to the forward picture plane again by the white space of the paper. In *Cézanne's Composition*, Erle Loran calls this visual movement a "return out of depth," which "a self-contained spatial organization," such as *Rhythm in Red*, provides.

Overlap

When you want to produce a greater sense of illusionistic depth in your drawings, try using successively overlapping shapes and lines to create a collection of progressively diminishing forms. Any such series of shapes or values will pull the eye through an implied space as you can also see in Gerard Haggerty's *Linda Sleeping* (page 158). In addition, notice how the lines surrounding each form are set off from one another. In general, you should try to avoid running the lines of one form directly into the lines of any adjoining forms, or you risk losing important spatial clues of overlap.

Value Patterns

Observe how Prud'hon uses values to manipulate your eye in *Study for an Allegory of the Rhine River (Un Fleuve)* (page 150), allowing the shadow shapes that run across different forms—both distant and near—to merge into one big, coursing shadow shape that moves the eye elegantly throughout the image. Sometimes all you need to do is run a long dark value shape along the objects or floor plane at the bottom of the composi-

tion, merging your vertical figure into a gravity-filled horizontal anchor. Whenever possible, try placing your darks against your lights; you can use the resulting contrasting values to capture the eye and move the viewer's attention across the image. Consider using simultaneous contrast—brightening the lights as they approach the dark shapes and vice versa—to enhance the effect.

Push-Pull Effect

Perhaps you're not interested in spatial illusion. Perhaps you have more abstract concerns and want to reinforce the picture surface so you can better manipulate the flat values and patterns across your composition. In his series of nudes for the book *Why Draw a Live Model?* Nathan Oliveira's expressively heavy lines push their way to the borders of his images, activating the empty background or negative shapes almost as much as they enliven the figure. Hans Hofmann called this the "push-pull" effect, when the background (or passive shape) and the foreground figure (or active shape) seem to pulsate back and forth in the mind's eye.

There are many other ways to trigger this dynamic spatial ambiguity. Any kind of bold calligraphic marks, drips, geometric-like shapes and tangents tend to rise to the picture plane—tangents are especially powerful in this context, since they have a tendency to attract our eye and you can use them to direct the viewer's gaze. Some artists like to call attention to the flip-flop tension between the positive and negative shapes by drawing lines or values against the outside boundary of the figure, as if they were drawing the air itself pushing against the edge of the model. You can also use reverse

perspective and strong, clearly defined or repetitive, graphic patterns to flatten the picture space, as Matisse did so effectively in many of his paintings and drawings.

Improvisation

Francis Bacon had a real fear of becoming complacent or too controlling of his own work. According to some of his interviews, he would often throw paint at his canvas so that he would need to respond to the unexpected.

Not all compositions need to be premeditated to be valid as art. Sometimes you can improvise a great composition as you go along. First you might drop in an arm, then you might respond by drawing a face that looks toward the arm, followed by a hand that might lead away from the face and point toward a newly added leg. Raphael may not have had a finished design in mind when he began *Five Studies of a Male*

Torso, a preparatory sketch for the *Stanza della Segnatura* in the Vatican. Yet, it's clear that he considered the placement of each figure fragment so that a pleasing pattern resulted.

Ultimately you need to listen to your own voice. There are no absolute compositional rules, and all compositional choices are personal. Determine your purpose or ambition for the drawing before you begin. It's better to make a passionate, decisive statement than to produce equivocal images based on another artist's formula.

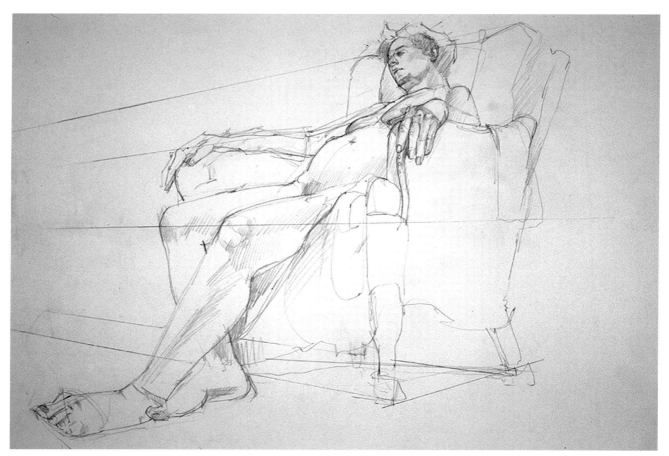

Contour of a Woman Relaxing
Alex Zwarenstein, 2002, graphite, 20" × 30" (51cm × 76cm), collection of the artist

Zwarenstein uses linear perspective, even to the point of retaining some of his converging tracking lines, to create a deep sense of space and give a powerful, looming sense of form to the figure.

Woman Leaning on a Staff
Rico Lebrun, 1941, ink and chalk, 25¼" × 11¼" (64cm × 29cm)

Lebrun combined both line and value to create a sculptural sense of form and space. Weaving a powerful calligraphic line rhythmically through the figure, he reinforced the vertical thrust with a strong shadow value that blurs across the figure into the surrounding air and morphs into a dark, horizontal counterthrust onto the floor. Lebrun found a second visual counterpoint in the diagonally bracing cane.

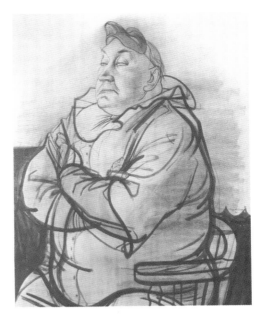

Seated Clown
Rico Lebrun, 1941, ink and wash, collection of the Santa Barbara Museum of Art

The clown's powerful and intense face is turned leftward, filling the empty left side of the composition with great tension. This is balanced by the bold, dark line along the clown's back and the psychologically forceful stare of his eyes turned somewhat outwards through the center of the picture plane and fixed on the viewer.

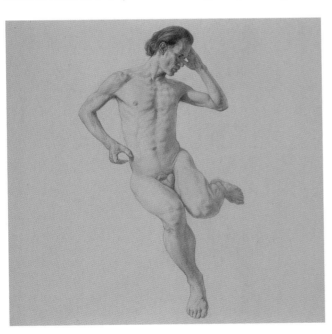

Bruno
Andrew Reiss, 2001, graphite, 23" × 29" (58cm × 74cm), collection of the artist

By leaving the background blank, Reiss treats the figure as an abstract shape or silhouette. Reiss's images have the beauty and sense of volume that one finds in free-standing sculpture.

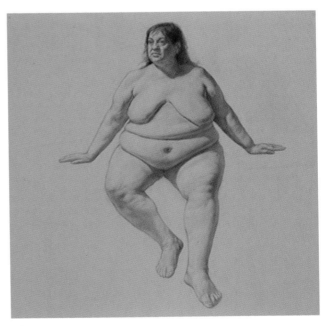

Aviva
Andrew Reiss, 2001, graphite, 23" × 29" (58cm × 74cm), collection of the artist

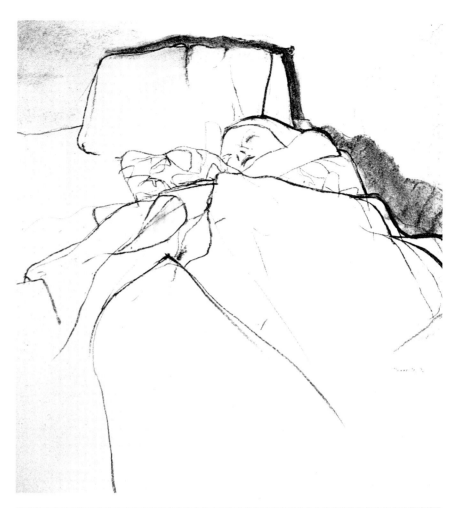

Linda Sleeping
Gerard Haggerty, 1973, charcoal, 30" × 22"
(76cm × 56cm), collection of Robert Marquis

Haggerty invites us into this work from a low level, leading our eye relentlessly upward through the composition, moving our eye from one overlapping shape to the next.

Rhythm in Red
Anthony Antonios, 1972, red chalk,
12" × 12" (30cm × 30cm), collection the artist

Notice how an odd or highly foreshortened view of the figure can imply enormous space, dragging the viewer into the picture plane and through the composition. The viewer enters this image at the foreground portion of the figure, shooting past the middle ground of the far hand and into the background past the distant leg, where the viewer is finally pulled back to the forward picture plane again by the white space of the paper.

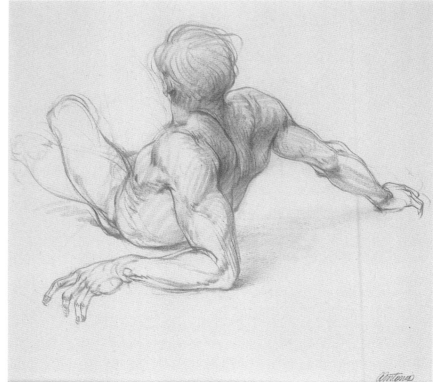

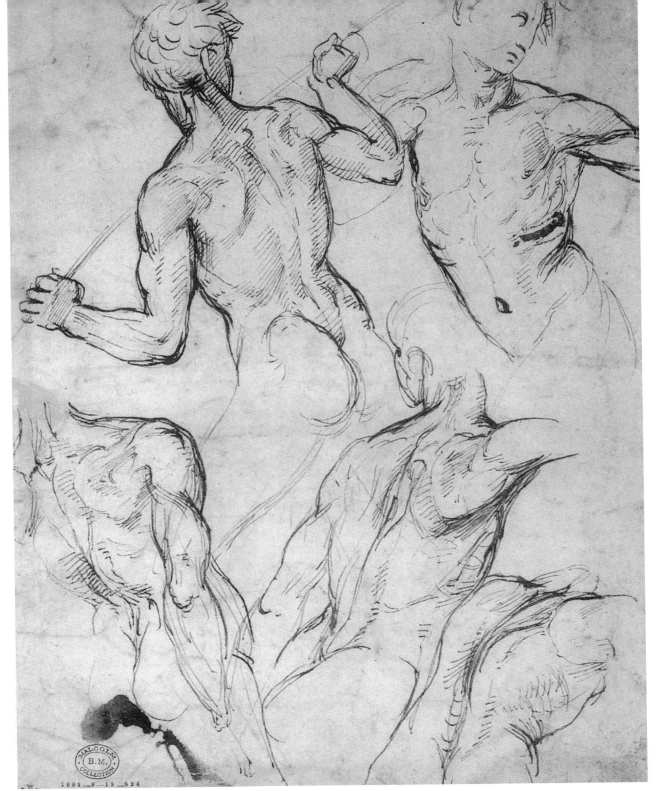

Five Studies of a Male Torso
Raphael, pen and ink over leadpoint underdrawing, 10½" × 7¾" (27cm × 20cm), collection of The British Museum, London, England

According to the art historian Michael Hirst, the great Italian master Michelangelo was downright paranoid that other artists would steal his ideas.

One artist who borrowed a great deal from Michelangelo was Raphael. He found inspiration in Michelangelo's rhythmic line and manipulation of musculature. But Raphael, along with many other Masters, such as Tintoretto and Titian, did not simply copy him. They paid him a nobler compliment by learning from his example and transforming the lessons into something very personal.

10 How to Use Narrative in Your Art

Here are some techniques to make your narrative drawings and paintings speak eloquently to the viewer.

The narrative form is a remarkably powerful force able to grab viewers with its use of metaphor, allegory and literary content. It slows down viewers and forces them to think through and contemplate the meaning of the image. Narrative, telling a story or dramatizing a concept with a painting or drawing, is one of the most rewarding modes of expression for visual artists, and it even has the potential to change the world in some small or big ways. Over the ages, artists or their handlers have used the narrative form to affect all areas of our lives, including the spiritual, political and social arenas.

In addition, narrative can reach us on the individual level, influencing our personal morals and ethics. Unfortunately it's also one of the most difficult forms. Besides the typical formal issues encountered in all art making, the narrative form is fraught with technical difficulties and, particularly in the past, physical dangers. Both Honoré Daumier and Jacques-Louis David served jail time for their visual musings, but as I shall discuss in this chapter, it's no longer quite as dangerous to speak your mind. And although the many difficult technical odds may seem stacked against you, with a little study, preparatory sketching and effort, you will find it feasible to create a convincing and compelling narrative.

Study for The Death of Socrates
Jacques-Louis David, 1787, black crayon and chalk, 14½" × 20¾" (37cm × 53cm), collection Musée des Beaux-Arts, Tours, France

Finding the Correct Eye Level

Few artists can afford to work from life models, and far fewer can afford to work with a troupe of simultaneously posing players. But some narrative-based images can become rather complex, employing a multitude of figures spread across a large tableau. What do you do if you want to draw a group of people and you can only afford to draw or paint one figure at a time? How do you organize their positions one next to another?

First, and most important, even if you are working totally out of your head, you need to establish an eye level or a horizon line for yourself as the artist/viewer. Imagine that you are standing in the midst of the scene watching events unfold, and draw a line across your preparatory sketch or the primary canvas that coincides with your eye level. Scale all of your players, props and architecture to this line.

In this scheme, the first figure you draw within the picture surface is your key figure. Ask yourself, "Where does the eye-level line cross the key figures?" Hold a pencil horizontally in front of your eyes to determine its position. For instance, if both you and the model are about the same height and if you are both standing, the eye-level line will pass through the key figure's eyes. A taller model's eyes will ride above the eye level, and a shorter person's eyes will sink below the line. In another situation you might want to draw your scene from a lower angle. In this case the eye-level line might cut across the belt line of your key standing figures. The belt lines of all the other standing people will cross slightly above or below this line, depending upon their height.

For further control, run convergent perspective lines from the tops and bottoms of your figures, props and architecture to a vanishing point along the horizon line.

Le d'Fenseur (Counsel for the Defense)
Honoré Daumier, 1858–1860, black chalk, pen, watercolor, gouache, 19" × 29½" (48cm × 75cm), collection of the Louvre, Paris, France

Renowned for his controversial, politically charged newspaper work, Daumier also took a socially conscious approach to his more private easel paintings too, depicting the underclass and poor workers in a dignified manner as they relentlessly pursued their daily chores. Few people saw his painted work until after his death. Ironically, this more universal work speaks to our modern age, not the journalistic, event-specific images that brought him fame in his own time.

Manipulating Your Light Source

Pay close attention to your light source when you combine individually posing models into a multifigure narrative. It doesn't matter how you light your key figure as long as it enhances the mood or effect you're trying to create, but keep its orientation consistent for all your subsequent models.

Nothing destroys a narrative, or any visual composition for that matter, more than indecision. If you light the key figure from above and to the right, do so for all the other players. When working from life, I much prefer to use natural, northern light cast from the side. But when I don't have this as an option, I use a clamp light, outfitted with a 200-watt equivalent CFL or LED light fixture (rated at 5,000 Kelvin to duplicate the color of north light). I mount the lamp atop an old broomstick that I've taped to the extended stem of a derelict camera tripod. I place the lamp to one side of the model to get a strong, flanking chiaroscuro effect.

It's difficult to illuminate your own canvas without disturbing the dramatic shadows on the model with fill light. Artist Jerome Witkin sometimes builds a curtain and cardboard baffle around the model to block the extraneous light. I normally place my easel light, a 100-watt equivalent, daylight CFL lightbulb on another similarly outfitted tripod. I like to aim it at the ceiling, just behind and ideally to the left of my canvas. (Try to place your light to the right if you are left-handed to avoid your hand casting a shadow across the image.) This creates an ambient light that is sufficient to illuminate your working area but doesn't interfere with the model.

The Death of Socrates
Jacques-Louis David, 1787, oil, 51" × 77¼" (130cm × 196cm), collection of The Metropolitan Museum of Art, New York, New York

After David began his studies in Rome, he adapted ancient Greek historical subjects to large paintings that served as critical metaphors for current events.

Dispelling the Cutout Effect

Most artists have learned that it's actually not that difficult to render individual figures. But some artists find it very hard to integrate their actors into an atmospheric sense of space so their figures don't look like flat paper cutouts, destroying the coherence and decisiveness of the narrative. The Italian Renaissance and Baroque artists were experts at creating a smoky sense of atmosphere, or sfumato, and they frequently used strong value contrasts or *chiaroscuro* to run the darks of the figure into the shadows of the surrounding environment.

You can also run the lights of your model into the lights of the background to enhance the harmony of figure and ground. Until recently, many artists called this unifying effect just that: "the effect" or *l'effet*, in French. You can see ample evidence of the effect in David's *The Death of Socrates*, with the darks of various Athenians running into the shadows of the background. In fact, notice how David melted the shadows of some characters into others, noticeably the group of grieving individuals on the right. On the other hand, you can see little sfumato in *The Tennis Court Oath*

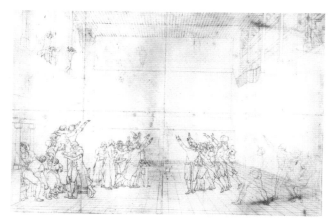

Study for The Tennis Court Oath
Jacques-Louis David, ca. 1790, pen and brown and black ink over black chalk and graphite on white laid paper, 25¾" × 38¼ (65cm × 97cm), collection of the Fogg Museum at Harvard University, Cambridge, Massachusetts

where David, in his effort to record every detail and personality with near democratic equality, comes dangerously close to the dreaded cutout effect.

Using a Shadow Box and Spotting

It's not always easy to anticipate the play of light as it crosses over several figures in an imaginary scene. Some artists, such as Pontormo, Tintoretto and Luca Cambiaso, sculpted small figurines in preparation for their narrative works. Others created elaborate miniature stage settings so they could test out their lighting ideas and determine which lights and darks would blend into one another and where the cast shadow from one figure might pass over another.

You can easily make your own test figurines with wax, plasteline or clay (not to mention Play-Doh). On occasion I've set up a couple of my old classic-size GI Joes to test out my lighting ideas. Try setting them up in a large box, called a shadow box by many still-life artists, turned on its side like a stage set. Remove one or two of the four sides so you can fiddle with the light until you get the lighting effect you're looking for.

Some artists use the term *spotting* to describe the rhythmic distribution of lights, darks and repeating geometric shapes flowing across their images. You can use these strong, graphic shapes to direct the viewer's eye through your narrative. Examine how Daumier "spots" the black shapes of the lawyers' robes and the stark light shapes of their collars throughout *Grand Staircase of the Palais de Justice* to manipulate the viewer's eye progressively up and down the page and through the underlying drama.

Grand Staircase of the Palais de Justice
Honoré Daumier, lithograph, 9½" × 7⅛" (24cm × 18cm), published in *Le Charivari*, February 8, 1848

Art Lovers
Honoré Daumier, brush and gray, black, orange, red wash, charcoal, graphite, 7½" × 10¼" (19cm × 26cm), collection of the Cleveland Museum of Art, Cleveland, Ohio

The Tennis Court Oath (opposite)
Jacques-Louis David, 1791, pen washed with bistre with highlights of white on paper, 25½" × 41 (65cm × 104cm), collection of the Musée National des Château, Versailles, France

Not only did David promote a form of exalted propaganda painting, he also often took a personal, journalistic approach to his work. This drawing is a study for a mass-produced lithograph, which in turn served as a fundraiser for a never-completed painted version. The painting was never finished for a good reason: The political scene changed more quickly than David could paint.

Capturing Action Poses

Some narratives evolve into rather wild compositions with figures, limbs and faces in motion, shifting in all directions. So what do you do if your composition demands that the model take a strenuous action pose? Request that the model take the position in parts.

For instance, with running poses, I often ask models to pose with their bent knee supported by a soft director's chair. When I want to paint models walking, I have them rest one of their heels on the edge of a telephone book, and if their hand is uplifted in a gesture, I normally have them brace their elbow on a photographer's tripod.

Whether depicting an action pose or a sedate seated position, some artists prefer to work from a life-size "lay figure." Essentially a large cotton-stuffed doll, these fully articulating manikins were common in most artists' studios before the twentieth century. You can use them to study the pose at your leisure, and you don't have to worry about the drapery's folds changing with every breath or break that the model takes.

However, lay figures are now considered antiques and are very expensive. Some artists prefer to buy an inexpensive plastic skeleton with an articulated spine. You can wrap the skeleton with cloth or foam rubber to soften its boney forms and clothe it with your Sunday best if you so desire. I've tried putting my GI Joes in action poses to study drapery, but it is not a very workable solution. Their cotton clothes are much too thick for the figurine's small size, leaving you with clumsy and unbelievably large fold shapes. You can get thinner, tighter fold shapes if you wet the cloth with water—a temporary solution that might provide you with the necessary information in an urgent situation.

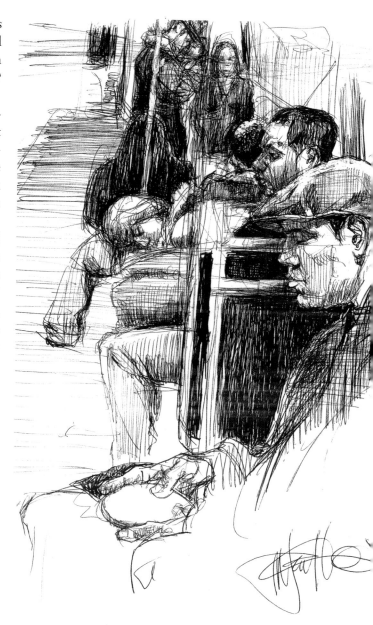

Subway Series, Morning Rush Hour
Marvin Franklin, 2004, ink, 14" × 11" (36cm × 28cm), collection of Tenley Jones-Franklin

Take your sketchbook wherever you go. You never know when you'll be touched by inspiration or simply the opportunity to practice your journalistic skills—whether on a subway or a bus, a café, or watching television with a friend.

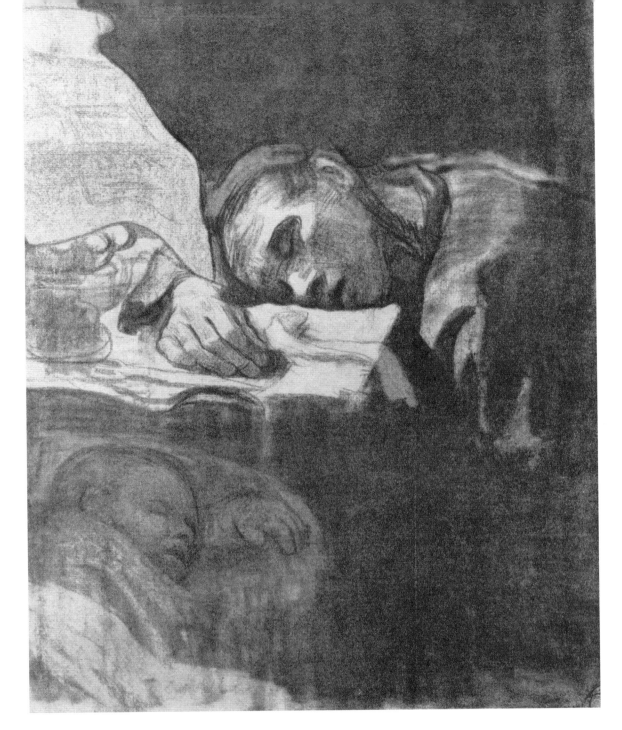

Homeworker, Asleep at the Table
Käthe Kollwitz, 1909, charcoal, 16" × 22" (41cm × 56cm), collection of the Los Angeles County Museum of Art, Los Angeles, California

Kollwitz was extremely active in politics in her early years. An ardent socialist and pacifist, this German artist did a series of weekly political and socially charged drawings between 1908 and 1911. Most people are unaware of the mass-media nature of her work since she produced many variants of her printed work that were devoid of slogans, captions or headlines. Throughout her lifetime Kollwitz produced hundreds of posters and prints to support various social protests or highlight the needs of the poor and hungry. She continued to do her work in private after the Nazis came to power and, when questioned, never backed down from her principles. Ironically the Nazis "appropriated" her imagery into the service of their own cause, reprinting the worker motifs and replacing her words with Nazi slogans. Although they could eradicate her individualism and the meaning of her artwork for a little more than a decade, the true meaning of her work lives on, now finding a larger audience than ever before.

Photography and Squaring up Drawings

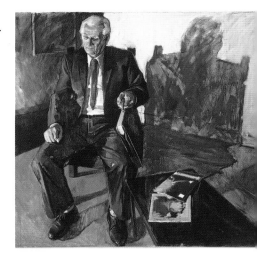

Some critics say that photography and motion pictures have supplanted narrative painting and drawing. But these are merely innocent tools if they're not used as a crutch. Even artists who prefer to work from life often like to supplement their observations with the camera, particularly if they are painting or drawing an action pose and want to see the figure in its entirety, unencumbered by supporting props. Some artists prefer to take photographs as their sole source material.

Whatever your needs, all the rules that apply to working from life equally apply when you use a camera, particularly the injunctions regarding the position of the light source. Furthermore, be forewarned that the camera is not as sensitive as the human eye and can create visual distortions that will throw off your drawing and painting. Be sure to set your focal length to 55mm or above. A lower focal length, or wide-angle lens, will cause fish-eye distortion and wreak havoc with your sense of proportion.

Preliminary sketchbook drawings for *Part 3* and *Part 1* of my *Nightmare Triptych*.

Try to get as far away from the model as possible to minimize this distortion. Keep the camera at the same eye level that you use while working from the live model, and don't move the camera to zero in on details; use your zoom lens for that. Although all digital cameras now automatically correct the coloring of the light source, many artists prefer to shoot in black and white when using film so they are not thrown off by color distortion, or the phony "Kodachrome effect," as some artists derisively call it.

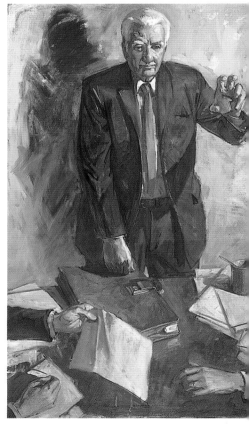

Other artists work totally out of their imaginations when initially composing their narratives. Sometimes they then return to a life model to draw the individual poses as Pontormo, Michelangelo and David often did. Some artists, such as David, meticulously squared up their drawings and transferred them onto their easel paintings. Many artists, such as Michelangelo, enlarged their drawings on paper and then scored (traced) them onto the wet fresco surface that they colored in with pigment.

I routinely do preparatory sketches before I begin a large, painted project, but these drawings are normally nothing more than scribbles. I fre-

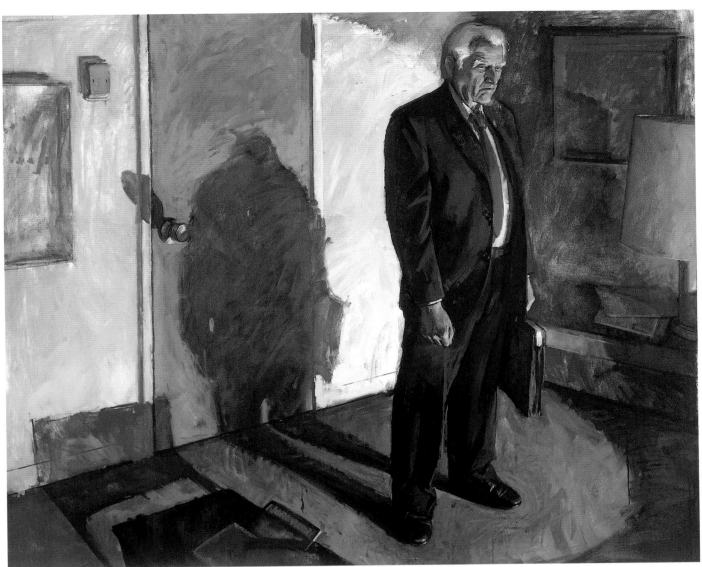

quently sketch the model on paper while working on a painting, but usually I prefer to do most of my drawing with charcoal or paintbrush on the canvas itself.

Often the visual concept that I start with is not the one I end up with. Sometimes I find myself changing an outdoor scene into an indoor one or replacing a male figure with a female figure and vice versa. As you can see, I did minimum sketching in preparation for my *Nightmare Triptych*. Although I did adhere closely to my initial gestural sketches in *The Waiting Room* and *The Aftermath*, I composed the middle panel, *The Sales Pitch*, wholly on the canvas. I purposely chose a sequential format for this series of paintings, trying to metaphorically dramatize the succession of frustrations that are often incurred by a salesperson.

First I focused on his nervous anticipation in the waiting room, represented by his clenched fist, the jagged cast-shadow looming behind him and the copy of *Newsweek* sitting on a table before him—its cover depicting the cataclysmic shuttle explosion. Then I painted his fervent, eager sales pitch and finally the aftermath—he may have succeeded, but whether he did or didn't, it doesn't matter. He's a person caught up in an endless cycle and, even now, faces into the darkness and girds himself for a relentless repeat of the nightmare.

The Waiting Room; The Nightmare Triptych (Part 1)
Dan Gheno, ca. 1986–1987, oil, 60" × 72" (152cm × 183cm), collection of the artist

The Sales Pitch; The Nightmare Triptych (Part 2)
Dan Gheno, ca. 1987–1988, oil, 60" × 40" (152cm × 102cm), collection of the artist

The Aftermath; The Nightmare Triptych (Part 3)
Dan Gheno, ca. 1987–1988, oil, 60" × 72" (152cm × 183cm), collection of the artist

Practice, Practice, Practice

Whatever approach you take, practice is the key word, especially if you want to use humans in your narratives. Draw the figure whenever and wherever you can, creating a strong image of the human form in your mind so you feel more comfortable setting up complicated narratives on canvas and paper. And don't just practice the human form. You need to practice interiors and landscapes too so you feel confident placing your figures in a setting. You didn't think you could change the world without at least a little work, did you?

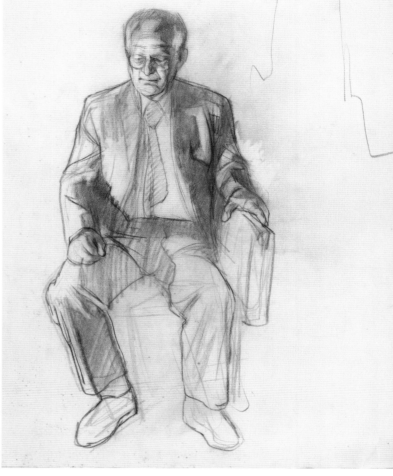

Study of Nightmare Triptych, Waiting Room #2
Dan Gheno, mid 80's, charcoal, 18" × 24" (46cm × 61cm), collection of the artist

Study of Nightmare Triptych, Waiting Room #1 (Detail)
Dan Gheno, mid 80's, charcoal, 18" × 24" (46cm × 61cm), collection of the artist

These are two sketches of many that I did while painting the *Nightmare Triptych: Waiting Room*. They chart some of the evolutionary changes I considered as I worked on the painting.

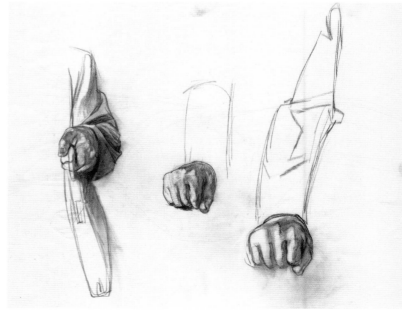

Conclusion

Learning to draw the human figure doesn't come quickly. You must develop new habits, setting aside a certain amount of time for practice and study every day, treating those hours like a job. You should also take as many figure drawing classes as you can and, while I've tried to cram as much as I could into this book, you need to collect other books on figure drawing and anatomy, reading them over and over, drawing from them to make the information stick in your mind.

After months and months of practice, you may find yourself thinking that you haven't made any progress in your work. That's a normal fear, but don't throw away your drawings in frustration as you do them. Save them, and then look at the collection every half year or so. Even for someone with a lot of innate eye-hand coordination, it can take at least ten years of constant, relentless study, working on your anatomy, sculpting the figure's form as well as drawing and painting from life, to feel truly competent to the point where you can start trying to make art. For those of us with only less than average coordination, it may take longer. However, whatever frustrations you may feel, you have to be willing to continue your studies no matter what. You have to want to be an artist so badly that you'll endure all manner of frustrations to reach your goal.

This journey to educate our eyes, hands and brains is a never-ending learning process and can seem impossibly frustrating at times. It was for the Old Masters; why should we expect anything different for ourselves—whether we are beginners or longtime veterans? If we approach each endeavor with passion, honesty and sincerity, then we will all push and test our limits every time we take pencil to paper and draw the human figure, study anatomy, copy Old Master drawings or analyze their compositions. Remember—when you think you're stuck in mud, you're not! You're simply looking at your artwork with a higher set of standards, which comes with practice and experience. Respect the progress you've made, look toward future discoveries with an excited sense of expectation and remind yourself that you are not alone.

Dan Gheno

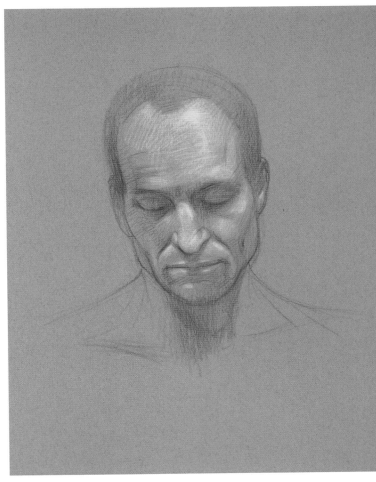

Continuing On (Cast Within)
Dan Gheno, 2006, colored pencil and white charcoal on toned paper, 10" × 11" (25cm × 28cm)

INDEX

a content + ecommerce company

Other fine North Light Books are available from your favorite bookstore, art supply store or online supplier. Visit our website at fwcommunity.com.

19 18 17 16 15 5 4 3 2 1

DISTRIBUTED IN CANADA BY FRASER DIRECT
100 Armstrong Avenue
Georgetown, ON, Canada L7G 5S4
Tel: (905) 877-4411

DISTRIBUTED IN THE U.K. AND EUROPE
BY F&W MEDIA INTERNATIONAL LTD
Brunel House, Forde Close, Newton Abbot, TQ12 4PU, UK
Tel: (+44) 1626 323200, Fax: (+44) 1626 323319
Email: enquiries@fwmedia.com

DISTRIBUTED IN AUSTRALIA BY CAPRICORN LINK
P.O. Box 704, S. Windsor NSW, 2756 Australia
Tel: (02) 4560-1600; Fax: (02) 4577 5288
Email: books@capricornlink.com.au

ISBN 13: 978-14403-3994-3

Edited by Brittany VanSnepson
Designed by Laura Kagemann
Production coordinated by Mark Griffin

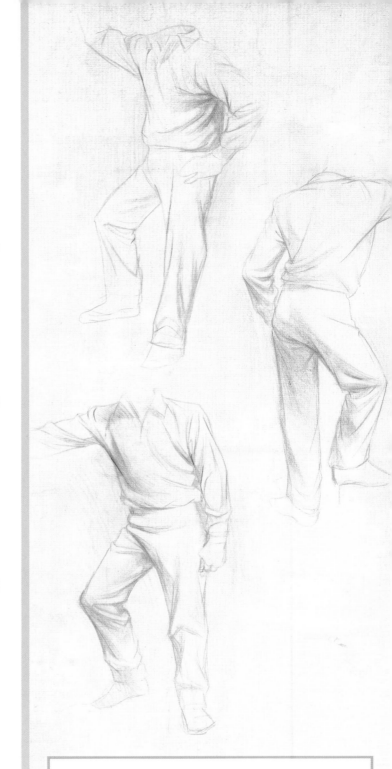

Metric Conversion Chart

To convert	to	multiply by
Inches	Centimeters	2.54
Centimeters	Inches	0.4
Feet	Centimeters	30.5
Centimeters	Feet	0.03
Yards	Meters	0.9
Meters	Yards	1.1

About the Author

Dan Gheno grew up in Santa Barbara, California, and later moved to New York where he pursues his art and teaches. He exhibits regularly, both nationally and in New York, at locations that have included the Museum of the City of New York, the National Academy Museum and many more. Gheno's work is included in several public and private collections including the Museum of the City of New York, the New Britain Museum of American Art, the Butler Institute of American Art and the Griswold Museum, Connecticut.

Gheno is a member of the Pastel Society of America and the Allied Artists of America. His awards include a Rome grant from the Creative Artists Network. His artwork and writings have appeared in various magazines and books, including *American Artist*, *Drawing* magazine, *The Artist's Magazine*, *Oil Highlights*, *Pastel Highlights*, *Portrait Highlights*, *The Best of Pastels II*, *Classical Life Drawing Studio* and on the cover of *The Best of Sketching and Drawing*. His work was included in the book *Painting the Town*, from the Museum of the City of New York. He was the art critic for the *Santa Barbara News and Review* in the 1970s.

Gheno studied at the Santa Barbara Art Institute, the Art Students League of New York and the National Academy of Design School. He is Professor Emeritus at the Lyme Academy College of Fine Arts in Old Lyme, Connecticut, and teaches at the National Academy School and the Art Students League of New York. To learn more, please visit dangheno.net.

Acknowledgments & Dedication

This book is dedicated to my always encouraging mother and father, to my wife and wonderful painter, Robin Smith, and to the very giving teachers that I was lucky enough to study with, and in several cases still count as my close friends including: Mary Beth McKenzie, Harvey Dinnerstein, Gerard Haggerty, Tony Askew, Ronald Sherr, Ralph Gilbert, Terence Coyle, Priscilla Bender-Shore, Phil Cohen, Douglas Parshall, and Harry and Inge Norstrand.

This book would've never happened if not for the vision of Steve Doherty and Bob Bahr who initiated *Drawing* magazine and encouraged me to think of my series of articles as a potential book, as well as my current editor there Austin Williams. Thanks also go to the editor of this book, Brittany VanSnepson.

I want to thank those who inspired me early on including Dan Spiegle, Mark Evanier and of course my very supportive family. Over the years, I've been blessed by my many inspiring, artistic friends such as Karen Schmidt, Jerry Weiss, Leo Neufeld, Sigmund Abeles, Peter Hazell, Minerva Durham, Joseph Catuccio, Deane Keller, Andy Reiss, Joe D'Esposito, Michele Liebler, Lisa Dinhofer, Daryl Cagle, Jerry Caron, Frank Martinez, Larry Mach, Joe Rubenstein, Alex Zwarenstein, Anki King, Patricia Way, Jim Woodring, Nomi Silverman and numerous others. Without my friends, my family and my teachers, I could not have followed this life I've had in art.

Ideas. Instruction. Inspiration.

Receive FREE downloadable bonus materials when you sign up for our free newsletter at ArtistsNetwork.com/Newsletter_Thanks.

Find the latest issues of *The Artist's Magazine* on newsstands, or visit ArtistsNetwork.com.

 These and other fine North Light products are available at your favorite art & craft retailer, bookstore or online supplier. Visit our websites at ArtistsNetwork.com and ArtistsNetwork.tv.

Follow Artist's Network for the latest news, free wallpapers, free demos and chances to win FREE BOOKS!

Visit ArtistsNetwork.com and get Jen's North Light Picks!

Get free step-by-step demonstrations along with reviews of the latest books, videos and downloads from Jennifer Lepore, Senior Editor and Online Education Manager at North Light Books.

Get involved

Learn from the experts. Join the conversation on **Wet**Canvas